Painting Better
LANDSCAPES

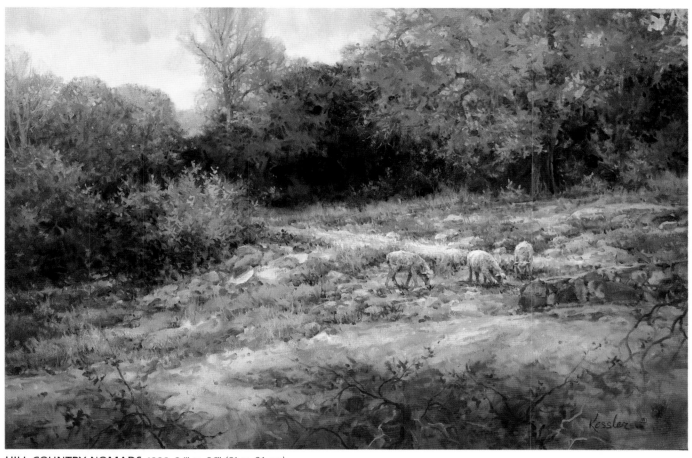

HILL COUNTRY NOMADS *1986, 24" × 36" (61 × 91 cm)*

Painting Better
LANDSCAPES

MARGARET KESSLER

WATSON-GUPTILL PUBLICATIONS/NEW YORK

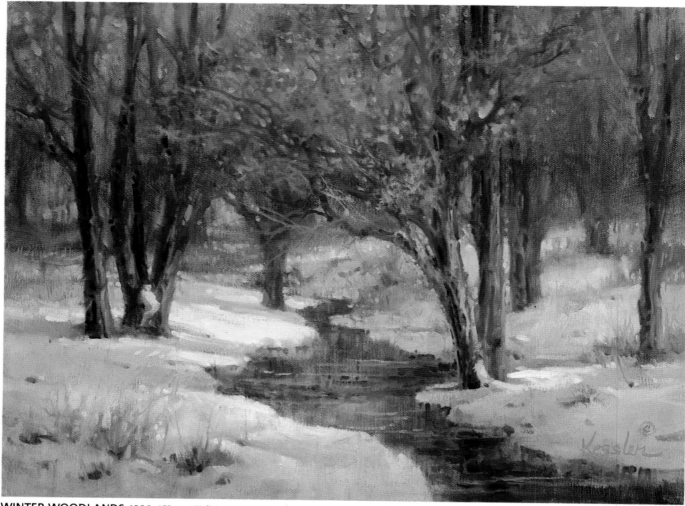

WINTER WOODLANDS *1986, 12" × 16" (30 × 41 cm)*

Copyright © 1987 Margaret Kessler

First published in 1987 in New York by Watson-Guptill Publications,
a division of Billboard Publications, Inc.,
1515 Broadway, New York, N.Y. 10036

Library of Congress Cataloging-in-Publication Data
Kessler, Margaret.
　Painting better landscapes.

　Bibliography: p.
　Includes index.
1. Landscape painting—Technique.　I. Title.
ND1342.K47　1987　　751.45′436　　86-32509
ISBN 0-8230-3575-1

Distributed in the United Kingdom by Phaidon Press Ltd.,
Littlegate House, St. Ebbe's St., Oxford

Manufactured in Japan

First printing, 1987
3　4　5　6　7　8　9　10 / 92　91　90

Art on preceding page:
PINERIDGE, *1986, 24" × 36" (61 × 91 cm)*

WRITTEN
in gratitude to the maker above
who made me see
that the value of art
lies in its uselessness.

DEDICATED
to my mother,
E. Cardinal Jennings,
the artist who started it all;
to my sisters,
Lorna Webb and Donna May,
who share in the lingo;
to my teacher,
Carroll Collier,
whose landscapes keep me humble;
to my husband and best friend,
Jere Kessler,
who keeps me going
with love, patience, and money;
and to our two sons,
Wade and Paul,
who gave me a reason for writing this book.

SPECIAL THANKS
to Bonnie Silverstein, for editorial direction;
the color lab, inc., Dallas, for photography;
and Francis E. May, for proofreading assistance.

CONTENTS

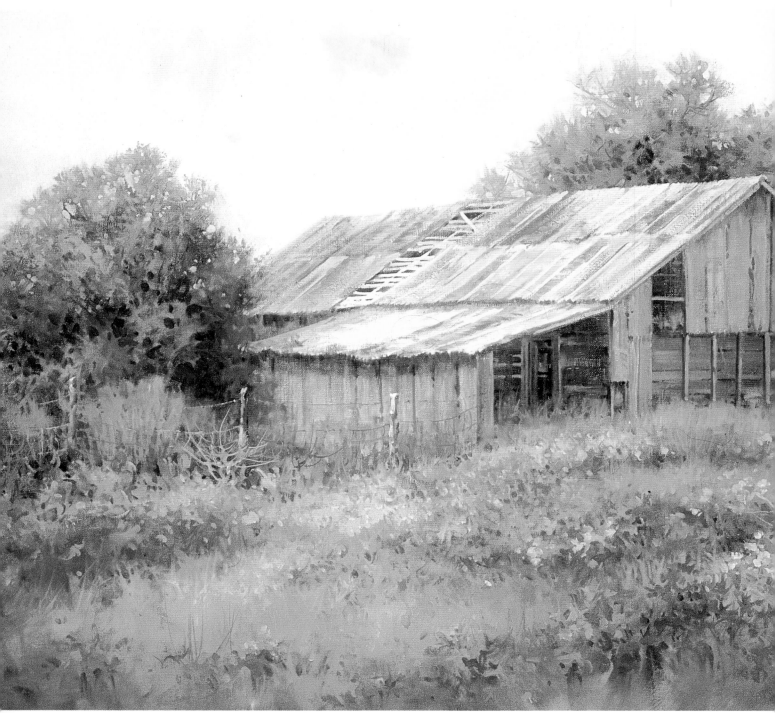

SUMMERTIME FANTASY *1986, 20″ × 30″ (51 × 76 cm)*

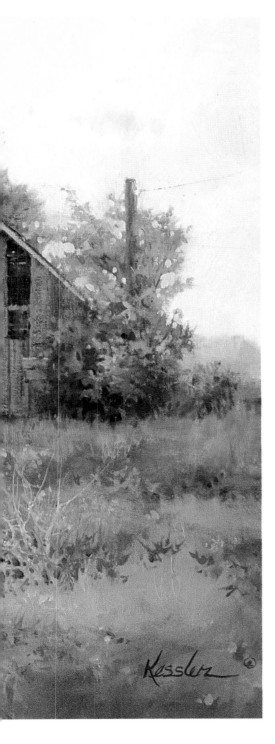

Kessler

PROLOGUE

An overview of the painting process

Why is it always easy to see mistakes in someone else's painting and hard to see them in your own? You know immediately when another artist has failed to create a sense of order in his or her picture; you can quickly spot the chaotic areas. But it seems that by the time you have finished your own painting, you are so involved with it that you cannot evaluate it with the objectivity of a good art critic.

As the creative "parent," it is difficult to take a hard, cold look at your own painting. But you can learn to critique your pictures even if you have only limited painting experience. With this book as a guide, you can learn to sit back and view your finished painting with the knowledge of basic art principles and the degree of detachment that it takes to identify problems in your own work.

Throughout this book I discuss the basic principles of art theory and how to apply them to landscape paintings—specifically oils. The instruction covers composition, design, line, space, values, color, texture, detail, and more. At the end of each chapter there is a self-critique section to help you identify strengths and weaknesses in your paintings. Then, at the end of the book, I include some sample self-critiques, discussing problems I located in my own work and showing you how I solved them.

To help you understand my points, I will start from the beginning and walk you through the painting process. The plan I use to construct a painting is similar to one you might use to build a house. There are five progressive steps:

1. Visualizing the idea

2. Composing the idea (the blueprint)

3. Establishing values (the foundation)

4. Blocking in the color harmony (the framework)

5. Refining the details (the finishing touches)

Keep in mind, however, that there is no right or wrong way to create a painting. Experiment with different methods and then pick the one that fits your needs and your personality. Try a spontaneous technique as well as the more controlled method I use. After you master the technical skills required to make good art, branch out on your own and develop a style that is all yours. As long as you are following someone else's lead, you will always be behind.

I hope this book will provide practical information to help you "proofread" your paintings and make final adjustments so you can experience "the sweet smell of success." But, I must caution you, major problems cannot readily be changed. Don't keep patching and repairing one painting forever. Do the best you can at the time and then move on to a new challenge. No painting is perfect.

PRELIMINARY WORK

The first step in any landscape painting is to select a subject. You don't have to wait for perfect weather, and you don't have to travel to the Swiss Alps to find something to paint. Wherever you are, simply set out to enjoy the day. If you are sensitive to the sights and sounds around you, the light and atmosphere, the season, and the uniqueness of the terrain, you will continually discover new visual elements that are stimulating and exciting. Luck—being in the right place at the right time—helps, but you have to be out there a lot to have a lot of luck!

I prefer to go on my material-gathering trips at a time other than high noon, as midday light is not very dramatic. I don my hat and hiking boots, load up with sunscreen and bug repellent, arm myself with all the camera equipment I could possibly want (including an extra battery), and take a small ladder for those hard-to-get shots. It usually helps if I remember to take my sense of humor, too.

I wait for some little element of surprise to catch my eye. I may be amused by some adventuresome goats or awed by an old homestead mysteriously veiled in fog. Or I may be captivated by a spot of sunlight striking a manmade subject. (Incidentally, one of the easiest compositional possibilities to pinpoint is a scene with sharp value contrasts—the starting point for an exciting design.)

Once I know what I want to paint, I visualize what I want to say about the scene. I find it helpful to describe the scene verbally. I ask myself, "Why am I attracted to this specific scene?" Then I think of all the adjectives I can that describe the scene as I want it—words like "warm and dry," "light and bright," "happy and playful." As I work, all my energies go into artistically expressing these feelings to reveal the underlying spirit of the scene.

Although I use a camera to record the scene and facilitate my recall of the details, I always strive to make a more personal statement. As an artist, aim to convey the mood and capture the quality of light you experienced at the scene. Go beyond the camera's capabilities to express your reaction to the setting with an intense enthusiasm that is obviously more than superficial. In this way you share your world, as you see it, with others and invite their emotional participation. It is this personal quality that makes each painting special—an expression of the unique individual who created it.

Whatever you do, don't paint from published photographs. Quite aside from the legal issues, you are short-changing yourself as an artist, for experiencing the scene helps you identify the mood you want to express.

GATHERING MATERIAL

My first efforts at composing a painting are done on location through my camera lens. Although working from real life is desirable, it is not always convenient; paintings done strictly from memory, on the other hand, usually look mechanical and primitive. Good photographs, combined with on-site oil sketches and notes, are sound stepping stones to a good painting. As your photographic skills improve, so will your finished paintings.

A viewfinder—be it your camera, a cardboard mat, or framing with your hands—helps you see the two-dimensional possibilities in the three-dimensional scene. It eliminates distractions and allows you to concentrate on the important compositional elements: value contrasts (light against dark), simple shapes, light qualities, motion, and textures. Although not unimportant, at this point subject matter and color are usually of secondary importance. Think "design."

If I have a hard time deciding whether I want a panoramic view or a more intimate study of a particular scene, I change the focus on my camera so that the scene is somewhat blurred. Without the distraction of details, it is easier to see the natural light-dark patterns in the scene and to locate large, interesting, simple shapes. Sometimes, however, I have more money than time, so I take photographs of both the panoramic view and the object of interest. I can make the choice later in my studio. Besides, maybe the location will inspire more than one painting.

It is best to have an abundance of material. I take several shots of each scene as I actually want to paint it, as well as some more distant shots of the general setting and a few closeups to provide details. A finished painting is generally a composite of this information. In any case I never scrimp when it comes to photography. On one week-long painting trip to New Mexico, I shot sixteen rolls of film at thirty or forty sites. I will probably complete less than a dozen studio paintings from that material. It is better to throw slides away than to try to use uninspiring material or wish you had more information about a scene you are trying to paint.

I must mention that photographing on a partly cloudy day can double your options. With patience, you can record the scene as a gray day and as a sunny day and make your choice later. Painting on location on a partly cloudy day, however, is frustrating—to say the least. The constantly changing light is bewildering, tempting you to keep changing your mind about how to portray the scene.

The camera quickly records sunlight and shadows and detailed facts for later reference, but the camera also distorts images. A zoom lens, for example, grossly flattens a real-life scene. Use your photographs in conjunction with a sound art education and on-site painting experience.

A NOTE ON EQUIPMENT

Adequate photographic equipment is expensive but crucial. A 35mm single-lens-reflex (SLR) camera, with both a standard 50mm lens and a zoom lens (preferably 70–210mm), is a must. (My camera is a Canon AE1.) With the zoom lens, you won't have to trespass on private property or risk an encounter with a big dog to photograph the material you want. A collapsible unipod is helpful, especially if it is windy.

Although color prints are fine, I prefer slides (Kodachrome 64). When projected, they provide a much larger image and portray the light with illumination. With slides, you can check the potential design elements in a scene by viewing them out of focus. Also, you can flop the slide in your projector and see the design potential of the scene from a different vantage point. You may even decide to paint the reversed image.

If you choose to use slides, you will need to buy a special projection screen that allows you to see your slides in a well-lit room. (It's hard to paint in the dark!) Visit a good camera store, as there are several options available. Ask about rear-projection screens and Kodak's Ektalite (reflective) screens.

When you use a projector, it is a good idea to have a spare light bulb (long-life) for it. Also, don't become absorbed in your work and forget to cool the projector every half-hour or so. Slide meltdown is heartbreaking.

DECIDING WHAT TO PAINT

After your rolls of film are processed, it may be hard to decide which scene to paint first. I like to sleep on it, letting my subconscious do the work. I try to spend an hour or so on Sunday evening quietly viewing my slides. I do not, at that time, choose a scene to paint in the coming week. I just sit back and enjoy the show and the feelings each new location evokes.

It is best to view slides taken in the same season you are experiencing, as you are influenced by your environment. Paint what you are seeing, feeling, hearing, and smelling, and it will improve your work.

Because of my Sunday evening reflection, when I reach my studio on Monday morning, the big decision of what to paint comes with relative ease. In trying to recall some of the dozens of scenes I saw the night before, usually one or two come quickly to mind. I look again at these specific scenes and try to visualize a completed painting for each setting. Ideas begin to evolve and excitement builds, favoring the scene that develops most clearly in my head. The big decision is made. I am then ready to work out the composition with a value study in my sketchbook.

My photographic equipment includes a single-lens-reflex camera, film, a collapsible unipod, a zoom lens, and a cable release.

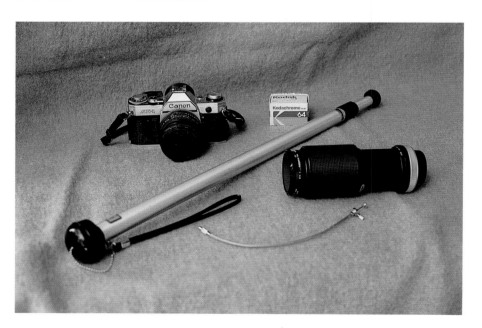

A TYPICAL PHOTOGRAPHIC SELECTION

Since the camera cannot handle a wide range of values as well as the human eye, photographic material needs to be used with discretion. Paintings that duplicate the values recorded by a camera are usually identifiable, as the shadows are too dark and vague, and the lights are too flat.

My painting *Boxcar and Billy Goats* (page 13) provides a good example of how I use photographic material. Although I took two dozen slides of the real-life scene for this painting, the selected photographs will give you an idea of how I use the camera to gather painting material.

Before I thoroughly explore a setting, I photograph it from a distance to remind me later of the general feeling of the scene. At this point I was undecided about what I wanted to feature—sky, barnyard clutter, haywagon, boxcars, or goats in the sunlight. This slide was taken with my camera set on "automatic." Notice that the wide value range overwhelmed the camera. The shadows are dark and fail to provide detailed information.

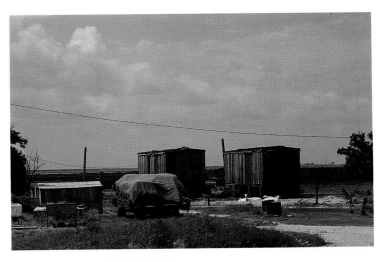

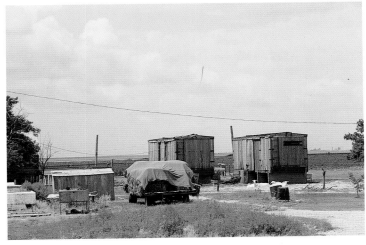

This is the same view, but I intentionally created a high-key image by pushing a button on my camera that opened the aperture one and a half f-stops more than the normal automatic setting. Now, although the sky is bleached out, I can see into the shadows. Unfortunately, you cannot intentionally overexpose like this if you use color prints rather than slides. The automatic developing process for prints will compensate for the "inadequacy" of the photographer and print both exposures in the same values.

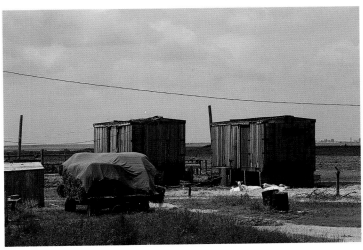

When I have finished photographing from a distance, I begin composing my painting with the camera lens, taking two slides (automatic and overexposed) of each view. In the view shown here, there are too many entertaining elements. I don't want the theme of my painting to be the vast sky and open space of west Texas, so I eliminate that element. I do, however, like the exciting spot of light on the goats and include that in my painting plan.

There is no direct sunlight in this image, the sky space is larger than I want, and the overall values are too dark. But this view most closely expresses what I want to say about the scene. The composition features the goats—the most interesting aspect of the scene to me—although I won't include the goat on the right because he is leaving the scene, and the viewer's eye might leave with him. Unfortunately, the horizon line cuts the picture in half, but when I crop the top of the sky, that will no longer be a problem.

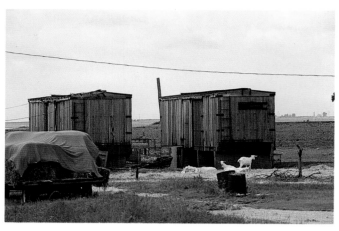

Before I leave the area, I take miscellaneous shots for reference material. The camera automatically bleaches out the sky if a large percentage of your picture is scenery. I therefore photograph the sky, leaving only a small fringe of the scene at the bottom, so the camera can record the values within the sky correctly. The small fringe helps me identify the scene that the sky matches.

I always take a few closeups of the principal objects for reference when I paint the final details. By nearly eliminating the bright light of the sky, I enable the camera to capture accurately the values within the setting. I wish, however, I had a spot of sunlight at my command to add excitement to this shot.

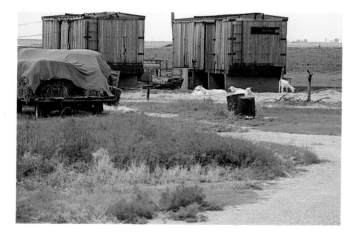

I like to investigate the same scene from a number of vantage points. If you look closely here, you can see the billy goats on the far left. From this angle, I took another full set of slides—distant shots, test compositions, and detailed studies, all at both normal camera settings and intentionally overexposed. Someday I may decide to do a painting from them, too.

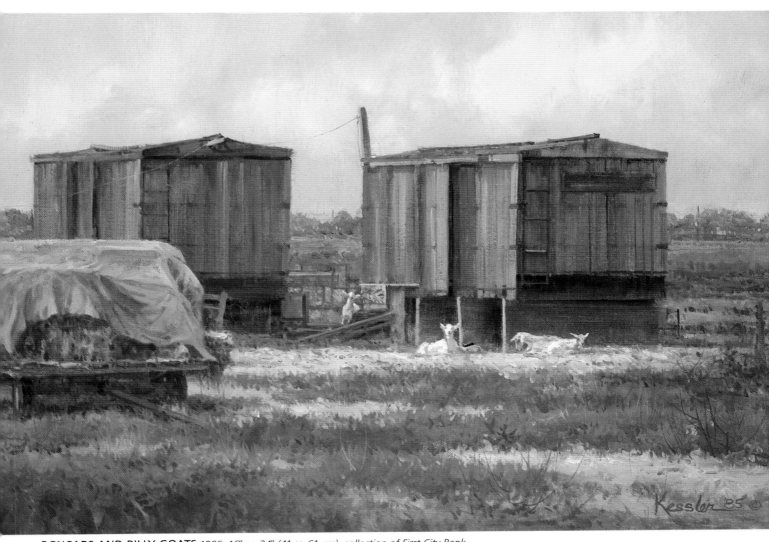

BOXCARS AND BILLY GOATS *1985, 16" × 24" (41 × 61 cm), collection of First City Bank*

I have always been fascinated with farmers' creative use of boxcars. Here the two barnlike boxcars and the haywagon cluster in a protective semicircle to form the abstract pattern underlying my painting. The tongue of the wagon and the patterns in the grass direct the viewer's eye into the composition. Changing the color of the tarp from an eye-catching red to a more subdued color allows quick passage to the goats warming themselves in the sun.

FROM SKETCH TO FINAL VARNISH

Now let's walk through the actual painting process. As you read, refer to the stages of my painting *Dappled Light* (shown below).

COMPOSING THE VALUE PLAN

Planning the values in your sketchbook is probably the most neglected aspect of the painting process. I cannot overemphasize its importance. Your value plan, with its abstract black-and-white pattern, is the foundation that will hold your painting together. Inevitably when I skip this step, I regret it later.

Using charcoal or pencil, I compose the value study to scale. A 3 × 4-inch (8 × 9 cm) sketch, for example, might become an 18 × 24-inch (46 × 61 cm) or a 15 × 30-inch (38 × 76 cm) painting. Now is the time to select your canvas shape and size. I let the subject I am painting determine which canvas I use. I never buy a canvas and then look for a subject to fit onto it.

In the value study I concentrate on placing the objects and dividing the space so as to achieve an aesthetically pleasing balance and movement. At this stage it is still easy to move trees and other objects; a sweeping motion with an eraser can change the scene in a flash. You can try this and that until you arrive at an organized pattern of light and dark that expresses the scene as you see it. Remember: now is the time to make these decisions, not later. Once the scene is established in thick paint on your canvas, it is a major undertaking to move a tree or even a small bush.

PREPARING THE CANVAS

I prefer to work on a textured surface because later, by dragging thick, light-colored, opaque paint over thin, dark, transparent paint—scumbling—I can create the impression of twigs, grass, and foliage with ease. The texture I create on my linen

THE SCENE ITSELF

Trees are high on my list of favorite things to paint, so a trip to Cloudcroft, New Mexico, during early October is a real joy. The timing is just right to take full advantage of the changing colors. Although the aspen trees at this particular site are all rather yellow-green, just around the bend are yellow-gold trees and bare ones too. I know I will want to remember this and incorporate these variations into my painting.

I am also attracted to the pine trees. I see the very young one in the left foreground as setting the stage for the strong, healthy pines farther back. The isolated pine tree just to the right of center represents the older generation to me. It seems rather frail in comparison—something I decide to exaggerate in my painting.

The camera does not do this scene justice. The display of brightly colored aspens contrasting with dark, majestic pines reminds me of the excitement of bright lights at a night carnival. I wish I had more time to absorb it all.

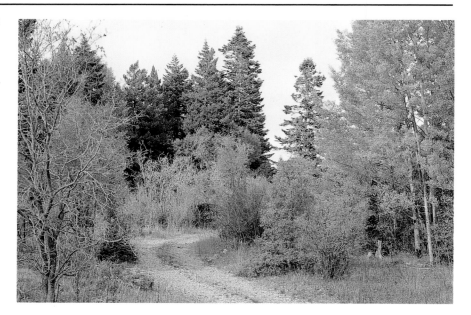

canvas with full-strength gesso and a one-inch housepainter's brush adds another dimension to this illusion.

By toning the canvas with an overall color, I set the mood for the finished painting. Selecting a color that conveys the lighting conditions of the moment, I quickly apply this in a very thin wash with a piece of paper toweling or a rag dipped in turpentine and paint. Since the turpentine evaporates rapidly, the canvas is ready in minutes.

TRANSFERRING THE DRAWING
Sometimes I add a grid to both my black-and-white sketch and the toned canvas to transfer my sketch to the canvas accurately. After carefully developing a sound value plan, I don't want to lose its delicate balance when I transfer it to the canvas. The more complicated the scene, the more I rely on the grid technique.

Unless I am working on an oversized canvas, I generally just divide the sketch and the canvas into four equal parts for my grid. The resulting intersection of lines at the center provides a convenient checkpoint. To avoid the "bull's-eye syndrome," I am careful not to place anything important at that intersection.

I prefer to use a brush to draw on the canvas, rather than pencil or charcoal, because I find it liberating. I am able to let go of my natural impulse to indicate small details and instead suggest just the large, simple shapes, which can be clarified later. Sharp, thin charcoal lines can be restrictive and may lead to "number painting"—filling in the shapes between the lines.

After transferring your drawing, pause to study the results. Because the sketch is now in a different medium (paint rather than pencil or charcoal) and enlarged, you can take a fresh look at the basic line structure. Reanalyze it, checking for unity with rhythm and variety.

BLOCKING IN THE VALUE PATTERN
As soon as I am confident things are placed where I want them, I block in the value pattern, keeping it

COMPOSITIONAL DECISIONS

After studying my slides of the scene, I find it easy to arrive at a value study that pleases me. I'm not always so lucky.

For this particular scene I choose a wide rectangular canvas (24 × 36 inches, 61 × 91 cm). This shape conveys strength without being as powerful as a vertical canvas; it is also a more relaxed shape than a perfect square would be. An elongated rectangle, such as a 15 × 30-inch (38 × 76 cm) canvas, would be entirely too horizontal. By choosing a relatively large canvas, I hope to establish the majesty of the forest. The blank canvas itself immediately begins to communicate the mood of the painting— the quiet strength I experienced at the scene.

The bank of pine trees provides a large, dark shape that fascinates me. I stretch this dark value across the drawing by connecting the pines to the shadows in the aspens on the far right. The road then provides a perfect avenue to lead the viewer's eye into the scene, moving down the road, through the trees, and up into the sky. This S-curve composition is favored by landscape artists.

I am especially intrigued with the shape of the sky space. The original material is inspiring, but I do change it somewhat. Compare the height of the individual pine trees in my photograph with the ones in this sketch. Since the tallest tree is nearly dead-center, I decide to emphasize a different one in my painting.

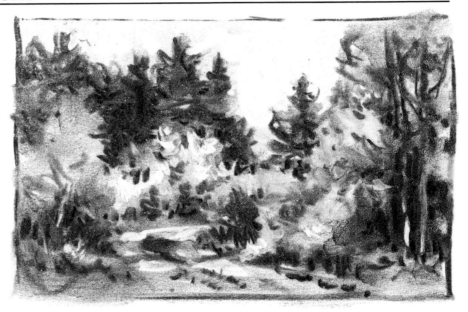

bold and simple. During this phase I concentrate on establishing values and relating them to each other correctly. I am not too concerned about color, although I will imply color by indicating warms and cools. My main concern now is to establish the values. I cannot emphasize this strongly enough. If the simple light-dark pattern of the block-in is not a sound abstract design, nothing I do from this point on will save the painting. I could paint every leaf on the tree to perfection, but the painting would still be structurally weak.

I begin by placing the darkest value on the canvas and working toward the lights. To keep things simple and avoid detail, I usually apply the paint with the corner of a dry facial tissue or a soft, lint-free rag such as cheesecloth, keeping the paint quite thin. (I always wear disposable plastic gloves as the paint is hard on my hands.) I do not use a medium or turpentine, and I usually don't add white paint at this point.

To establish the light values, I leave the paint very thin, allowing the original tone to show through. To achieve even lighter values, I use a clean, dry corner of a rag to wipe off the original tone, revealing the canvas itself. To indicate a very bright, light value, I dip a corner of the rag into a little turpentine and wipe out all the pigment, down to the raw white canvas.

As I work, I take advantage of the gesso texture I have given the canvas by pressing the painting rag to the canvas with a swirling motion to leave the impression of grass and other foliage. Occasionally I work with a brush rather than cheesecloth or tissues, but I take care to use a large brush at this stage. A small brush may encourage you to add details too soon.

CRITIQUING THE VALUE PLAN

After the value plan is blocked in and before establishing the color harmony, I study the painting in a mirror. By reversing the familiar scene in this way, I can double-check the activity within the

BEGINNING ON CANVAS

I begin by toning the canvas with a warm ochre color (cadmium yellow deep with a touch of orange and a yellow-green) to indicate that the scene is bathed in golden sunlight. For the same reason, I place the objects on the canvas with a warm brown (lemon yellow hansa, cadmium red deep, plus a little phthalo blue) rather than a cold brown or purple.

Although the actual road took me on a slightly uphill hike, I decide to lower the horizon a little in the painting to give a more relaxed feeling of an afternoon stroll along a sun-dappled lane. By lowering the horizon I also divide the three major sections of my canvas (sky, upright planes, and ground) in a more interesting way. Since this scene is relatively simple to draw, I do not use a grid to transfer the drawing to canvas.

Notice that the pine trees almost line up like tin soldiers on parade—equal distances apart. That may be true of the actual scene, but to avoid boredom, I will create some variety in this area. When I develop the value pattern, I will indicate a variety of tree groupings rather than a row of individual trees.

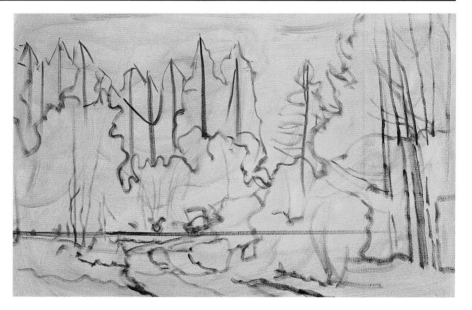

painting. I can easily see if the simple abstract shapes are interlocking in a way that is aesthetically pleasing to me. I ask myself: "Is there a sense of order in the picture or is it lost in chaos? Is the basic value design sound? Are the values consistent with the mood I want to capture? Are the source and direction of the light apparent?" If I have lost the original linear rhythm or accidentally created additional linear excitement, it quickly becomes apparent.

Don't stop with checking your painting in the mirror. Turn it upside down and sideways too. You'll be surprised at how useful this easy exercise is. Seeing the new image from a different perspective can help you solve problems and inspire new ideas.

This critique seems to be a natural stopping point, so I usually quit for the day. By morning the thin paint of the block-in will stabilize a little as it dries, providing a nice surface on which to work. Also, by then I will feel rested and ready to begin the next step.

ESTABLISHING THE COLOR HARMONY

The mood of the painting determines the colors I use. Warm, bright colors indicate playful, carefree emotions. Blues, purples, and grays dominate moody scenes. Too many colors can be confusing; I prefer a dominant color, contrasting with accents.

When it comes to establishing the color harmony, think in terms of large masses of color—not small dabs. To unify the color scheme, repeat and relate these large color areas throughout the composition.

For most landscape paintings, it is the sky that sets the mood. It indicates the time of day, the atmospheric conditions, and sometimes even the season. The sky also controls the degree of light, warmth, and color intensity.

For these reasons I usually begin with the sky, placing the warm spots of color first and then moving into the cooler hues. I do not stop to clean my brush as I work until I have arrived at the coolest hue—unless I reach it too quickly (in which case, I have to add some warm color, so I clean my brush

INITIAL BLOCK-IN

Now I begin to block in the values, starting with the darkest dark. Although I am concentrating on the values as they relate to each other, I am also thinking about what I'll be painting and what colors I'll eventually use. That is, I do not paint poster-flat shapes but instead try to describe the objects through my brushstrokes. By scraping, scratching, pushing, and dragging paint over the gesso texture, I can create an active impression of the foliage.

To overcome the camera's tendency to flatten perspective, I widen the road as it reaches the bottom edge of the canvas. (Looking back, I wish I had made it even wider, creating additional depth in the scene.) I also eliminate the bare tree in the extreme foreground of the photograph to allow the eye to enter the painting more easily.

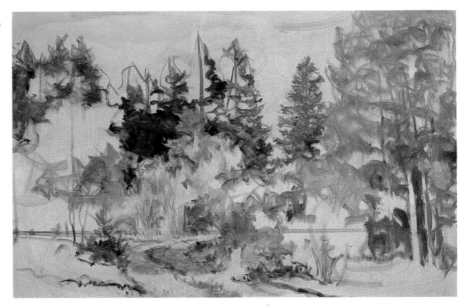

and repeat the process). The theory is that it is easier to cool a warm than to warm a cool. I follow that principle religiously. If you try to warm a cool color, whether on the canvas or on the palette, you may quickly arrive at a muddy, nondescript color. Should this happen on your canvas, don't continue to struggle with the unwanted color. Instead, lift the area off with a palette knife and begin again with warm spots of color, progressing to cools more slowly.

As I mass the spots of color with a large, flat bristle brush, I strive to emphasize the light source through the use of color as well as value. My value block-in serves as a guideline for the lightness or darkness of the sky color, so I need only decide how warm (or cool) and how bright (or dull) to make the sky colors. In making these two decisions, it is important to recall the mood I set out to convey in the first place.

Don't be tempted at this point to develop the lower edge of the sky. And don't leave a hard edge where the sky meets the landscape itself. Instead, using a feather touch, lightly drag a little of the sky down into the landscape, losing some of the detail of the block-in. Later, when it is time to redefine edges and establish details, you can work this paint into the scene so that it gives the impression of atmosphere. It can also help create the illusion of "skyshine," of the way light from the sky reflects off treetops and rooftops. Moreover, it is a subtle way to begin working the sky colors into the rest of the landscape, thus relating the two units.

After the sky is massed in, I usually turn to the focal point, or center of interest. Some landscape artists start at the top and work their way down—moving from sky to background to foreground. I prefer to key the picture's level of excitement at the focal point first. Then I carefully avoid overpowering that home key.

The way to attract attention to the center of interest is through contrast. You might, for example, play the lightest lights against the darkest darks, put

COMPLETED BLOCK-IN

With the value block-in complete, you can see how I have used a wide value range to create a lot of contrast in this scene. The values run from near-white to almost-black to express the excitement of the light on the subject. Although I started with large, simplified value shapes, I have gradually made them more precise.

With a filbert bristle brush and turpentine, I lift out a few pockets of sky within the pine trees, as well as the aspens on the right. Notice that I do not paint each tree trunk from the ground up to the sky. Although the trunks are not disjointed, I indicate how they are lost here and there into the foliage.

As usual, I now clarify the mood of the scene by developing the sky. I apply rather thick paint in this area as the very luxuriousness of the paint creates the sense of luminosity that I want. Here I work with a flat bristle brush rather than a filbert, as its brushmark is more appropriate.

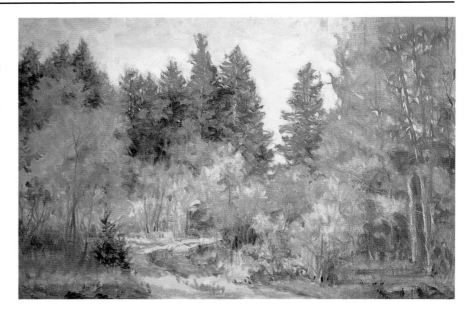

warm colors beside cool, or bright colors against dull ones. But keep the degree of excitement in tune with the overall atmosphere you want to capture. A scene with a quiet mood might not have a strong center of interest, while a more dramatic situation might require an exciting focal point.

With the focal point established, I finish massing in the color harmony. Although there should be several secondary areas of interest on a large canvas, I control the contrasts so nothing in the painting competes for attention with the focal point.

DEVELOPING THE DETAILS

I consider the detail phase the fifth and final step of the basic painting process—after choosing the subject matter and visualizing the painting, working out the composition, establishing the value design, and massing in the color harmony. Each step along the way is of utmost importance in its time. I try not to be overly concerned about the step ahead or

behind me so the task seems more manageable. If each step has been done well, the detail should almost paint itself.

Painting details can be very relaxing. This is the time when the stereo is turned on and the small brushes are put to use. But this is also the time when a picture can be loved to death. Knowing when to stop painting is an art. It is also a personal decision. What is enough and what is too much? Since there is no absolute, I choose to stop just as soon as I begin feeling comfortable with the painting. It is an inner feeling that I have learned to trust.

When it comes time to begin developing detail, I cannot help thinking of my friend and watercolor teacher Bud Biggs. He had a large poster in his studio that said, "Don't paint the [de] tail." Although we students enjoyed the humor, we also appreciated the lesson. Detail is just one phase of the creative process. As I have mentioned before, no amount of detail will save a poorly designed

FOCUS AND DETAIL

In the last step I began indicating some branches and twigs. Here you can see that I have added a lot of calligraphy to convey the natural, unkempt state of the forest. As I apply these wiggly lines, I continually smudge with my finger to lose some edges and at times to eliminate the marks completely. Later as I refine the foliage, I will make no effort to preserve all these brushstrokes.

To bring out the golden aspen as the center of interest, I work on the contrast with the green pines. Remember that by using such contrasts as warm/cold, light/ dark, bright/dull, and even rough/slick surface texture, you can direct the viewer's eye to any given location. I then subtly work to the four corners of the canvas, keeping the rest of the painting subordinate to the focal point.

Notice the clump of aspen trees on the right. At the base of these trees, there are dark-colored shapes around the light-colored trunks. Near the top, there are light-colored shapes around the darker foliage, which create "sky holes" in the trees. This kind of "negative" painting adds atmosphere to the scene, so the trees don't look cut out and pasted onto the picture. You can use this technique in weed and foliage areas too.

The road provides another area of interest, and casting a shadow across it seems to increase its charm even more. Take care, however, not to create too much excitement too close to the edge of the canvas. I cut down the contrast between the sunlight and the shadows as the road leaves the picture so the eye won't be drawn to this area.

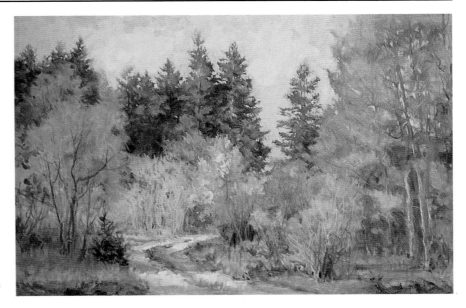

painting. On the other hand, I think too much refinement can ruin a good painting.

How do I paint detail? If, as in the demonstration below, I am painting trees and foliage, I begin by indicating any tree trunks or major limbs that were missed or lost in massing in the color harmony. Then I move on to the smaller limbs. I frequently use a no. 4 script liner brush, a little paint, and quite a bit of turpentine to paint these branches and twigs and to suggest a few saplings in the foreground. I dilute the paint to a watery consistency, so it flows from the brush onto the canvas easily.

Keeping my light source in mind, I establish some light and dark, warm limbs in the sunny areas and some light and dark, cool limbs in the shaded areas. I always paint many more branches and twigs than I need since a high percentage of them will be lost when I redefine the foliage. It is not wasted effort because I can pick and choose the ones I want to keep as I paint the clumps of leaves. Moreover, the paint is generally rather thin on my finished paintings, so these branches have a tendency to peek through the leaves and add another dimension to the illusion.

As I work, I gradually reduce the size of my filbert bristle brush. I now develop some of the areas in between the limbs. In other words, I paint the negative spaces. By working back and forth from the limbs to the areas behind them, I knit the tree into the surrounding landscape.

I finish by developing the foliage itself. I first return to the focal point (in the example here, the central golden tree) and define some of the edges by painting the contrasting area behind it. Then I suggest some leaves within the center of interest. I use a push-pull technique—cooling and darkening some shadow areas while warming and lightening sunlit areas—to give the tree form and make it appear round.

I customarily finish a large canvas (24 × 36 inches, 61 × 91 cm) by using nothing smaller than a no. 2 bristle brush. On smaller canvases I

AN EVALUATION

Problem-solving is part of finishing any painting. In evaluating this one, I discover the need for two major changes. First— the sky. It is so light and bright that it competes for attention with the sunlight on the golden aspen. To overcome this, I decide to darken the value and cool and dull the color of the sky.

I also decide to improve the picture by adding a background. Here there is a foreground and a middle ground, but no illusion of real depth. The painting is rather shallow. By adding one tree in the distance (just to the right of center), I will suggest that the road leads into the forest rather than out of it, adding a tantalizing touch of mystery.

Including this distant tree will also improve another area. There is a strong vertical line where the tall, dark pine cuts into the light sky, and this draws too much attention from the center of interest. By filling most of this space with a middle value (the distant tree), I can give the painting a new sense of depth and diminish this distracting situation. If only I had foreseen these problems! Oh well—next time.

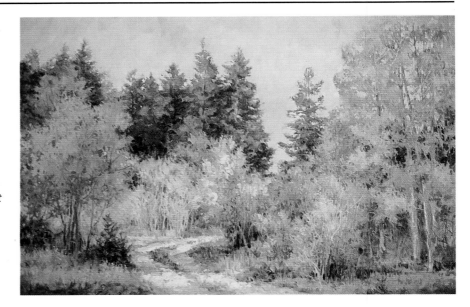

sometimes switch to a small flat sable (no. 4) to develop the detail to the point where I am satisfied. Just remember: don't reveal everything you know. Leave something to the imagination. An air of mystery in a painting is very liberating.

SELF-CRITIQUE
Now is the time for an intensive self-critique session. Study the painting again in the mirror, as well as upside down and sideways. There are self-critique questions in each chapter in this book, as well as a summary on page 151, to help you identify areas that are weak. Ask yourself: "Is the painting too light or too dark? Too warm or too cold? Too bright or too dull? Too textured or too smooth?" Once you identify the problem, you're well on your way to solving it.

FINAL VARNISH
Although my pictures dry rather quickly since I do not pile the paint on thickly (except in the sunniest areas), I still wait two to three months to begin the varnishing process. After wiping dust off the surface with a lint-free cloth, I spray the painting with damar retouch varnish to seal it. (Don't inhale the spray or accidentally varnish nearby objects.) Recall that I do not use a medium. If I did not spray the painting before applying the final varnish with a brush, I would risk having the delicate, thin turpentine underpainting lift off, right down to the raw white canvas.

After I let this coat of spray varnish dry overnight or longer, I then apply the final varnish. I lay the canvas flat and use a soft, one-inch household paint brush to apply a 50/50 mixture of damar varnish (heavy solution) and matte picture varnish, working ten-inch (25 cm) square sections at a time. I prefer the semigloss finish of this mixture as it restores a rich vitality to the dark hues without creating the glassy look of a high-gloss finish. When this varnish has dried in a dust-free environment, my painting is completely finished and ready to frame.

FINISHED PAINTING

By darkening the sky, I emphasize the golden aspen tree. And by adding the distant tree, I complete my "theater-in-the-woods": stage front, center stage, and back stage. With these changes, I am able to quiet the sense of confusion and to regain the original mood of the scene. I am finally comfortable with the painting.

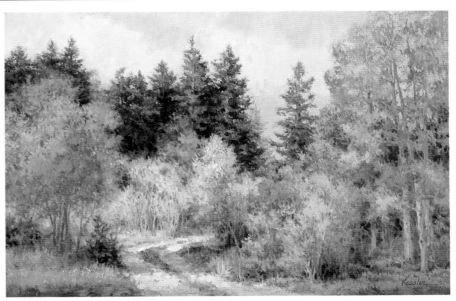

DAPPLED LIGHT *1984, 24" × 36" (61 × 91 cm)*

HOW TO IMPROVE YOUR LANDSCAPES

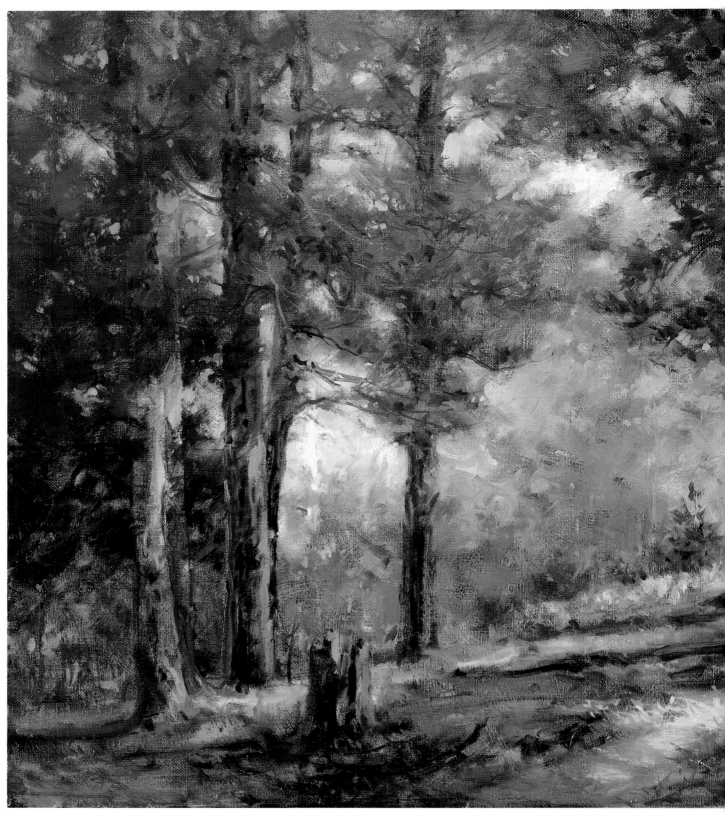

WOODLAND CATHEDRAL *1986, 16" × 24" (41 × 61 cm), collection of Fowler Drilling Co., Inc.*

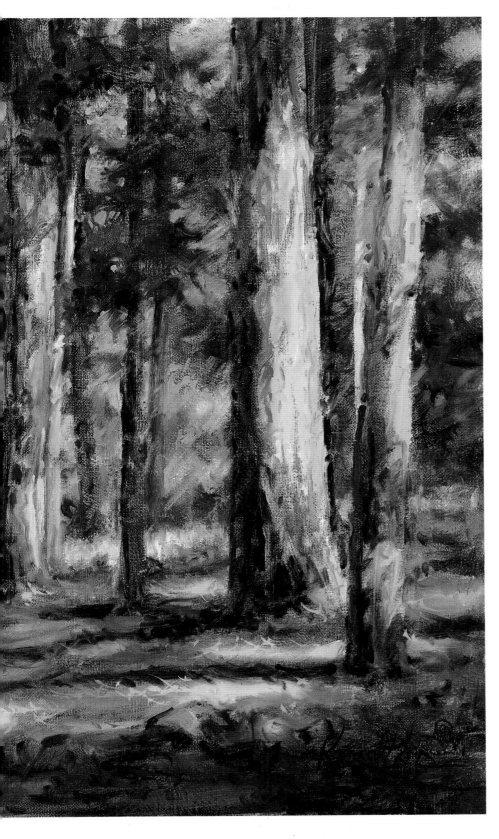

I was in a critique class for nearly three years and found it very helpful. Each month the twelve aspiring artists in this class brought two paintings each to our instructor, and he helped us analyze them, looking for both strengths and weaknesses. Obviously, there was a benefit to consistently producing two completed paintings each month. But, most important, the class taught me how to critique my own paintings and consequently improve my work overall. That class was the inspiration for this book.

The fifteen chapters in this section present practical information about landscape painting to help you locate problems in your pictures and decide what is wrong and why—the preliminary steps to solving your painting problems. There are concrete questions that you can ask yourself to identify specific elements that are desirable—and, conversely, to zero in on undesirable elements. The more you are able to question and evaluate what you are doing, at every stage, the more you will develop as a painter.

1
VISUALIZING
AND PLANNING

Why are you painting this scene? What do you want to say?

What you choose to paint is an individual decision based on your life experience. Some artists prefer rustic homesteads to glass-walled cityscapes, hardship-and-poverty themes to sunbathing-on-the-beach scenes, barnyard critters in the mud to the glamour of racetrack silks, or the Grand Canyon to lily pad blossoms. What you paint is a personal choice. Most likely, there will be someone who can identify with your subject matter. What you say about your subject is the important element.

To make your painting say something interesting and meaningful to your audience, try to awaken their emotional senses. Express intimacy with your subject by conveying what you experienced at the scene—pity, pleasure, romance, mystery, excitement. As the song goes, "make folks feel what you feel inside."

To maintain a sense of unity and prevent confusion, deal with just one mood per painting. It is confusing to have more than one mood in your picture, but without that one emotional appeal, your painting has no reason to exist.

To communicate emotions, express your interpretation of the effects of light and atmosphere on your subject. After all, that's what landscape painting is all about—capturing the unique mood of a scene as you see it. Remember that the sky —the source of light—plays a major role in establishing the subject's mood. It keys the intensity and color of the light, which is reflected throughout your painting.

Within the limits of convention, paint the ordinary in an extraordinary way. Don't just decorate: dramatize. Exaggerate motion and color; vary the value range and textural quality. By emphasizing or downplaying objects, manipulate the scene to engage the viewer psychologically. Editorialize with sensitivity, avoiding triteness and syrupy nostalgia. Edit unnecessary elements: "When in doubt, leave it out."

Don't just duplicate what a camera can do; that's impossible and discouraging. Besides, you are not judged for your accuracy, so why compete with the camera? Filter the scene through your own personality rather than the camera lens. Combine objective observation with emotional response and then skillfully render *your* impression of the landscape.

LIGHTHEARTED

What mood do you want to convey? Is it pleasant and playful? Lighthearted and carefree? Is the atmosphere sparkling, clear and dry with bright, dancing lights? Then try light values and warm, vivid colors—fresh as a spring breeze. Contrast value extremes—black beside white. Juxtapose warm and cool colors to strengthen the feeling of sunlight. Convey textural excitement with vigorous brushwork. Create some diagonal movement within the composition. Use large, bold shapes with predominantly crisp edges on a large, squarish canvas. Well, this isn't a large canvas, but you get the idea! Show your exuberance for living, so your painting vibrates with emotion.

SPRING PROMISE 1983, 11" × 14" (28 × 36 cm)

MELANCHOLIC

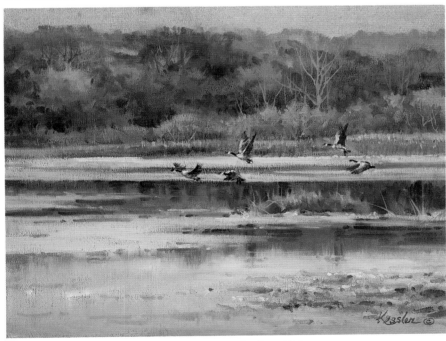

Is the scene quiet? Somber and romantic? Is the atmosphere humid and overcast? Then limit the depth of the scene and the intensity of the colors. Use cool colors, as they are contemplative. (Warm colors are urgent, passionate, violent.) Dark values in a close value range can communicate mysterious beauty. Try horizontal movement through a predominantly horizontal canvas. Be consistent with your textural treatment. Keep your edges soft, losing some into the unknown. Experiment combining any or all of these ideas. The technique you choose personalizes your painting.

THE LAGOON 1985, 12" × 16" (30 × 41 cm), collection of J. Lang

TONING THE CANVAS FOR MOOD

It has been said that Monet could tell the time of day by the color of the light on the wall outside his studio. You, too, must develop a sensitivity to subtle changes in the quality of light, as this can affect the mood of a scene.

One way to suggest the character of the light is by toning your canvas with an overall color and allowing this color to show through your finished painting, thus providing a consistent lighting theme and mood. Using a primer color not only eliminates the bewildering blankness of the raw white canvas, but it also provides a richness that a white canvas lacks. It controls the temperature and value range of your picture and saves time, as you don't have to cover up bothersome spots of white canvas.

Apply this thin wash of color with a piece of paper toweling dipped in turpentine and paint. The tone should be dry to the touch in minutes—as soon as the turpentine evaporates. Don't make it too thick, or it will mix into the thicker overpainting later on. Also, keep the tone transparent; don't combine the tone color with white.

My selection of a tone color is based on the time of day, the atmospheric conditions, and the season. Cadmium yellow deep might set the mood for an early morning in spring, as it is light, bright, and delicate. Avoid lemon yellow, however—it is so sunny that it becomes difficult to establish depth; background trees seem to leap forward. Yellow ochre, the most frequently used tone color, works well for the yellow-gold light of most of the day, but turn it toward a golden orange as evening

WARM

I discovered this barn on a beautiful, warm autumn day. The evening light exaggerated the reds in the dry foliage and atmosphere. I toned my canvas with cadmium yellow medium and cadmium red deep to create a warm, inner glow, setting the mood for the painting. Since I planned a wide value range, I used a middle-value tone so I would not be limited in the amount of contrast I could create. (A dark-value tone prepares the ground for a painting limited to predominantly dark values.) I drew the scene on the canvas with a warm brown to continue the warm, dry theme.

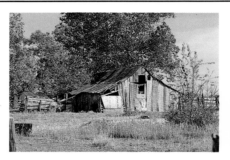

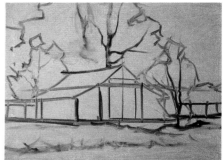

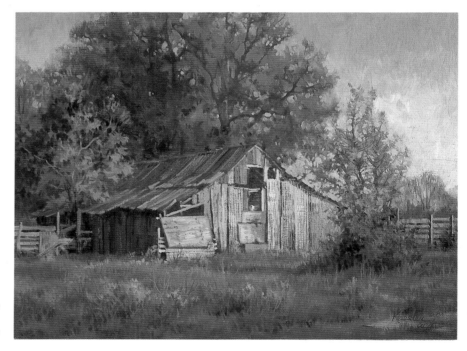

CHARACTER OF THE COUNTRY
*1984, 18" × 24" (46 × 61 cm),
collection of R. McCormick*

approaches. For me, a sundown painting usually begins with cadmium red deep. Don't overdo the reds, though, as they have a tendency to bleed through the finished painting—especially when it is shown under warm, incandescent lighting.

In other words, as the day passes, the tone on my canvas moves along the color spectrum: yellow, yellow-gold, gold (ochre), golden orange, orange, orangish red, red, grayed red. As the day shifts from morning to evening, I establish the degree of the warmth of the light by removing the yellow element.

Different weather conditions, of course, change this situation. For a snowy scene, I use the golden tones just mentioned for a warm, sunny glow or an ultramarine violet for a cold, wet atmosphere. For night scenes and some rainy themes, I like to use a warm gray (orange with a speck of phthalo blue). I generally prefer a relatively warm tone for my work as it gives the painting a warm, inner glow,

complementing the outer, primarily cooler surface.

Although I select a color based on the character of the light, some artists select the complement of the picture's general color theme for the tone. Portrait artists frequently choose this approach, using a grayed green to complement the reddish flesh colors. When the tone shows through the finished painting, it neutralizes the brilliant flesh colors effectively. It seems that this could be done with landscapes too. It's an idea to explore.

Keep in mind that the value, as well as the color, of a toned ground influences the picture's mood. Tone your canvas with the middle value of your chosen value range; for a high-key painting, for example, use a medium-light tone and, for a low-key painting, use a medium-dark tone. If the tone is too light or too dark for your value scheme, you will constantly be fighting it. With the middle value, you can work up to the lights and down to the darks—adding "salt and pepper" to spice it up.

COOL

To capture a melancholic, times-are-changing feeling, I chose cool colors and a limited range of dark values for this gas station. I toned the canvas with a fairly dark, warm gray (orange with a speck of phthalo blue) rather than a sunny yellow ochre. Drawing with a brush, I placed the scene with a warm dark in the sunlight and a cold dark in the shade. When compared with my warm-theme painting, the overall tone of this canvas was generally cooler, even in the early stages.

Incidentally, the subject you select is not all-important; interpretation is. The scene here, for example, could have been treated as a playful, sunny, bright theme, rather than given this mellow interpretation.

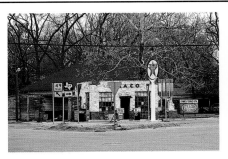

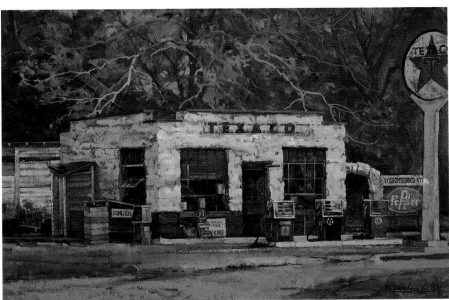

OUR NEW PUMPS
1985, 16" × 24" (41 × 61 cm),
collection of H. T. Tischer

FREEDOM OF EXPRESSION

Degas once said that he did not draw what he saw but what he had to make others see. You, too, are free to change the appearance of the real-life scene. Not only can you exaggerate colors, motion, and the like depending on what mood you want to convey, but, if you are careful and knowledgeable, you can change the season.

Notice that the photograph of the actual scene for *Springtime Drama* was taken in the winter. Because I wanted to depict the cycles of nature and the passing of man's feeble efforts to tame nature (the abandoned homestead and broken windmill), I changed the setting. In my painting the early evening light (the death of the day) and the bare trees suggest that nothing endures forever on this earth. The spring flowers (bluebonnets) and patches of sunlight in the rain-filled clouds, however, indicate the other side of the dependable life cycle: rebirth (flowers), hope for survival (sunlight breaking through), and continuity (rain—the lifeline). The distant hills leave the sides of the canvas with an upward swing—a smile. You can use artistic license in a similar way to communicate your thoughts about life.

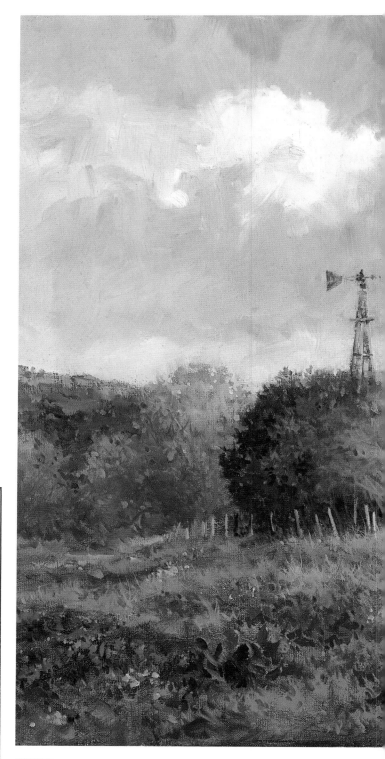

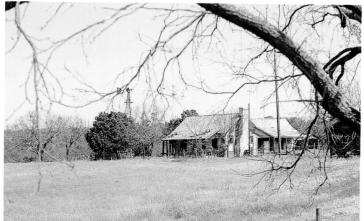

SELF-CRITIQUE

Does your painting portray emotional excitement, or is it dull, strained, and sterile? Did you capture a mood, or just mimic a scene? Did you take liberties to communicate the deeper psychological meaning of the scene? Did you make others feel what you felt inside?

What emotional theme did you portray? Verbally identify it. Is it cheerful? Somber? Dreamy? How did you portray that theme? Through the color or value scheme? Dramatic linear movement? Textural qualities? Emphasizing, downplaying, or omitting objects?

Remember: the color and value of a preliminary tonal wash can set the stage for your message, suggesting the time of day, atmospheric conditions, and even the season. Did your preliminary tone work for or against you?

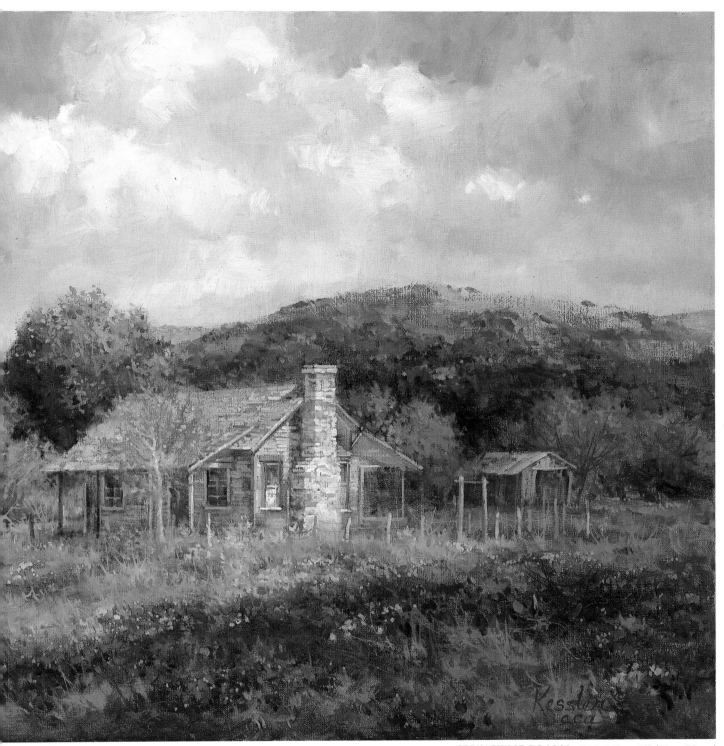

SPRINGTIME DRAMA *1985, 20″ × 30″ (51 × 76 cm)*

2
THE FORMAT

Do the shape and size of your canvas help or hinder the overall theme of the painting?

The shape and size of a blank canvas already communicate a mood, so selecting your painting format is an important decision in communicating your emotional theme. Some subjects work best on a horizontal canvas, others on a vertical. Some require an impressively large canvas, others an intimately small one.

Don't brush aside these decisions. Be wary of falling into a compositional rut and using the same format over and over. Experiment with various formats—horizontal and vertical, large and small—in your sketchbook, choosing a canvas based on the mood you want to depict. When you paint on location, take an assortment of canvas shapes and sizes so you won't be forced to use a given format.

Changing your format can even help with painting problems. If you generally use large canvases, which magnify compositional faults, switching to small ones may help you simplify your composition to the essential elements. When you do return to a larger size, you will then be able to manage it more effectively.

Occasionally, I break away from standard-sized canvases and stretch a 16 × 24-inch (41 × 61 cm), 18 × 27-inch (46 × 69 cm), or a perfectly square canvas. Such out-of-the-ordinary formats can extend your thinking about composition and spark new approaches. Unfortunately, when you use nonstandard sizes, you will need expensive, custom-made frames.

The size of your canvas communicates a mood. I've indicated some of my reactions to different sizes, but you may have additional responses.

LARGE
majestic, magnificent, awe-inspiring, impressive, generous, expansive, loud, exuberant, liberating, spacious, vast, bulky, weighty, voluminous

MEDIUM
comfortable, adaptable

SMALL
intimate, delicate, limited, modest, humble, quiet

The shape of your canvas also communicates a mood. Make sure the canvas shape you select is compatible with your overall theme.

STANDARD SHAPE
(18 × 24 inches, 46 × 61 cm)
comfortable, adaptable, moderate, stable, calm, graceful, nonassertive

SQUARE
(18 × 18 inches, 46 × 46 cm)
solid, blunt, stark, angular, strong, straightforward, firm, formal, rigid, direct

VERTICAL
(24 × 12 inches, 61 × 30 cm)
dramatic, exaggerated, tall, upright, powerful, mighty, dignified, proud, confident, authoritative, influential, energetic, tense, strong, forceful

HORIZONTAL
(12 × 24 inches, 30 × 61 cm)
dramatic, exaggerated, precarious or secure balance, reclining, restful, flat, level, panoramic, stretched

UNITING ACTION AND FORMAT

The action within the format must unite with the canvas to express a single mood. Mixing horizontal themes with vertical shapes and vice versa creates conflict and confusion. A predominantly horizontal movement on a horizontal canvas creates unity and harmony. A majestic mountain scene, however, loses some of its clout on a small canvas.

To communicate your message with unity and harmony, make sure all the elements of your painting work together. Coordinate the values, composition, and colors with the format you select. If, for example, you want to convey a quiet, rural landscape (a predominantly horizontal theme), don't place it on a strongly vertical canvas. On the other hand, if you use vertical linear movement, sharp value contrasts, and brilliant colors within a predominantly horizontal format, you will disrupt the overall quiet mood.

STARK AND SOLID

SOLITUDE *1985, 20" × 24" (51 × 61 cm)*

To capture the stark, unyielding form of the pyramid-shaped mountain, I selected a bluntly squarish format. I dramatized the mountain's impressive bulk by placing it on a relatively large canvas. The challenge was then to break up the space in an interesting way because a square lacks tension in its width-to-height ratio.

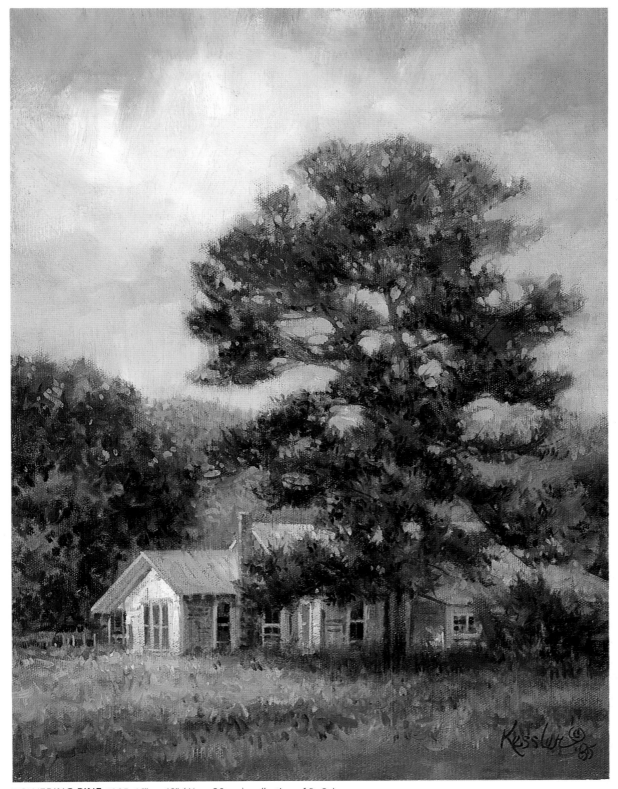

TOWERING PINE *1985, 16" × 12" (41 × 30 cm), collection of R. Osborne*

A panoramic scene would not work well on this vertical canvas. Wanting to emphasize the tall, dignified pine tree, however, I chose a vertical format. If I had wanted a peaceful, rural landscape theme, I would have placed this scene on a predominantly horizontal canvas (see page 39). The values and colors I used are just as dignified as the format, creating unity in my presentation. Take note: the narrower the proportion, the greater the sense of height and dignity.

MAKING A DECISION

When it comes to selecting a canvas shape for your subject, there is no right or wrong answer. Since each shape conveys a different mood, the challenge is to select the one that most clearly fits your theme—why you are painting that particular scene.

All of the compositions shown here are acceptable. I chose the one that was consistent with the mood I wanted to convey—a dramatically stable, secure setting for the little shed under the protective wings of the big barn. The subdued colors, horizontal value bands, and passing flock of birds are consistent with this restful theme.

When using an elongated shape, such as 15 × 30 inches (38 × 76 cm), I think it is especially important to keep the four corners of the canvas quiet and unobtrusive. In actuality, peripheral vision would subdue contrasting elements in the far corners, as your eye focuses clearly on objects in the center of your field of vision and less clearly on objects near the periphery.

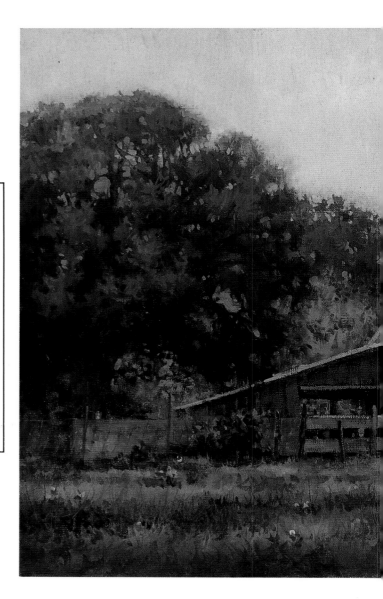

SELF-CRITIQUE

Is the canvas shape and size consistent with the mood of the painting? Did you select a comfortably rectangular shape for a generally peaceful scene? A vertical canvas for a forcefully upright composition? A long, horizontal canvas to complement a flat, barren panorama? Or a squarish canvas for a starkly solid or angular subject? Did you choose a large canvas to enhance a majestically grand subject? A small format for a delicate theme? Experiment with various sizes and shapes to find the format that best conveys the mood you want.

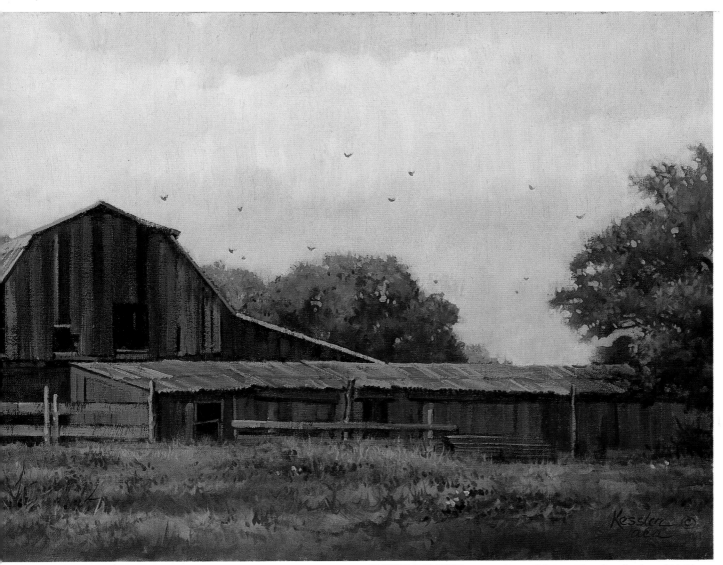

EVENING FLIGHT *1984, 15" × 30" (38 × 76 cm), collection of M. Myers*

3
DIVISION OF SPACE

Is the division of space decisive?
Is the scene clearly a landscape, skyscape, or closeup?

You must make a clear-cut decision about how to portray a specific scene. Be obvious—give the largest amount of space to the aspect that you want to feature. Use a high horizon line and let the landscape dominate (bird's-eye view); use a low horizon line and feature the sky (worm's-eye view); or zero in on a specific object and dedicate a large section of the canvas to that object (fish-eye view).

As you experiment with assorted compositional plans, you will find that dividing the canvas into unequal sections provides the key to arriving at a pleasing composition. If you divide your canvas exactly in half with the horizon line, the composition will tend to be static and dull. Thirds and fifths offer greater visual interest.

In general, dividing your canvas into thirds, horizontally and vertically, is a dependable, safe way to establish a strong, solid composition. The idea is similar to the "tic-tac-toe" principle used as a guide in placing the center of interest (see Chapter 6). If, for example, you are painting a skyscape, commit two-thirds of the canvas to the sky shape. As you work, don't lose your commitment to the dominant sky by creating too much contrast in the other third (the ground). If you put too much contrast or directional movement in that remaining third, it will compete with the sky for the viewer's attention and all of your geometrical planning will be lost. Although you may have a lot of variety in your composition, the sense of a unified whole will be lost and, with it, your chance for a successful painting. Conversely, if you are painting a landscape, don't attract a lot of attention to the sky. What you will create is chaos, and your audience will move on rather than try to sort it out.

By dividing your canvas into fifths, you can create an even more dramatic composition than with thirds. You lose some stability, but you gain excitement. Try committing four-fifths of the space to the sky and only one-fifth to the ground. Also try committing just one-fifth to the sky. These two compositional plans have a totally different impact on the viewer, and they are much more expressive

than a one-third/two-thirds division would be.

These division-of-space principles are just a few of the many ways to achieve variety during the planning stage of your painting. Try using them on various canvas shapes—subtle rectangles (18 × 24 inches, 46 × 61 cm), extreme rectangles (12 × 24 inches, 30 × 61 cm), nearly square shapes (20 × 24 inches, 51 × 61 cm), and even square ones. See how many exciting compositions you can create from just one scene. Learning to work creatively within the physical limits of the canvas is a fundamental task for all artists.

THINGS TO AVOID
When dividing the space, do not cut anything exactly in half horizontally, vertically, or diagonally. Don't, for example, let a telephone pole run vertically through the center of your picture. Don't put a fence post halfway between the edge of your canvas and the barn you are painting. Don't place a tree or building at the edge of the canvas so that it is half inside and half outside the picture. Also, don't create a situation that is half sunlight and half shade. Be committed to a sunny scene or a predominantly shaded setting. Indirectly, a high or low horizon line can help you to avoid creating a half-light/half-dark value plan. "Half and half" may be good for your coffee but not for your painting.

On the other hand, don't go to extremes, or you will lose the sense of stability necessary for a successful composition. If the horizon is too low or too high, the viewer may feel as if the creek were spilling out of the bottom of the picture. If your picture is nearly all sky, it risks looking fragile and shallow. But if your painting has virtually no sky, it may look flat and two-dimensional. Overcoming these problems, however, can be a challenge—see my painting *Golden Fleece* (page 58), which illustrates the struggle of conveying depth in a closed composition. And there is one advantage to not having a sky—you don't have to worry about it competing for attention with the center of interest.

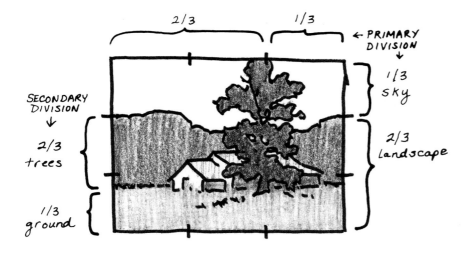

Dividing the space into one-third sky and two-thirds landscape (or vice versa) creates a quiet, peaceful scene. There is one hazard, however: if you proceed to divide the larger shape (the two-thirds section) precisely in half (half dark trees and half middle-value ground), the scene will probably become so mechanical and static that it will put your viewer to sleep. Unless you want an extremely restful scene, divide the space within the two-thirds section into similarly unequal portions—two-thirds trees and one-third ground.

Notice that the pine tree in the illustration here does not divide the canvas in half, nor does it divide the house in half. In fact, about one-third of the house and one-third of the sky are on the right side of the tree.

Remember to experiment with a variety of canvas shapes. The compositional study shown here has the same length to width ratio as an 18 × 24-inch (46 × 61 cm) canvas. On page 33, you can see that I chose a different composition for the finished painting of this scene, Towering Pine (16 × 12 inches, 41 × 30 cm).

One sure way to be decisive is to divide your canvas into fifths. Then there is no doubt that your painting is a skyscape or landscape. These extremely unequal sections create a sense of restless excitement.

You do not have to divide the canvas into fifths (or thirds) both horizontally and vertically. You can combine the two systems, as in this illustration. Here I use fifths to emphasize the sky and thirds to place the primary cloud in a way that quietly balances the barn. Notice how I draw additional attention to the sky by contrasting the large cloud shape with the little barn. When painting this kind of scene, don't make the color of the barn too bright, or it will cause confusion by competing for attention with the sky.

With this example as a guideline, do several thumbnail sketches to practice dividing your canvas shape into thirds and/or fifths. Experiment with various arrangements of the essential elements.

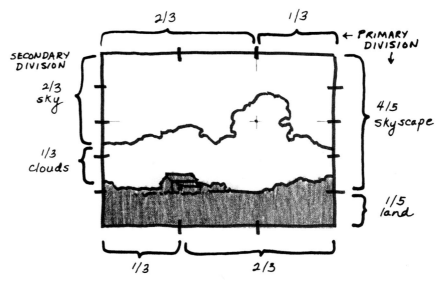

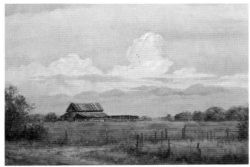

CLOUD TOWERS
1984, 20" × 30" (51 × 76 cm),
collection of Southwestern Bell

CREATING EMPHASIS

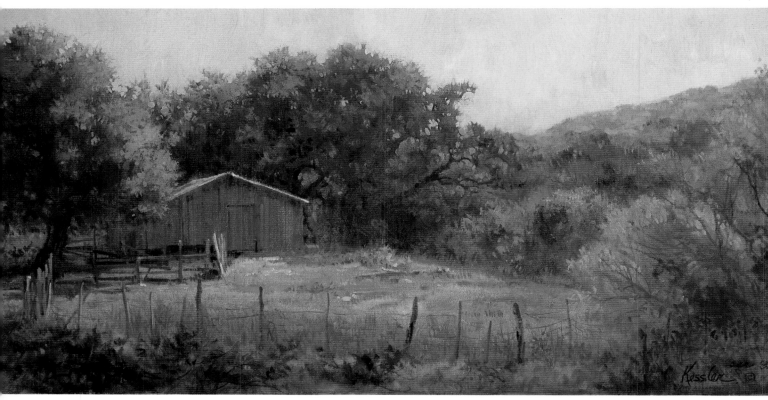

HILLCOUNTRY BARN *1983, 15" × 30" (38 × 76 cm)*

Hillcountry Barn *is clearly a landscape, not a closeup of a barn: I deliberately kept the barn small and committed a large section of the canvas to the scene itself. And since the focus is the land, only about one-third of this painting is sky. The rule of unequal division extends to objects within the composition as well. Notice that the large green tree on the left is three-quarters inside the picture— not half in, half out. This tree also acts as a stop for the zigzagging movement of the composition.*

The point is—if you want to portray a landscape, rather than a skyscape or closeup, plan it that way from the beginning. When you are nearly finished with the painting, it is too late to discover that you made the sky space too large and let your painting accidentally become a skyscape rather than a landscape. And don't let your landscape unintentionally grow into a closeup of an object. Worse yet, don't be wishy-washy and paint something as half skyscape and half landscape. It can happen all too easily!

Summer Road is clearly a skyscape: two-thirds of the canvas is sky, and the conservative foreground does not compete with it for attention. In the sky I repeated the two-thirds/one-third principle by placing the clouds closest to me in the top two-thirds of the sky, leaving the remaining third of the sky (near the horizon) for the distant clouds.

By the way, even a skyscape has to have a center of interest. The blue sky showing through the broken clouds provides an opportunity to contrast warm and cool, bright and subdued colors. The birds circling overhead add a secondary bit of entertainment. This is one of the few times I have managed to use an even number of objects (four birds) and make it work for me. Notice how the placement of the birds moves the eye through the composition. The eye enters the painting along the road and is then swept up into the sky in a circular motion. The tilt of the soaring birds guides you along this visual path. The torn edges of the windswept clouds then extend this motion.

SUMMER ROAD *1982, 18" × 24" (46 × 61 cm), collection of G. Richardson*

Speaking of big skies, a panorama provides a unique set of problems. Unlike a skyscape, it generally does not have a dramatic center of interest. Instead, a panorama, by definition, provides an unobstructed view of a large section of the land.

You may be surprised to discover how hard it is to paint "nothing." When confronted with the urge to paint a panorama, I usually focus on establishing a mood statement, so color generally becomes a major consideration.

In this on-site sketch, painted in two hours, I tried to capture a lighthearted mood. It was a pleasant day. The gentle autumn breeze and comfortable temperature put me in a playful mood, which I wanted to share. Using the largest brush I could handle comfortably, I quickly committed one-third of the canvas to the foreground. I used the small plowed field, fence row, and the sunlit country road to establish the scale of the scene. These objects also guide the eye into the distance, as the landscape quietly merges into the sky, without losing its own identity. I did not paint clearly defined cloud formations. Instead, with intense enthusiasm and vigorous brushwork, I established movement and depth in the sky while maintaining the playful, free mood that was my original goal.

MEANDERING FLIGHT *1984, 12" × 16" (30 × 41 cm)*

MAKING A DECISION

Deciding what to feature—the scene, sky, or object—cannot always be done on the spot. Here you can tell that I was not sure what I wanted to do with this scene when I took my photographs. I liked the feeling of an old house isolated in the middle of nowhere. (The sky takes up four-fifths of the scene in the first photograph.) But I was also fascinated by the house itself. Back in my studio, however, I decided to paint a closeup portrait of this house. The structure of the building, the windows, and the cast shadows were just too interesting to pass up.

As I worked on the painting, I remembered how hot it was the day I took the photographs, and I decided to portray the abandoned house baking in the hot Texas sun. I could just as easily have stayed closer to the actual colors of the scene and rendered the house in cool hues (blues, grays, and greens), but then no one would have known how miserably hot I was. I toned the canvas with cadmium yellow medium and cadmium red medium deep; with my brush, I drew the building with a warm brown (cadmium red medium deep, lemon yellow hansa, and a touch of phthalo blue). The rest of the painting is a combination of all of these colors plus cadmium orange and ultramarine blue.

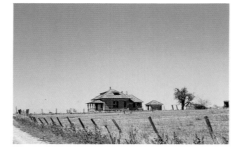
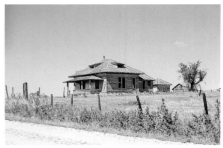

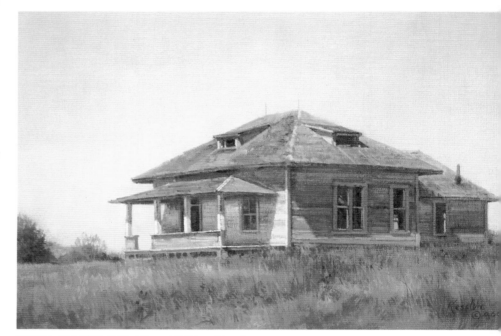

RURAL CLASSIC *1982, 16" × 24" (41 × 61 cm)*

SELF-CRITIQUE

How did you divide the space in your painting? Did you make the scene predominantly a landscape, skyscape, or closeup? Or is your decision ambiguous and unclear?

Did you divide the picture in half horizontally or vertically—creating a boring composition? Is the horizon line decidedly above or below the halfway point on your canvas? Think in terms of unequal divisions: thirds and fifths are more intriguing than halves.

Within the composition, did you divide

anything into equal portions with another object; for instance, did you place a tree at the center point of a building, visually dividing it in half? Also check the spaces between the edges of your canvas and any objects, such as buildings or bridges. If you placed fence posts or trees within these spaces, did you accidentally divide them in half rather than thirds or fifths? And have you extended the principle of unequal portions to the lighting—creating a predominantly sunny or predominantly shaded scene?

As you can see here, when you do not make a clear-cut decision about what you want to say, the result can be less than satisfactory. Every section of this painting shouts for attention. The clouds are accurately painted; you can feel the massive forms boiling up. The effect of the evening sun shining on the house is exciting. The shadowy tree shapes are also interesting. The composition is balanced, the colors are harmonious, and the detail work is well done. But where is the viewer supposed to look? Even though the sky takes up a little more than half of the canvas, the house and the sky compete for attention. There is no clear-cut center of interest because there was no preliminary decision about which basic element should be featured.

Visualize in your mind how you want the finished picture to look. Using division-of-space principles, clarify this decision in your sketchbook before you start working on your canvas; then stick with it.

MIDSUMMER EVENING *1983, 20″ × 24″ (51 × 61 cm)*

WINTER'S LAST RAYS *1981, 16″ × 24″ (41 × 61 cm)*

For every rule, there is at least one exception; the ''largest space dominates'' principle can be overridden by other factors. In this case it was a matter of contrast (an idea discussed in Chapter 6). Although the sky occupies about two-thirds of the canvas, the painting has not automatically become a skyscape. Instead, the big sky quietly sets the stage for a dramatic center of interest— winter's last rays of sunlight on the white house. If this same house had been silhouetted against a colorful sunset, then the painting would have been a skyscape.

A tip on skies: if the scene you are painting is complex, it is best to use a simple, quiet sky. Conversely, a busy, exciting sky should be balanced with a more reserved landscape scene. A relatively dark sky, like the one in this painting, helps the viewer concentrate on the center of interest.

For the warm colors in the sky here, I used cadmium orange near the top, cadmium red medium near the middle of the sky, and cadmium red deep near the horizon. For cool colors, I used phthalo blue near the top and ultramarine blue near the horizon. Phthalo blue has a little yellow in it, which makes the clouds along the top appear closer to the viewer than the reddish-blue clouds near the horizon.

4
LINES AND COMPOSITIONAL MOVEMENT

Is there an organized movement through the painting?

You are the leader; you are in control. It is your job to guide your viewers along a visual path to the center of interest and then around and around through your landscape. If you don't, they will become lost, confused, bored, or worse—escape from the scene.

To organize the movement through your painting, you must understand how to use lines. Lines in a painting are often the result of value and color contrasts—where light and dark values or warm and cool colors come together. Rivers and roads cutting into a landscape are good examples. An eye-catching shadow pattern is another example. By using these and other linear devices, you can create directional movement from side to side and front to back, keeping the eye traveling within the picture. The trick is to guide the eye along your chosen route and at the speed you wish without being too obvious.

Rather than totally relying on last-minute details and brushwork to create motion, try to establish movement in the painting's early stages. Think the composition through first. An old carpenter's maxim applies here: measure twice and saw once.

As you set the direction, length, and curvature of each line, you create tension, rhythm, and balance—or the lack of it. Through a line's velocity—its direction and length—you determine just how fast the eye moves to the center of interest. Curved and angular lines can prevent escape from your painting.

Routing the eye through a painting from left to right is favored by many Western artists, as that is how we read. Oriental cultures read from top to bottom and generally design their paintings accordingly. You might try placing the light source on the left side to create directional left-to-right movement through cast shadows, including shadows that indicate the contour of the ground.

Determine the movement initially with a minimal use of line; then move from simple to complex. Use your underlying directional lines to convey energy and create a sense of life in your painting. Make each line come alive, and then echo your linear construction to make your composition more exciting. Use repetition with variety to make the visual trip an adventure.

As you work with line, be aware of its emotional impact. Study the examples on these pages, and consider how each might be used effectively in a composition. The lines you choose should be compatible with the mood you want to capture.

HORIZONTAL
restful, calm

VERTICAL
rigid

PERPENDICULAR
stable

CROSSED
static

CRISSCROSSED
conflicted

ZIGZAGGING
active motion

DIAGONAL
dramatic action

RADIATING
bursting

42

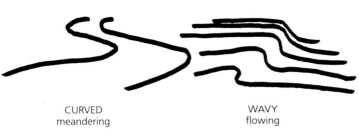

CURVED
meandering

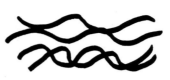

WAVY
flowing

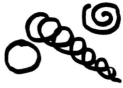

UNDULATING
dramatic rhythm

CIRCULAR/COILED
continuous

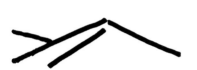

PINWHEEL-LIKE
rotating

SPRAY-LIKE
spontaneous
(natural growth)

CONVEX
formal
(natural growth)

CONCAVE
deterioration
(manmade)

SLOPING
peaceful, gentle

PARALLEL
mechanical
(manmade)

BENT
wilting, tired

STRAIGHT
confident

SWIRLING
inspiring

ARCHING
strong

**ARCHING
(CONCENTRIC)**
expansive

WEDGED
distance, depth

SQUARE/TRIANGLE
architectural

PYRAMID
stable

unstable

CONE/CYLINDER
solid

SETTING DIFFERENT SPEEDS

Convey speed and excitement with linear movement. Long, straight diagonal lines move the eye quickly into the painting. Zigzagging lines are lively and aggressive, while the S-curve leisurely entices. Horizontal lines, in bands of varying values, can drastically slow the action as the eye stops to step over each of these parallels.

RAPID

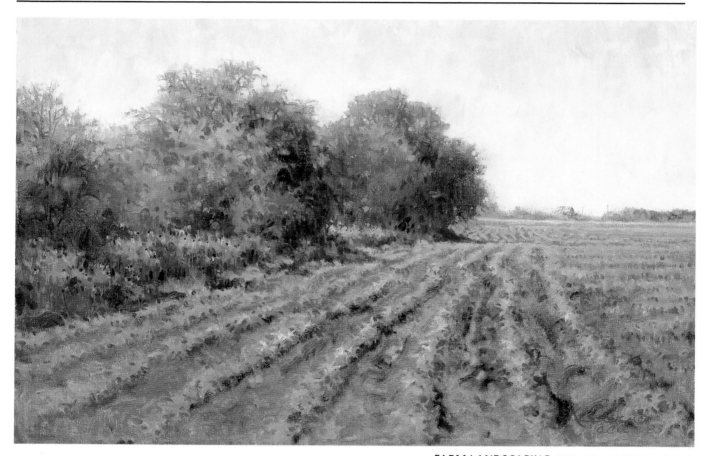

FARM LANDSCAPING *1983, 16" × 24" (41 × 61 cm)*

When all the lines point suddenly into the scene, as they do in this painting, a feeling of rapid movement is created. Here the simple foreground, with its long, diagonal lines forming a wedge, quickly moves the eye to the focal point—the barn in the distance. Incidentally, you must lead your viewers to something, or there is no reason to take them on the trip.

LEISURELY

To the artist's delight, a wavy S-curve invites you to linger a little longer in the picture. The rhythmic sequence of lines holds your attention as you slowly navigate from left to right and front to back. By starting the S-curve of the river on the bottom right here, I coax the eye to make a preliminary trip from left to right before entering the scene. Note how breaking the lines with value changes slows the flow of the movement. Points of interest then entertain along the way.

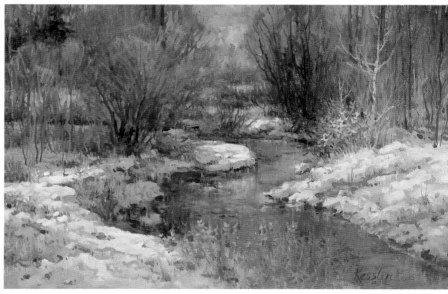

AUTUMN SNOWFALL *1985, 18" × 27" (46 × 69 cm), collection of G. Morchower*

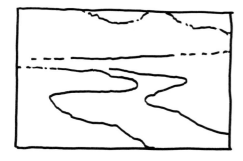

LIVELY

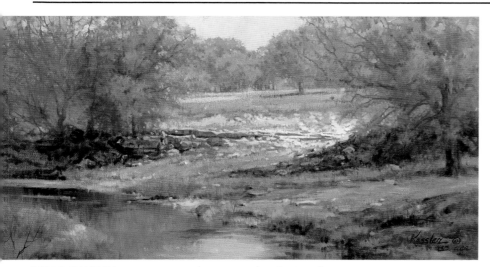

MEADOW RUN *1983, 15" × 30" (38 × 76 cm), collection of J. Webb*

Meadow Run *is an example of dramatic diagonal movement across the picture plane. Snappy, zigzagging diagonals and numerous lines emphasize the animated action. The sharp angles of this aggressive linework require careful planning to avoid chaos and achieve balance. Use repetition with variety and rhythm to create unity and harmony in your design. Be decisive—keep the zigzagging movement clearly confined within the canvas or boldly exit at the sides. Don't just tickle the edges.*

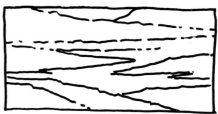

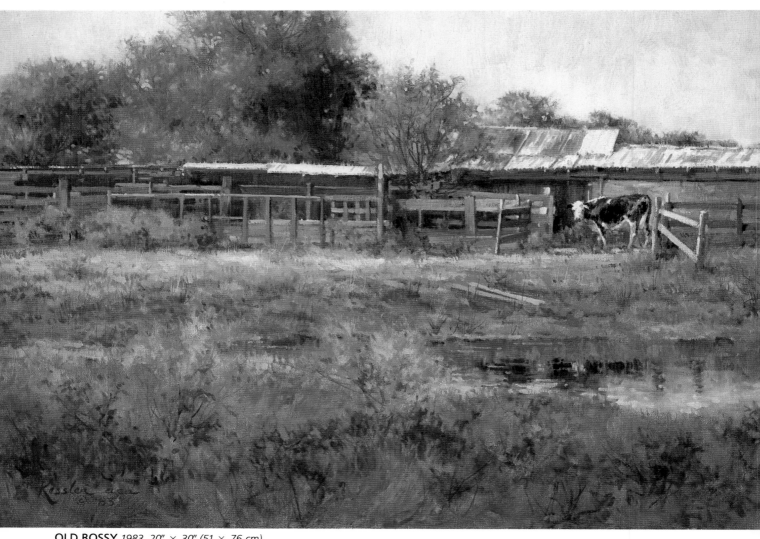

OLD BOSSY *1983, 20" × 30" (51 × 76 cm)*

When the linear movement stretches into nearly horizontal lines, the tension diminishes, as the eye must cross each boundary without assistance. To prevent boredom, don't make your lines parallel with the bottom edge of the canvas. Make both narrow and wide linear bands in a variety of values and colors; break at least one of these bands into interesting shapes; and establish a strong focal point.

CHOOSING A COMPOSITIONAL SCHEME

There seem to be an infinite number of compositional schemes from which to choose. Select one that most closely fits your emotional theme and then marry that scheme to your subject matter.

THE L-SHAPE

The L-shape composition is a blocky, bold design created by a large value shape within the painting. In the example here, the L is lying on its back and is created by the line between the dark tree shape pressing against the lighter building-sign-foreground shape.

For this design to work, the L and the negative shape created by it must vary in size—one large and one small—creating an interesting abstract pattern. Also there must be enough local interest—created by texture, line, color, or form—in all parts of the composition to carry the eye

from one side of the picture across to the other side. (In Our New Pumps, for example, the driveway leads you into the scene from the left and the overhead tree takes you back.) Of course, the L-shape compositional scheme can be used on vertical canvas too.

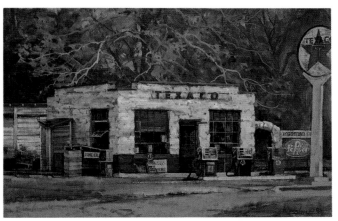

OUR NEW PUMPS (see also page 27)

THE O- OR U-SHAPE

The basic scheme here is an O-shape; if the trees were open at the top, it would be a U-shape. This kind of scheme suggests continuous motion. Sometimes, as in this on-site sketch, it is used to frame a point of interest, or it can be

used to create a tunnel leading the eye into the depths of the scene. This composition keeps the viewer's attention trapped within the confined opening, making even a small center of interest seem important. The opening should be

an interesting shape in itself, and the focal point within the opening should be located off-center, dividing the shape creatively. As with the coil, the frame of the O-shape needs to touch at least three sides of the canvas.

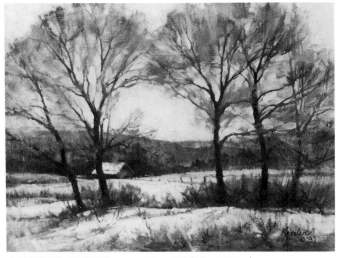

A WINTER SKETCH 1984, 14" × 18" (36 × 46 cm), collection of L. Hurn

THE COIL

This composition captures the viewer's attention by continuously drawing the eye to the focal point of the painting. To stabilize the coil, firmly anchor it to at least three sides of the canvas and indicate the continuation of the subject beyond the confines of the canvas. This composition can be used to whirl you around and around on one plane, as in the example here, or to funnel your eye far into the distance.

THE TIRE SWING *1985, 9" × 12" (23 × 30 cm)*

THE PYRAMID

Because it conveys stability and permanence, the pyramid, or triangular, composition is well suited for mountainous scenes. This composition works especially well on a squarish canvas, which also conveys solid stability. Although it is not always necessary for the pyramid to have a peak, it must have a visually strong horizontal base. By using a low horizon line and exaggerating the width of the mountain's base, you can emphasize the stability and the imposing upward thrust of the mountain. Don't, however, center the pyramid.

Notice that my painting Solitude also illustrates the "big shape/little shape" composition, as the massive mountain shape is echoed by the tiny but harmonious house shape. I feel that this compositional device is well suited for contrasting the awesome permanence of nature and the temporality of man. Notice how I have established a sense of balance and rhythm through the placement of the essential objects: as you visually step from the house to the small mountain to the large mountain, you can see that the house balances the latter. The size and location of the steps create rhythmic movement.

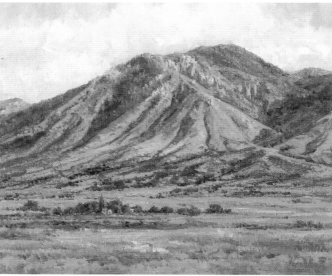

SOLITUDE *(see also page 32)*

STOPPING THE EYE

Without stops or pointers, a strong horizontal thrust can carry you right out of the picture. With value or color contrast (as line or mass), you can create an intersection that stops the eye and points it back into the picture. In landscapes, the most common stops are strong verticals, such as trees or poles, placed in a predominantly horizontal format.

Notice how the dark shrubs in *Stoney Creek* not only act as stops but also add to the illusion of depth as they step into the distance along the S-curve. Be careful: don't divide a stop exactly in half vertically with the edge of the canvas. Don't tickle the canvas edges, either—be decisive.

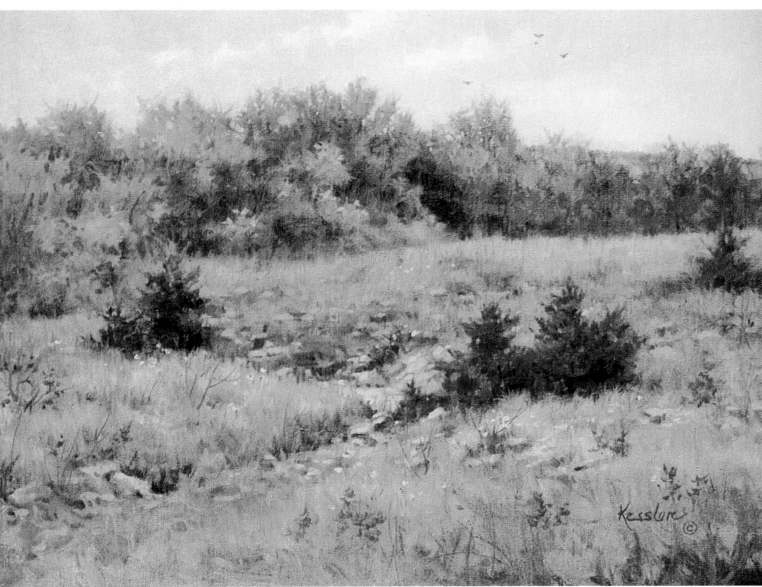

STONEY CREEK *1982, 18″ × 24″ (46 × 61 cm), collection of H. Palmer*

THINGS TO AVOID

Don't "tickle" edges; overlap them. Don't exit at the corner or center point.

Don't divide the composition in half; group objects.

Don't draw attention to the corner; pull inward.

Don't divide object in half; use unequal portions.

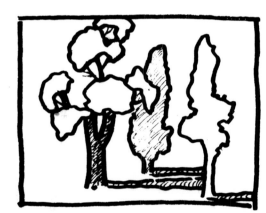

Don't "disjoint" skeletal features (trunks and limbs). Don't stop cast shadows prematurely; follow through.

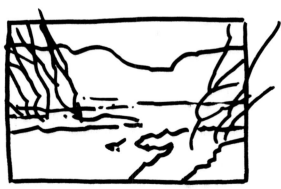

Don't lean out; point inward.

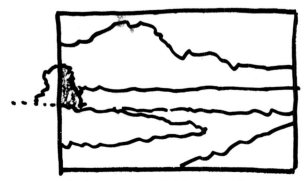

Don't cut stops in half at the edge of the canvas.

50

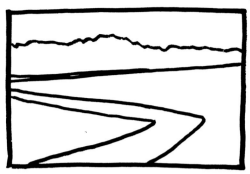

Don't suggest points of interest outside the canvas; use stops.

Don't repeat similar shapes, positive or negative.

Don't be unfriendly—verbally or visually. (Notice the closed gate.)

Don't use strong verticals on a horizontal canvas or strong horizontals on a vertical canvas.

SELF-CRITIQUE

Did you guide the viewer along a visual path to the focal point and on through your picture? Have you created a rhythmic linear movement from side to side and front to back—leading into the picture, not abruptly out of it or into the corners?

Have you chosen a definite compositional scheme, such as an L-shape or a coil? Are your lines compatible with the mood you want—lively, zigzagging diagonals or lazy, horizontal lines? Is this skeletal framework too obvious? Did you subtly echo the linear movement using stops and omitting unnecessary objects? Check how objects meet; be sure they don't just tickle each other or the edges of your canvas. Remember: time spent planning and organizing your painting is never wasted energy.

5
ARTISTIC GROUPINGS

Have you grouped objects artistically?

Our culture favors groups with even numbers. Cafe tables are set for two, four, or six. The animals marched into Noah's ark two by two. Tour groups charge extra for people traveling alone. In our culture no one wants to qualify as "the odd man out," or to be told, "Three's a crowd."

In art, however, it's different—odd is great! You want to use uneven numbers, as even is boring. Do everything you can to avoid numerical monotony. Try thinking in terms of one, three, five, seven, nine, eleven: one building, three clouds, five trees, seven windows, nine birds, eleven fence posts, for example.

"Repetition with a variety" is a good rule to follow. If you must have two of something, such as two pine trees, make one big and one small—one tall and scrawny; the other short and full. Use bright colors on just one of the two trees. Make an object dominate. Variety adds spice; use it generously.

When you group things, don't limit yourself to the objects. Consider the negative spaces between the objects too—here is another opportunity to entertain with variety. Now is not the time to be neat and tidy, arranging things like little tin soldiers on parade.

Keep in mind that when you include people or animals, they generally become the center of attention. Plan the painting around them from the start. Adding people or animals at the end can be risky as they may, at the very least, distract from your intended focal point.

Twins attract attention. That is why so many television commercials are made with twins. Because it is so unusual to see two people exactly alike, we are fascinated with them. But in a painting, two of a kind attracts too much attention.

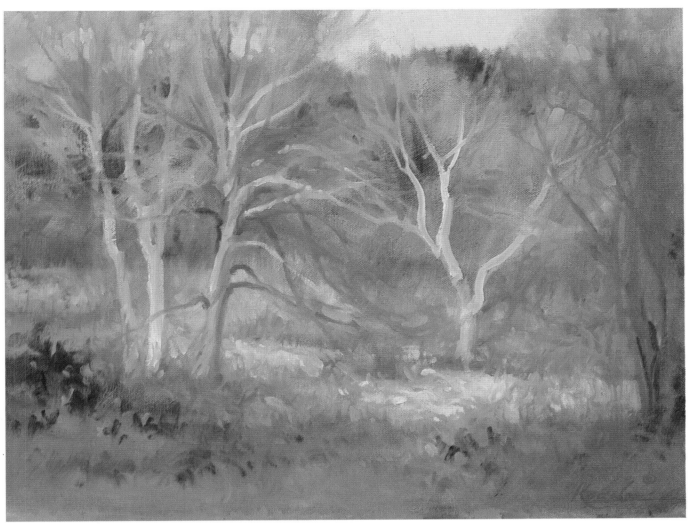

DRY RIVER BED *1984, 14″ × 18″ (36 × 46 cm)*

Using three of the same object with variety creates a more dynamic composition than two of the same thing. Compose with small, medium, and large as I did with trees in this on-site sketch. Vary the shapes and the way you handle the edges. Make one tree full with multiple trunks, one lacy, and one vague. Indicate various depths by placing the trees in the foreground, middle ground, and background. You can also vary the distance between the trees themselves and between the trees and the edges of the canvas. (Notice that the tree on the right is not divided in half by the edge of the canvas.) Balance the weight of the objects in an artistic manner.

EXPLORING DIFFERENT ARRANGEMENTS

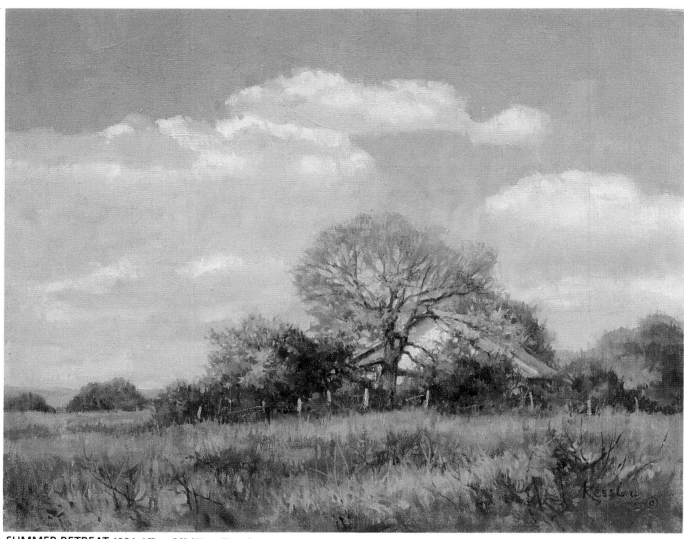

SUMMER RETREAT *1984, 16″ × 20″ (41 × 51 cm)*

"Repetition with variety" does not apply just to trees. Remember this guideline when you arrange cloud shapes and bushes, too—one, three, five, seven, and nine in small, medium, and large shapes. There are three major cloud shapes and three middle-ground bushes in Summer Retreat. *Single items—one building and one tall tree—add variety. Notice the two distant trees on the left: one large and one small.*

Incidentally, when you paint a scene like this one, be careful that the sky does not distract from the intended focal point—the secluded building. If there is a lot of contrast in the sky (light, warm clouds and dark, cold sky), the busyness will attract attention and the viewer will not know where to look. To solve that problem in this painting, I cooled and darkened the whites of the clouds with a subtle "glaze" (see page 155).

To create the golden glow of the bright, sunny day, I toned the canvas with a mixture of cadmium yellow medium and cadmium red medium deep. The blues in the sky are ultramarine at the zenith and phthalo blue as you move down toward the horizon.

For a different arrangement of three objects, try two groups, one big and one small, as in my painting Spanish Goats. Place the goats carefully on the canvas so the spaces around the two objects are different. Achieve balance without centering. If you view the objects themselves from various angles—from the side and from behind, for example— this will add interest to the painting.

Goats, by the way, are a favorite subject of mine, as they are playful and fun to watch. They poke their heads through holes in the fence to eat the grass on the other side. They stand on their hind legs and eat leaves off the trees, and they climb around wherever they can. A silhouette of a single goat is a fascinating shape all by itself. Capture that characterization when you paint them. You may be surprised, but they are not all that hard to paint. Don't think: "head, leg, tail." Think form—sphere and cylinder (see Chapter 10). Give it a try. If you have never painted an animal, you are missing a lot of fun.

Note the variety of brushstrokes used in this painting. Compare the smooth strokes in the water with the choppy marks on the goats, or the grass with the bushes. (For more on brushwork, see Chapter 14.)

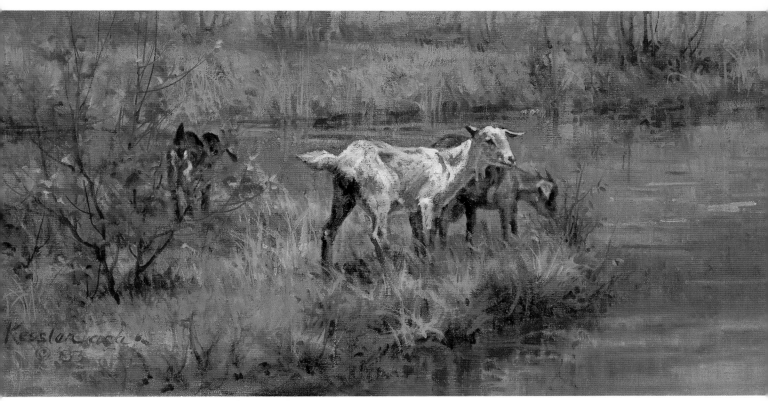

SPANISH GOATS *1983, 12" × 24" (30 × 61 cm), collection of J. Rozek*

ADDING DOORS AND WINDOWS

People are naturally curious. They are drawn to openings in buildings, as they want to see what is inside. Windows and doors seem to have personalities of their own. Study them and try to capture their interesting characteristics.

Vary the number of openings in buildings. If you must have two openings (or another even number), make one large and one small, one square and one rectangular, one dramatic and one subdued. If you have a large number of openings, emphasize some and deemphasize others. Don't forget to arrange birds artistically too—three birds (small, medium, and large) spaced rhythmically.

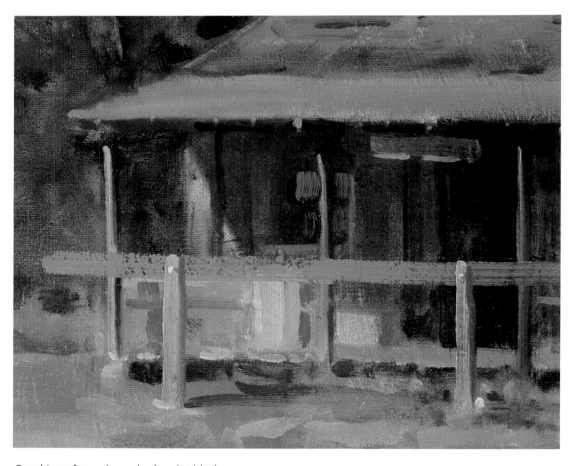

Speaking of openings, don't paint black holes! Create varied light and dark patterns within each opening. Reflected light bouncing around within the scene and within the building itself affects the values in these openings. They are not totally without light.

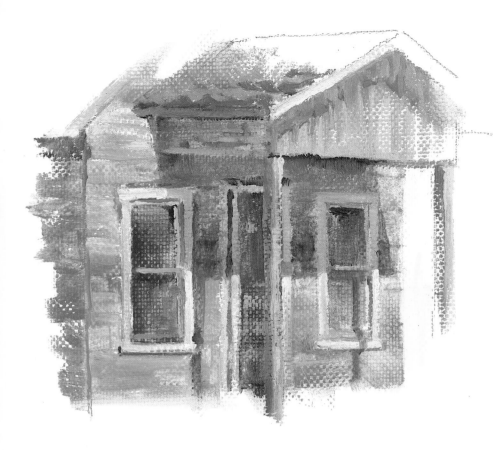

To create an illusion of depth in an opening, apply thin, transparent paint in the shadows and load the sunlight with as much thick paint as you want. The viewer will feel as if he or she were looking into the opening. ''Thick over thin'' is a good rule to remember.

DISTANT WINDOW

An opening is sure to be boring if you divide it exactly in half, vertically and horizontally, and then treat its edges with an equal amount of detail. To create interest, compose with unequal division of space; also, define some edges and lose others. If you keep contrasting values and contrasting color temperatures (warm against cool) under control, you can make intriguing openings without letting the area become too busy.

CLOSEUP VIEW

BORING

GROUPING LARGE NUMBERS

When you are dealing with a large number of objects, whether animals, trees, or petunia blossoms, arrange them in interestingly shaped groupings. The flock of ten sheep in my painting *Golden Fleece* is divided into three groups (an uneven number). It would have been better if I had separated the group on the right a bit more by moving it closer to the edge of the canvas and added one more sheep to that group, so it would clearly be the largest group. Then I would have had an ideal situation—an uneven number of objects (eleven) gathered in three groups, forming small, medium, and large shapes. I compensated for this by placing a white rock between the right edge of the canvas and that last group of sheep. In this way I managed to have each of the three shapes a different size, which is more important than having an uneven number of objects within the shapes.

The setting for this painting was a pleasant autumn day in the New Mexico desert. The sun was nearly overhead. As I photographed this flock of sheep, a hairy tarantula scampered past me—thank goodness for cowboy boots!

To convey the golden sunlight, I toned the canvas with yellow ochre and a touch of orange in a middle value. With a filbert bristle brush, I placed the sheep on the canvas with a warm brown color, which also conveyed the feeling of sunlight.

Since I block in the dark values first when I start a painting, I painted around the sheep, which are lighter in value than the foreground. I indicated depth by keeping the top third of the canvas lighter and cooler than the bottom section. Note that this painting is a "closed" composition, as there is no sky.

After establishing the values and the color harmony, I began developing the detail on the sheep. I selected a few sheep that I wanted to emphasize and painted them. Then I modeled the rest of the sheep, keeping them subdued. Indicating some detail on the shrubs and ground covering finished the painting.

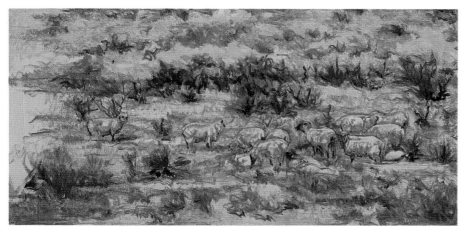

VALUE BLOCK-IN

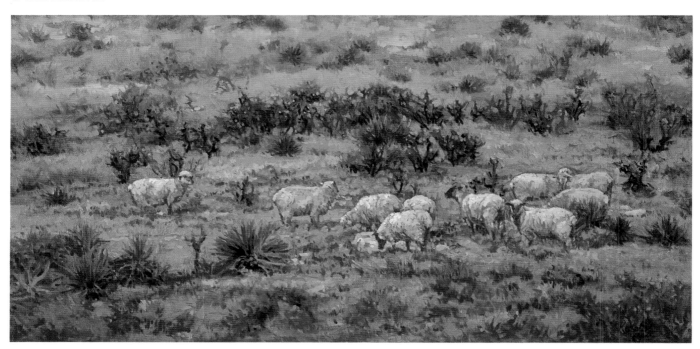

GOLDEN FLEECE *1985, 18" × 36" (46 × 91 cm)*

SPECIAL CONSIDERATIONS WITH ANIMALS

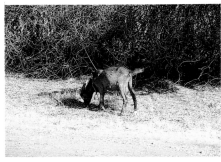

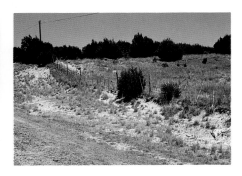

There are three essential objects in this illustration: two bushes (one large and one small) and one animal. Also notice that there are bits and pieces of five fence posts (an uneven number) placed rhythmically in the scene. The goat is the center of interest, even though it is smaller than the large bush, because it is a living creature. Remember that your viewers will be strongly attracted to any figures, human or animal, in a painting.

Animals are particularly difficult to photograph and even more difficult to paint on location, as they won't pose for you. When you are lucky enough to get a good photograph of an animal, chances are that the setting will not be just what you want. I found this old goat along the side of the road. He was tied to a chain-link fence that was covered with a dead vine. The goat was charming, but the setting left a lot to be desired.

In my files I located this photograph, which made a more interesting setting for the goat. The barren terrain and earthy colors were just what I wanted. I zeroed in on a small section of the fence row so that the goat and the setting would be on the same scale. (I didn't want the fence posts to look like toothpicks or the rocks to look like boulders.) Also, I wanted to emphasize the single goat— not the landscape.

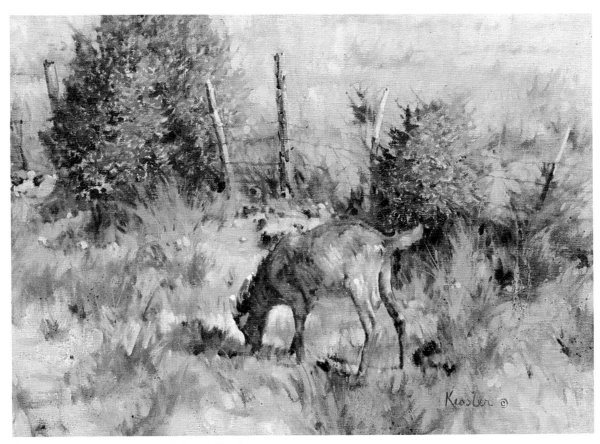

THE OLD GOAT *1980, 18" × 24" (46 × 61 cm)*

Before I took a canvas out of the closet, I worked out the placement of the three interesting shapes in a sketchbook to make a pleasing abstract design. When I combine two different scenes as I did

here, I am careful to indicate the sun's location and intensity accurately. Notice how I used the cast shadow to anchor the goat to the ground and to help develop movement through the scene.

INCLUDING HUMAN FIGURES

When a human figure is added to a scene, it changes the entire concept of the painting. In some scenes, like this one, the painting is brought to life by the figures and would be nothing without them. At other times a figure can limit your viewers' imagination and keep them from visualizing themselves in the scene.

When there are figures in a painting, you naturally look to see where they are looking or where they are going—another way to depict movement. Be aware of these dynamics and make them work for you.

SKETCHES FOR FIGURE

SELF-CRITIQUE

Did you arrange the objects in the scene artistically—using mostly odd numbers and placing things with rhythm and balance? Have you echoed the shapes, repeating with variety? If you used just two objects, is one large and one small? Have you aimed for an odd number of groups with an odd number of objects within these groups, including any windows or doors in buildings? (I hope you did not make your openings look like dark holes!) Remember: don't center objects. And take special care in placing animals and people.

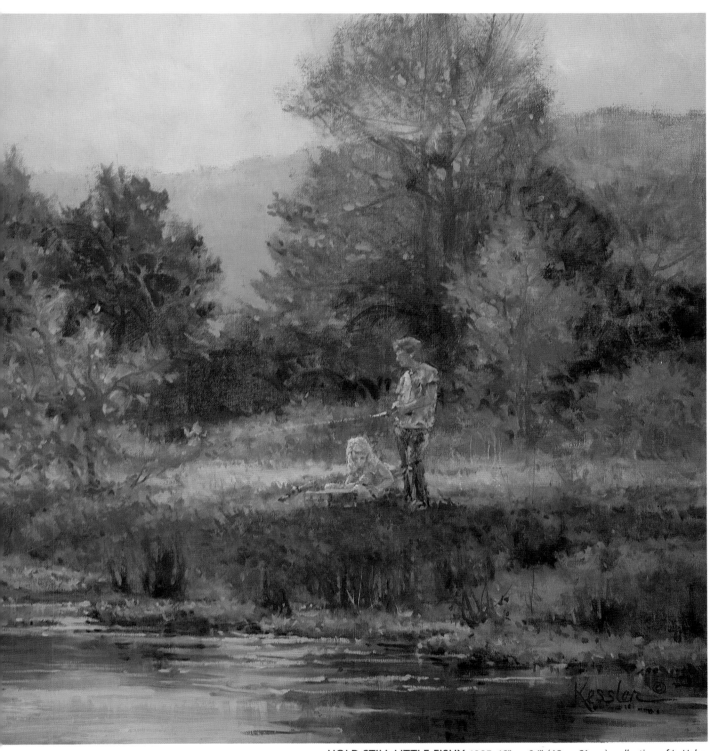

HOLD STILL LITTLE FISHY *1985, 18" × 24" (46 × 61 cm), collection of L. Hahn*

6
CENTER OF INTEREST

Is there just one focal point? Is it well located?

As you compose your landscape, you must create a center of interest—the one focal point that will ultimately command the viewer's attention. Decide which object in the scene is the most important—the one you want to emphasize to carry the theme aesthetically. Then judge the relative importance of the other objects: very important, rather important,

not too important. Using rhythm and balance, emphasize the objects in that order.

A good way to direct attention to the center of interest is by dramatically contrasting the various elements of design—light against dark, warm against cool, bright against dull, large against small. Of all the contrasting elements, the play of light

CREATING CONTRAST

A light tone appears lighter when placed next to a dark and vice versa. Without dark accents, a high-key painting looks anemic. Similarly, a bright painting doesn't vibrate unless there are a few neutral notes. Experiment with different kinds of contrast, as in the examples here.

WARM/COOL

BRIGHT/NEUTRAL

LIGHT/DARK

COMPLEMENTARY COLORS
(VIBRATING)

OPAQUE/TRANSPARENT

LARGE/SMALL

THICK/THIN

SHARP FOCUS/LOST EDGES

against dark is the most effective, as it is human nature to seek light. Use the light-dark patterns to set up linear movement leading to the center of interest and to lay the foundation for other design elements, such as color and texture.

With controlled contrast, you can regulate the force of the emphasis at the focal point, making it shout or whisper for attention. The more dramatic the interplay of the contrasting elements, the more quickly the eye responds to the call for attention. A lonely little petunia in an onion patch demands that you look at it! Because of the strong intensity of contrasting elements, the viewer will inspect the onion tops only after studying the petunia.

A generally quiet mood, of course, calls for a reserved degree of contrast at the focal point. Even then, all other elements within the painting must remain subservient to the focal point, as it is disruptive to divide and separate the visual interest. You may have secondary points of interest; but if they compete for attention with the principal point, you will create confusion and lose your audience.

Everything must be in harmonious relationship with the one dominant feature; therefore, after I block in the sky, I immediately establish the power of my focal point. Once this degree of excitement is established, I use it as a "home key" and pitch the rest of the painting in tune with this key. If your center of interest becomes too overpowering, tone it down or create areas of fairly strong contrast elsewhere in the picture, indirectly diluting the strength of the primary focal point. For an example of how to do this, see my painting *Fred's Junk* (page 69).

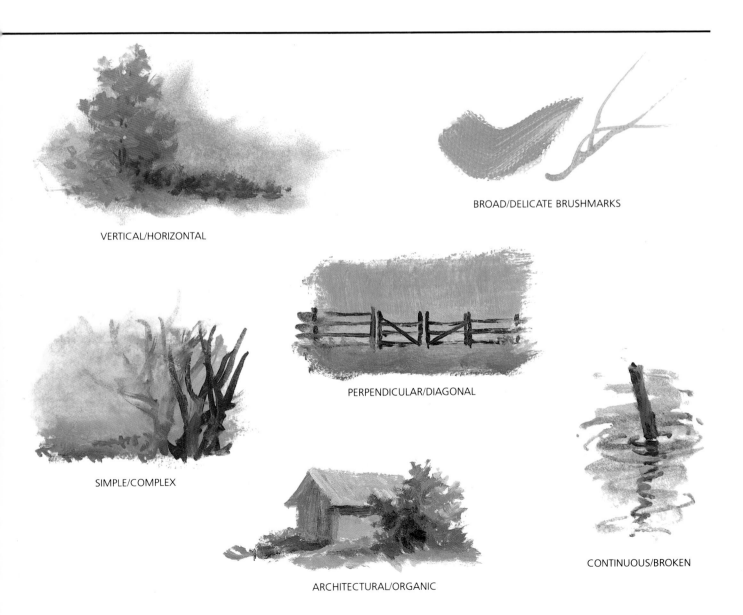

VERTICAL/HORIZONTAL

BROAD/DELICATE BRUSHMARKS

SIMPLE/COMPLEX

PERPENDICULAR/DIAGONAL

ARCHITECTURAL/ORGANIC

CONTINUOUS/BROKEN

ATTENTION-GETTING SUBJECTS

Even without a strong play of contrasts, the subject matter itself may hog the spotlight. Babies and animals are notorious for upstaging actors. Even when they are small in size, living or manmade objects in a landscape generally attract more attention than natural objects. In a painting with a lot of sky, for example, a small human figure in the scene will attract more attention than the large sky shape.

Some objects, such as mailboxes, rocking chairs, and baby carriages, stir nostalgic sentiments.

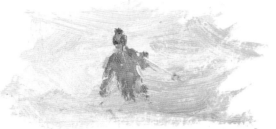

People, birds, and animals suggest companionship.

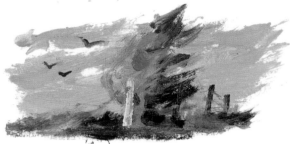

Doors and windows stir curiosity.

Patriotic or religious symbols such as flags, steeples, and crosses arouse emotions. Be careful that telephone poles with cross-braces don't accidentally resemble religious crosses.

Artificial lights at night or in the rain are warm and inviting.

THE POWER OF SUGGESTION

The more intense the play of opposites, the more eye-catching the center of interest. Some settings call for a flashy, dramatic focal point; some need a more subdued theme; others, such as a panorama, have virtually no focal point. Adjust the degree of contrast to fit your needs.

The interest in this painting is the sunlight; there are no birds, people, or other significant symbols to attract attention. Observe the dramatic contrasts of light/dark, warm/cool, bright/dull, sharp/soft, architectural/organic, and opaque/transparent, which all contribute to the vibratory lighting effect.

WINTER SUNLIGHT *1986, 24" × 36" (61 × 91 cm)*

NIGHT LIGHT *1985, 11" × 14" (28 × 36 cm)*

Unlike Winter Sunlight, *the somber mood of this twilight scene called for a more subdued lighting effect. I kept contrasts to a minimum as I subtly captured the day's last light rays. Specifically, I limited the values and colors, using neutralized cool colors in fairly dark values. Notice how the similarity of the shapes (there are no architectural structures) and gently curving visual path continue this theme. All the elements of the design are working together to maintain an intimate, meditative theme.*

LOCATING THE FOCAL POINT

There are at least two decisions to make when it comes to locating the center of interest. The easiest one is deciding where in the field of depth to place the focal point: foreground, middle ground, or background. Generally the combination of the theme of your painting and the objects themselves helps you make this decision. If, for instance, you intend to feature the evening sun on a barn that is across the field, you would not want to draw attention to a wagon in the foreground or to snow-capped mountains in the distance. You may, however, choose to feature the wagon in the foreground and then suggest the middle-ground barn and background mountains. To decide, ask yourself which object attracted you to the scene in the first place—the barn, wagon, or mountains.

Where to locate the primary focal point in relation to the outer edges of your canvas is more challenging. Over the centuries, many methods have been explored. The golden section and the tic-tac-toe principle are my favorites, but whatever principle you use, the idea is to place your center of interest at a point that is a different distance from each edge of the canvas—the rule of unequal spacing. In any case, don't place the focal point dead-center or distractingly close to the edges.

Here is an example of how you might locate your center of interest at a point (A) that is a different distance from each edge of the canvas. If you have secondary points of interest, place them at points (B and C) that are different distances from each other as well as from the edges of your canvas. Make sure these locations create balance and harmony within the composition.

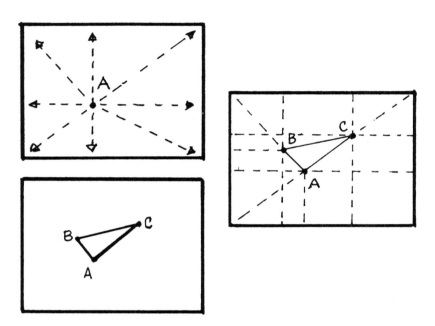

The tic-tac-toe principle is almost self-explanatory. In your sketchbook, divide your format into thirds in both directions—vertically and horizontally. Choose one of the four intersections as the location of your center of interest. If you place a dot directly at the center of your canvas, it will remind you where not to place the focal point. As you can see, this principle can be applied to any format shape: rectangular, square, or elongated.

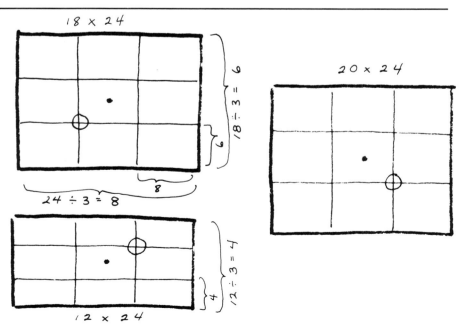

The golden section is one of the most widely known principles. It is quite easy to use. Simply divide the height of your format by 2.62; for example, 18 inches (46 cm) divided by 2.62 equals 6.9 inches (17 cm). Draw a horizontal line near this point. Now do the same for the width, 24 inches (61 cm) divided by 2.62 equals 9.2 inches (23 cm), and draw a vertical line. The intersection of these two lines is a magical spot for your center of interest. Again, place a dot at the center of your canvas to help visually orient yourself. Always remember: rules are not intended to be used rigidly; they are helpful compositional tools.

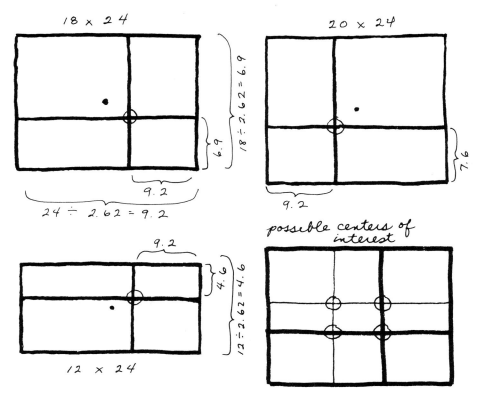

Remember to keep the edges and corners of your canvas subordinate to your center of interest, avoiding extreme contrasts in these locations. This does not mean that you must have dark corners, but simply subdue the degree of contrast. Whisper, don't shout, in the corners, pulling the eye into the picture, not out toward the frame. Specifically, don't place the center of interest in a corner or too close to the edges of the canvas, as I have done in this illustration. Although Texaco might love the bold star shouting for attention near the upper corner, artistically it is not desirable. (By the way, it is an optical illusion that the upper left corner seems to project forward—even on a blank canvas.) See how I used an L-shape composition and reversed the scene to avoid this situation in my painting Our New Pumps (page 27).

Sometimes it may be necessary to make the sky a fairly dark or muted color so that it does not distract from the focal point. You may choose to go so far as to omit the sky altogether, creating a closed composition, which allows the eye to concentrate solely on the focal point—as I did in Golden Fleece (page 58).

PUTTING IT ALL TOGETHER

It is difficult to separate compositional elements and deal with them one item at a time as I have been doing, as the elements of painting are interdependent; they must work together to create a unified picture. Everything we've discussed so far—about the format, division of space, linear movement, artistic groupings, and the center of interest—contributes to my planning and execution of the painting *Fred's Junk*.

I want to feature the antique car in this scene as it has more emotional appeal than the shed; also, the car's curving lines are more dynamic and friendlier than the harsh architectural angles of the shed. The contrast of the two will emphasize this point and therefore draw additional attention to the car. The main problem with this scene lies in the group of three essential objects: the car, barrel, and shed. Although these objects are varied and balanced as a group, the linear movement, as the eye moves from left to right, is rapid and stops abruptly at the car. The barrel and shed are anticlimactic. To change this situation, I flop the slide in my projector.

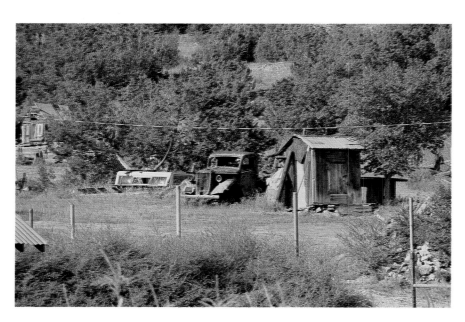

Reversing the image of this scene creates a better design. Now the eye moves quickly across the canvas to the dramatic play of light on the car and then circles back to the shed and on to the barrel and again to the car—creating continuous movement within the format. I choose a closed composition to avoid competition from a light, bright sky; besides, suggesting a hillside directly behind the bank of trees is a refreshing change from always painting skies.

Since I do not use the strong linear movement of a footpath to lead the eye into the scene, I decide to subtly darken the lower edge of the canvas, enticing the viewer out of the dark shadows into the warm sunlight. A strong, dark silhouette in the foreground contrasted against a light-value middle ground would make your eye jump, rather than step, into the scene.

The somewhat elongated canvas creates a peaceful, almost romantic setting. To position the center of interest, I use the tic-tac-toe principle, placing the car fender and headlight (the "eye" of the car) near the lower right intersection of this grid.

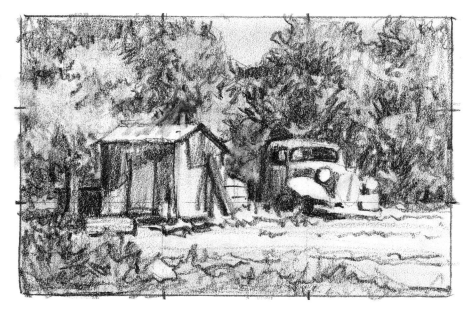

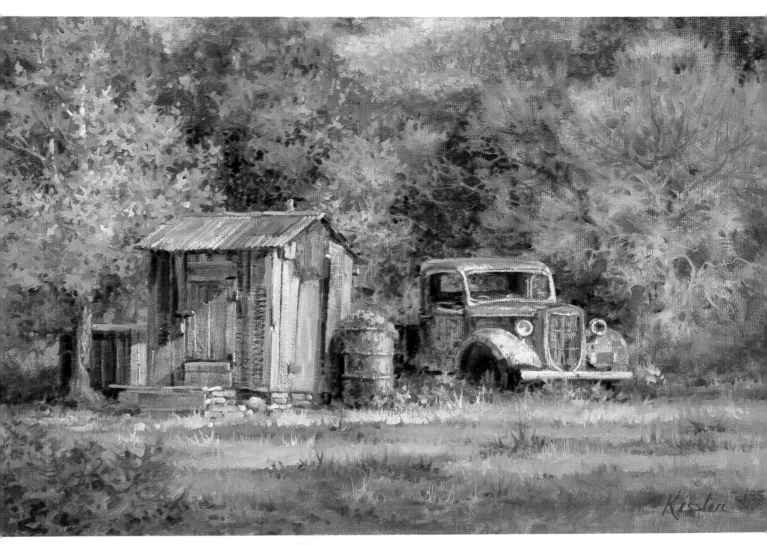

In the finished painting, additional attention is drawn to the car by contrasting colors: warm to cool and bright to muted. Even then it is hard to maintain just one point of interest. While painting I at first use too many contrasting elements in the shed, and it competes with the car for attention. I then glaze the shed to subdue it. To draw attention away from the shed, I add a sunny branch in the sycamore tree on the left, increasing the interest there. I also remove the distracting diagonal of the board leaning against the shed.

FRED'S JUNK
1985, 16" × 24" (41 × 61 cm),
collection of F. Haynes

SELF-CRITIQUE

Did you attract the viewer's attention and hold it? Is there a single, clear focal point? Does anything distract from it? Have you used contrast (light/dark, warm/cool, bright/dull) to emphasize your focal point? Squint your eyes, reducing the scene to three values, and look for any spots of contrast that distract from your focal point.

Did you control the degree of contrast at the center of interest, keeping it in line with the mood of the scene? It's best to reserve strong contrast for dramatic themes. Did you establish the strength of your center of interest early and then key the rest of your picture to it? Don't forget the strong psychological effect of people and animals, as well as certain manmade objects.

Is the center of interest well located on the canvas? Remember: don't center the focal point or place it distractingly close to the edges or corners. Instead, place it at a point that is a different distance from each edge.

7
LINEAR PERSPECTIVE

*Is the perspective correct
without being mechanically boring?*

When it comes to the subject of perspective, most artists moan and groan. The world of visual angles, horizon lines, and vanishing points often seems overwhelming. Yet if you want to suggest reality on a flat surface, you must be able to create an illusion of depth, using lines without becoming entangled in them. Remember the old adage: "What a tangled web we weave when first we practice to deceive"? Take heart: you, too, can learn to deceive the eye into seeing a three-dimensional form on your canvas. If nothing else, once you understand the basic theory, you will be able to diagnose perspective problems in your work. Also, being knowledgeable about perspective makes it possible for you to tackle convincingly more complicated subjects.

In the following pages, I will touch on some of the general perspective rules that are essential to landscape artists. You will see that once you know how to place a box in proper perspective in a scene, you can logically determine the perspective of any given object. In your mind's eye, "box" the object, be it a bush or a barn, as if you were going to send it in the mail. Then, practicing the basic principles of perspective, place the boxed object in your picture.

The first step in using basic perspective rules is to locate the horizon—that line where sky touches earth, disregarding mountains, hills, buildings, and other obstacles. (Pretend you are Superman using your x-ray vision.) The easiest horizon line to see is where the sky meets the ocean. This line is at your eye level: that is, straight ahead if you don't look up or down. Principal vanishing points—the points where things seemingly cease to exist—are located on the horizon line. Objects above the horizon taper down toward the vanishing point; objects below it taper upward toward it.

Usually, keeping these basic perspective rules in mind, you can adequately approximate reality by carefully drawing *what you see*. Easier said than done? Try this: Look straight at the subject in front of you. Hold a pencil horizontally at arm's length before your eyes. Close one eye, and without moving your head or the pencil, compare angles in the scene with the level "horizon" of your pencil. Then draw the lines as you see them, and the perspective will take care of itself. Ask yourself: "Does this line angle slightly or drastically in this direction? Is this line longer or shorter than that one?" In other words, judge relationships. Incidentally, even though objects are actually in front of or behind each other, when you arrange lines on your canvas, you must think "above" or "below."

TECHNICAL TIPS

Although you don't need to become an expert at perspective, you must understand the basic rules. If your drawing is so technically incorrect that doors and windows wouldn't function, you lose your believability and therefore your audience. If, on the other hand, you can draw the basic forms correctly, you will soon be able to go beyond an impersonal architectural rendering to denote a rich characterization. Here are some easy guidelines to get you started.

1. Begin with the corner of the building that is closest to you and establish its width, depth, and height.

2. Draw an X-shape to locate the adjusted center of a wall. Segment A should be longer than segment B as it is closer to you.

3. Locate the gable's peak on the extended vertical center line. Place centered doors and windows in perspective.

4. Pitch the rear gable on a line that is nearly parallel with the front, suggesting a very distant vanishing point.

5. Extend the roof's perspective lines to create overhangs. The front overhang (A) is closest and therefore widest.

6. Now that the perspective is essentially correct, you can add character—sagging roof lines and bulging walls.

A CLOSER LOOK

The lines at the gables are nearly parallel, even though they actually recede to a distant vanishing point above. To check these imaginary lines, use a straight-edge and compare shape A with B. The pitch of the roof on the left house is accurate, as shapes A and B resemble each other. On the other house, however, shape B is distorted because of the severe angle of the far edge.

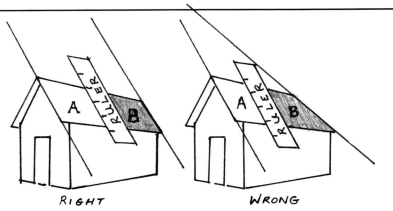

RIGHT WRONG

CHOOSING A VANTAGE POINT

Don't fall into a rut by consistently using a head-on viewpoint. Explore different vantage points—above and below eye level. Each has a different emotional impact.

Here you can see the effect of perspective on a building above and a building below the horizon line. Of course, you wouldn't actually see the bottom of the building on top—it would be covered up by ground.

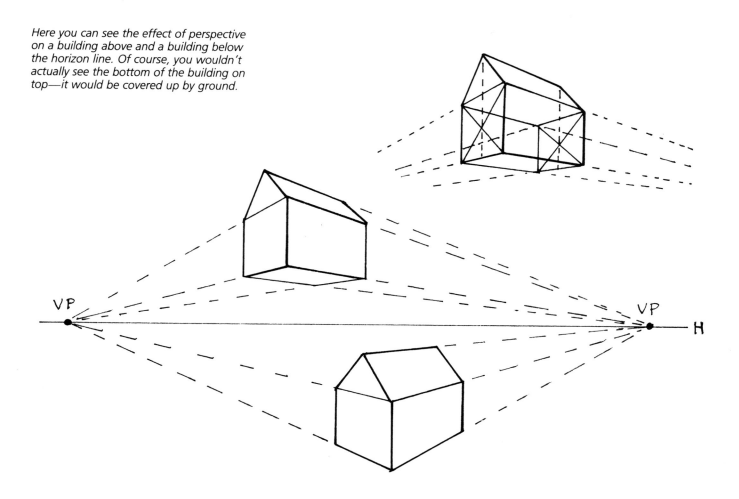

Placing objects above eye level is more dramatic than a head-on approach. The uphill climb stirs the viewer's curiosity and involvement. Incidentally, your audience may feel insecure about the shape and size of your buildings if you do not clearly reveal the location of most of the roof's corners and peaks. It is good to invite curiosity, but not insecurity—maintain a healthy balance.

THE GARAGE *1983, 18" × 24" (46 × 61 cm)*

EVENING LIGHT *1984, 18" × 36" (46 × 91 cm)*

Placement below eye level tends to create a feeling of reverence, a humbling sense of awe and closeness to nature, as the viewer's eye and psyche look out over the scene. From this vantage point, roof tops and tree tops are clearly visible— a change from the popular head-on view. The possibilities for dramatic value schemes, however, are limited, as objects are seldom silhouetted against a sky.

73

USING ONE-POINT PERSPECTIVE

If you are standing in the middle of a city street, looking straight down that street, use one-point, rather than two-point, perspective. Do the same with a railroad track or a river.

My painting *Farm Landscaping* illustrates this kind of perspective. All the objects—whether trees,

furrows, buildings, or clouds—recede along perspective lines that converge toward one vanishing point on the horizon. Lines parallel to the picture frame, such as the horizontal furrows on the far right, do not converge. As noted earlier, this kind of perspective can create a strong directional pull.

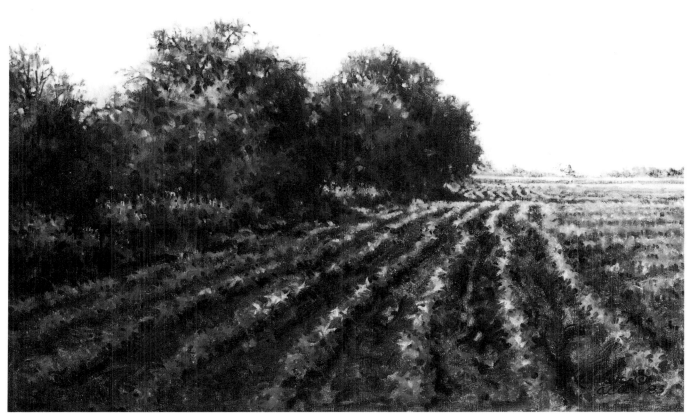

FARM LANDSCAPING *(see also page 44)*

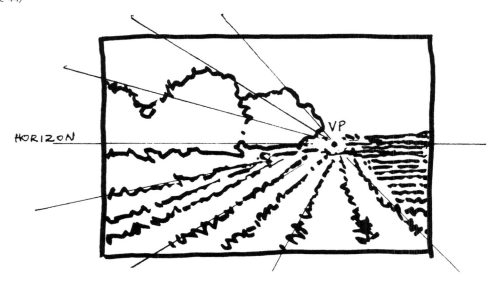

HANDLING RIVERS AND ROADS

It should be obvious that clouds generally stay above the horizon line, or eye level. In a similar way, things like rivers, roads, and railroad tracks generally stay below it. If you do indicate water above eye level, as in the second illustration here, it appears to stand upright like a wall rather than "lie down." Students seem to have a hard time with this principle, especially when drawing curved roads.

Inevitably they cross the horizon line without modifying the perspective, and consequently their roads do not lie down but look like jumping ramps for water skiers. When you draw rivers, roads, and footpaths, flatten the geometric shape as it recedes and keep its vanishing point below the horizon line. There are, however, exceptions—such as an elevated vantage point or a road climbing a hill.

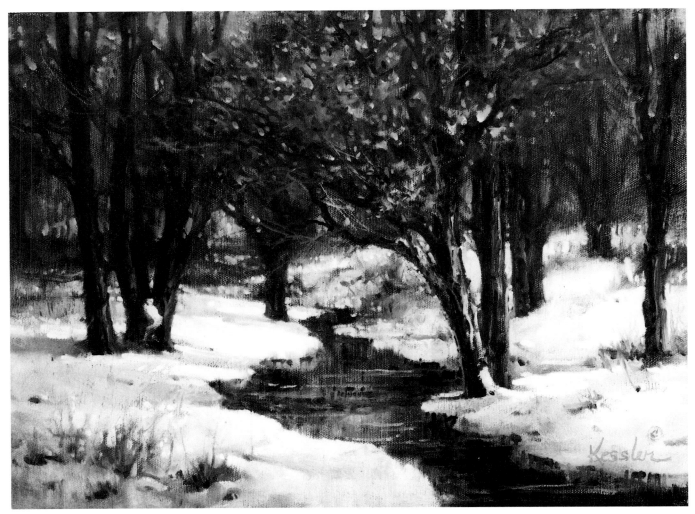

WINTER WOODLANDS *(see also page 4)*

EVERYTHING IS IN PERSPECTIVE

It is easiest to learn perspective with buildings. But people, trees, and other objects must be placed in perspective correctly, too. Essentially you box the object, whatever it is, and observe what happens to the box in perspective—above, below, or on the horizon line. By the way, don't paint "freak" trees or clouds that resemble ships and fish. Leave unbelievable oddities to the photographers, as your audience will think you made a mistake.

Here you can see how you might box a tree. Look for the main lines and basic shapes first. Details come later.

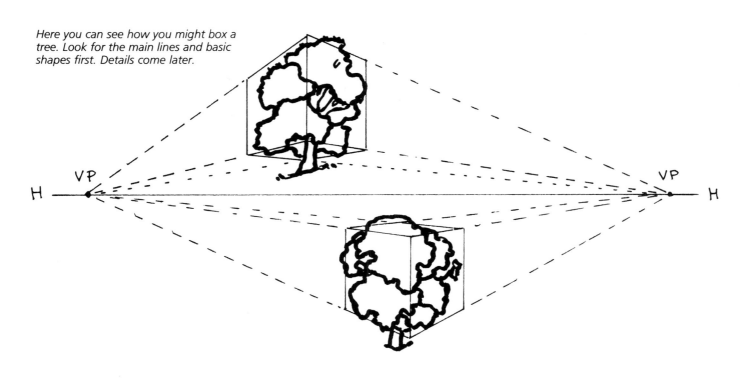

If you make exceptions for the natural upward growth of a tree, the limbs and clumps of leaves above the horizon line thrust upward; below the horizon, they hang down; and at the horizon, they push straight forward or pull backward, as illustrated here. Limbs angled toward you and up from the horizon line, presenting their underside, are dark in value; whereas limbs below the horizon, angled downward, generally reflect the light and are therefore light in value. As they sprout upward, limbs must taper: trunk, limb, branch, twig. Whatever you do, don't defy Mother Nature! A twig cannot support a branch.

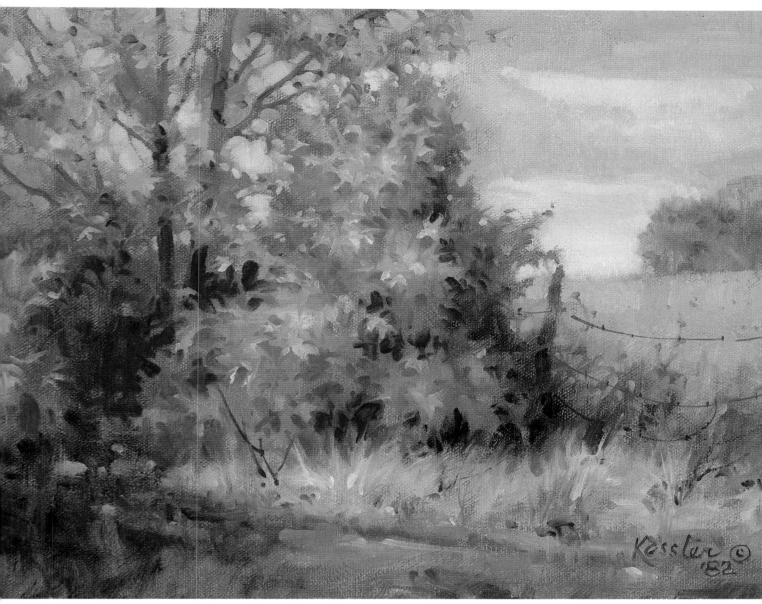

FENCE ROW BUSH *1984, 9" × 12" (23 × 30 cm), collection of R. Eads*

The horizon in this scene, disregarding the hill, is located along a line nearly level with the attachment of the top strand of barbed wire to the fence post. You look up into clumps of leaves above this line, down onto leaves below this line, and straight into the foliage along this line.

Keep in mind that people, animals, and manmade objects (including fence posts) must be the correct size, as their relationship to the surroundings sets the sense of scale. They tell you this is a giant sequoia, not a cypress tree. Or this is a ditch, not a creek or river. Incidentally, signs of human passage are reassuring— they indicate that you are not lost and alone, that mankind is not far away.

MORE THINGS IN PERSPECTIVE

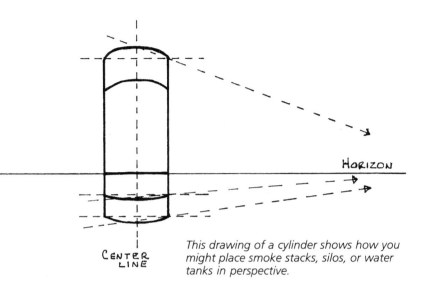

HORIZON

CENTER LINE

This drawing of a cylinder shows how you might place smoke stacks, silos, or water tanks in perspective.

Like other objects, clouds must be placed in perspective. Taking into consideration that some clouds are actually taller and larger than others, you should diminish the size of the clouds, as well as the spaces between the clouds, to create a feeling of recession (see my oil sketch on page 92). Edges are affected by perspective, too—ragged edges project forward and smooth edges recede. Of course, color and value must also be considered (see Chapter 8).

VP

VP H

Cast shadows must be in perspective, too. Don't panic. Observe carefully, draw deliberately, and paint them as you see them.

VP H

ADDING CHARACTER

A mechanically perfect rendering lacks sensitivity and is basically boring. A slight distortion of perspective, if done without grossly violating rules or suggesting an animated cartoon, can add character to a scene, bringing it to life. Don't flaunt your knowledge of perspective or become rigid with fear. Subtly take liberties; judiciously exaggerate angles and shapes. Norman Rockwell was a master at distortion—knobby knees, unruly hair, baggy pants. You, too, should express your personal viewpoint by making lines expand, sag, or lean in harmony with your emotional theme.

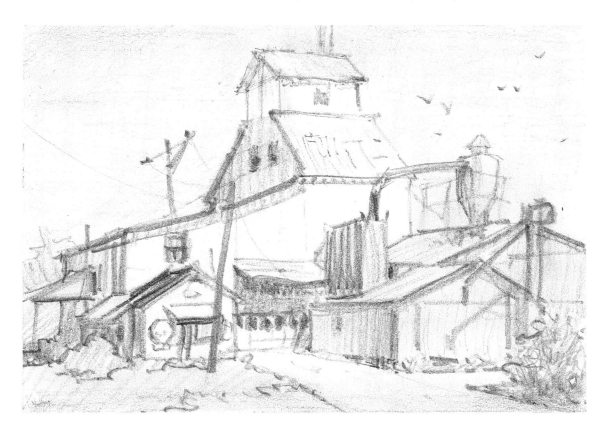

SELF-CRITIQUE

Has the perspective gone awry, making the scene unbelievable? Or, at the other extreme, did you make the objects mechanically correct, but stiff and boring? Remember: a slight distortion can be personable and entertaining. Also explore raised or lowered vantage points.

If you placed the objects in your picture in boxes, is the perspective on those boxes correct? Mentally trace perspective lines from the basic geometric forms to their vanishing points. Is the pitch of the roof correct? Check the angle with a straight-edge. Are enough building corners visible to create a balance between the need for mystery and for
security? Are centered doors and windows correctly located? Do they slant accurately toward the vanishing point?

Are trees and other organic objects properly drawn according to their relationship to the horizon line—above, below, or head-on? Did you taper the tree limbs correctly from trunk to limb to branch to twig? If your painting includes a river, road, or path, does it lie down, or is its vanishing point incorrectly above the horizon line? Check the perspective on your clouds and cast shadows too. Finally, are manmade objects and living beings the correct size for their surroundings?

8
DEPTH

Have you created a sense of depth?

Landscape paintings need a sense of depth—an illusion of space and distance that stirs viewers' curiosity and fascinates their imagination. As you compose your painting, design some degree of depth into it. You may choose to settle everything snugly into a short visual range or to stretch the scene to infinity. Whatever the span, you, the artist, must be able to fool the eye into believing some parts of the picture are closer than other parts.

How many ways of indicating depth in a painting can you think of?

1. *Division of planes*: establishing foreground, middle ground, background.

2. *Overlapping objects*: partially covering objects as they step back into the distance.

3. *Linear perspective*: reducing the size of objects toward a vanishing point.

4. *Value recession*: gradating lights and darks, and lessening contrasts with recession.

5. *Color recession*: modifying the local color to capture atmospheric perspective.

6. *Details*: explicitly defining edges in the foreground, then gradually changing to smooth or lost edges.

DIVISION OF PLANES

We've already encountered the division of planes in my demonstration painting *Dappled Light* (pages 14–21). Remember "stage front, center stage, and back stage"? Foreground, middle ground, and background? Thinking through and then clearly depicting a scene in this manner helps you simplify a complex setting, such as a deep woods, making it easier to create a sense of depth.

You might create an explicit foreground, as I did in *Floral Fantasia*; then combine this with an interesting middle ground and a vague background to convey a dramatic sense of depth. Suggesting extreme distance, distance beyond the depth of the stage, adds another dimension to the illusion. Incidentally, it's usually best to begin your painting about fifty feet from where you are standing and depict enough foreground to stabilize the bottom edge of your picture.

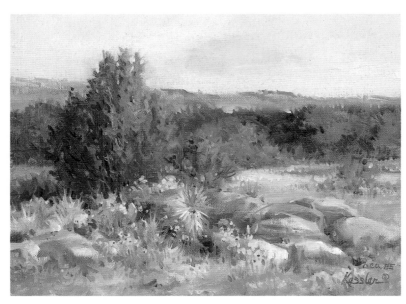

FLORAL FANTASIA
1985, 9" × 12" (23 × 30 cm),
collection of E. Peters

OVERLAPPING

Overlapping the foreground, middle-ground, and background planes, as well as overlapping objects within these planes, creates a sense of depth by pushing one plane forward and pulling another back. My painting *Summer Evening* shows a number of overlapped objects of various sizes stepping back into the distance. Notice that the lowest object, regardless of size, appears closest.

The sky is not really behind but all around in the scene, as it is a series of veils of atmosphere and not a flat backdrop. Even when the sky is just a small fraction of the picture, however, it does indicate one more step into the distance—something a closed composition lacks. Also notice how the dark areas in this picture move back in space and the light shapes pop forward.

The numbers in the diagram indicate different spatial levels. When you compare this to the final painting, you can see how color and value enhance the overlapping structure.

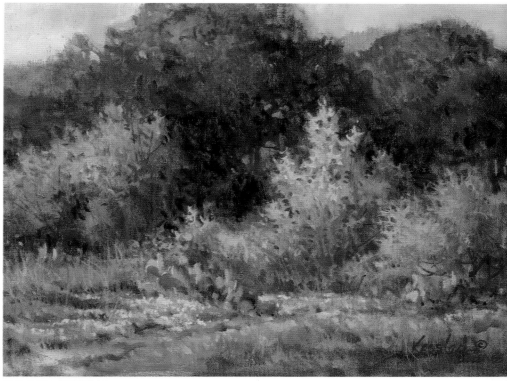

SUMMER EVENING *1985, 12" × 16" (30 × 41 cm), collection of J. Lang*

An overhanging object, such as this branch, effectively pushes other objects into the distance. Don't make these overhead masses too distracting or optically heavy, as an unsupported dark weight looming overhead suggests danger.

LINEAR PERSPECTIVE

We discussed linear perspective in the last chapter. Here I want to remind you that the principle of progressively reducing the size of objects as they recede toward the horizon must be applied to cast shadows and contour shapes, too.

Notice that the foreground shadows cast across the road in the black-and-white illustration here are wider and farther apart near the front edge and become narrower and closer together as they step into the distance. As you compose, make your cast shadows describe the contour and texture of the terrain—running down the grassy slope and gliding across the smooth pavement. Don't be careless with cast shadows—they're important.

Also notice that contour shapes on the mountain are widest at the point nearest you. Linear perspective reduces their size, shape, and proximity to each other as they move away from you and taper upward. Incidentally, contouring helps you convey the shape of an object without the need for sharp, well-defined edges or harsh outlines. Use contour shaping to push upward the inner thrust of natural forms such as mountains and trees. Save concave, sagging forms for manmade objects like ruts in roads, power lines, and roof edges. Echo, from foreground to background, these radiating patterns.

Extreme differences in scale also create a dramatic sense of depth, as you can see in my oil sketch *Copper Mountain*, with the large pine trees and the small mountain. Even the length of your brushmarks conveys depth—long, tall strokes (as in grass) advance, whereas narrow, broken lines recede.

Keep in mind that the mood of a scene takes precedence over accurate rendering. In my on-location oil sketch, I did not indicate sharply defined cast shadows in the foreground, as precise shadows would have been distracting.

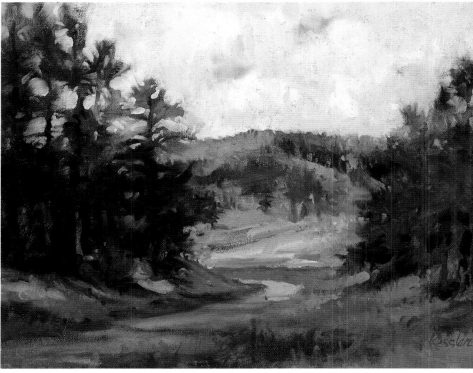

COPPER MOUNTAIN *1984, 12" × 16" (30 × 41 cm)*

VALUE RECESSION

In landscapes value recession, which is also called aerial or atmospheric perspective, is a major factor in expressing depth. By gradually changing the darks in your value scheme from very dark darks in the foreground to relatively light darks in the background, you can convey space and distance. Although value recession is more readily apparent in darks than in lights, light objects in the foreground—for example, near-whites such as snow, sand, concrete pavement, and reflected lights on water or clouds—do become slightly darker in the distance. You will find that veils of dust, smoke, and the general atmospheric conditions diminish the degree of light-dark contrast as you look into the distance; therefore, adjust your values, closing up the value contrasts, as you move, inch by inch, into the scene on your canvas.

If you place darks in the distance that are too dark, they will advance and compete with foreground objects for attention. (This is equally true of lights that are too light.) This rule applies to everything, including openings in buildings, cast shadows, and form shadows. Remember: darks must gradually diminish in value as they recede.

As I will elaborate later, you must establish a value plan that is so accurate that the scene would be believable if reproduced in black and white. Use this plan as a guide for colors and details. If the value foundation is properly laid, it will be easy to build successfully on it with colors and details.

STEP 1

STEP 2

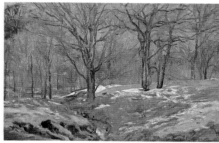

STEP 3

For Spring Melt, I began by toning my canvas with a middle-value wash and placing my objects, as you can see in step 1. Next, as shown in step 2, I blocked in the darkest darks in the foreground (the contour shapes on the left bank), the middle-tone darks in the middle ground (the carefully spaced trees), and the lightest darks in the background (a wall of trees). (If your scene has a strong light source coming from one side, subtly apply value recession as you work from side to side, gradually diminishing the intensity of the light as it flows across the canvas.) Once I was satisfied with this preliminary value plan, I established the location and the degree of drama for the focal point by washing off the original tone with turpentine and exposing the raw white canvas.

I then developed the value foundation from simple to complex, as shown in step 3. Notice the value recession, from light to dark, in the snow and the size reduction in the trees. Keep in mind that in scenes like this, due to the reflective properties of snow, the tree trunks are usually lighter in value near the ground.

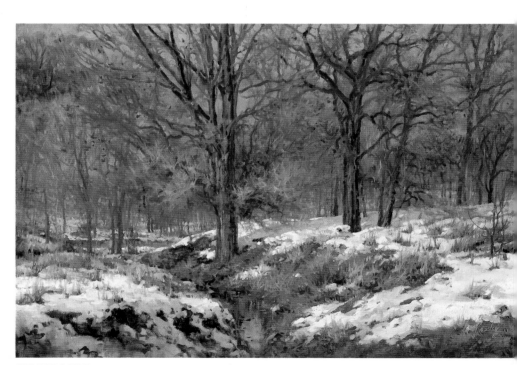

SPRING MELT 1985, 24" × 36" (61 × 91 cm)

COLOR RECESSION

Like value recession, color recession conveys aerial perspective. When you adjust a local color by neutralizing its brilliance and cooling its temperature to indicate changing lighting and atmospheric conditions, you are making colors recede into the background.

Let me explain. Bright colors at full intensity advance more than neutrals, so when the local color of an object like a green tree is neutralized, it begins to recede. Similarly, colors influenced by yellow generally advance more than colors that have been cooled by removing the yellow element. That is, as the yellow sunlight on a given object moves toward yellow-orange, orange, orange-red, red-violet, violet, blue-violet, blue, and ultimately to grays, the color tends to recede. When you combine color recession (both neutralizing and cooling a color) with value recession (fading the light-dark contrast into the distance) and linear perspective (diminishing sizes), as well as the other techniques I have mentioned, you can fool the eye into seeing depth on a flat surface.

Move from the white-hot color of the sun itself on the left, through yellow, reddish yellows, reds, and on into the cool blue of distance on the right.

Start with the local color of the object. For these trees, you might mix a warm green (cadmium yellow medium with a tiny bit of phthalo blue) and a cold green (lemon yellow hansa and phthalo blue). To adjust the local color, remove the yellow as you recede through the spectrum into the distance—moving from cadmium yellow medium through ultramarine blue in this illustration. As you progress through these colors, you should also mute the color intensity somewhat. You can see I added a touch of yellow ochre to the center tree to help neutralize the brilliant hues. The colors will be muted and cooled even more when you add a little white to adjust the values, as tube white is rather opaque and very cold.

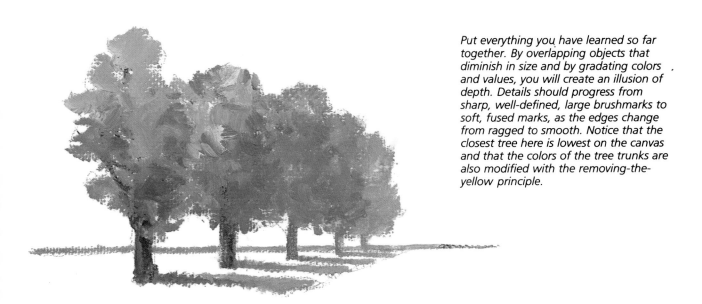

Put everything you have learned so far together. By overlapping objects that diminish in size and by gradating colors and values, you will create an illusion of depth. Details should progress from sharp, well-defined, large brushmarks to soft, fused marks, as the edges change from ragged to smooth. Notice that the closest tree here is lowest on the canvas and that the colors of the tree trunks are also modified with the removing-the-yellow principle.

A SPECIAL CIRCUMSTANCE

As mentioned, side lighting must be considered too. This tiny sketch illustrates how to remove the yellow element as the sunlight spills across your canvas. Notice how the light blue background moves from yellow-blue, orange-blue, reddish blue, to pale blue. The next step into the distance would have been a light gray.

When using the principle that warm colors advance and cools recede to depict depth, you must remember that the local color is usually a given with which you must work. If, for example, you have a boy in a blue jacket walking slightly in front of a boy in a yellow jacket, even though yellow naturally advances, the form in cool blue will, because of the overlapping theory, appear to advance. Use the principle of removing the yellow to modify and adjust the local color, cooling and neutralizing it until that local color fits properly into the floorplan of the scene. (It might be easier to have the boys exchange jackets!)

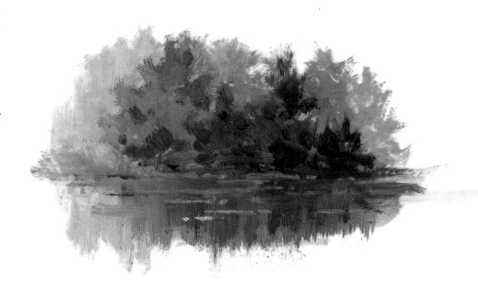

TAKING A CLOSER LOOK AT TREES

Using warm and cool greens for the local color, let's take a closer look at how to make colors regress in both sunlight and shadow by removing the yellow. Essentially the sunny branch shown here is warm green progressively modified with yellows, orange, and red. The branch in the shade is a combination of warm and cold green similarly modified—except for the lightest color (5), which shows the effects of reflected light. Here I lightened the value and muted the intensity of the local color with cadmium red deep and white rather than bright yellow as a branch in the shade reflects the coolness of the sky, not the yellow sunlight. By the way, if your colors look chalky, chances are you are adding too much white to create a lighter value. Try remixing that color by starting with lighter tube colors.

In the illustrations here, notice that the branches are the same color as the foliage. This technique adds to the sense of atmosphere and harmonizes the branch and foliage colors. When you paint branches, start with the next-to-last dark value (2) and move up to light (5) as you taper from limb to twig. Save the darkest value (1) for accents on the limb.

Once you know how to paint branches in the sun and in the shade, you can paint a tree at close range. Just put the two branches together, side by side. Then, to the top of the tree, add some light, cool reflections from the zenith of the sky ("skyshine"); locate a spot or two of reflected sunlight (highlights); bounce some warm earth colors up underneath the lower limbs and adjacent colors into the tree itself; and tie the tree into the setting with a cast shadow.

BASIC GREENS

WARM: cadmium yellow medium with phthalo blue

COLD: lemon yellow hansa with phthalo blue

SUNNY BRANCH

5. LIGHT PENETRATING LEAF: warm green mixture, lemon yellow hansa, yellow ochre, and white

4. BRIDGE TO LOCAL COLOR: warm green mixture, yellow ochre, and white.

3. LOCAL COLOR: warm green mixture and orange (cadmium yellow medium and Acra red)

2. BRIDGE TO SHADE: warm green mixture, orange mixture, and cadmium red deep

1. SHADE: warm green mixture and cadmium red deep

BRANCH IN THE SHADE

5. REFLECTED LIGHT: warm green and cold green mixtures with cadmium red deep and white

4. BRIDGE TO LOCAL COLOR: warm green and cold green mixtures with yellow ochre

3. LOCAL COLOR: warm green and cold green mixtures with orange mixture (cadmium yellow medium and Acra red)

2. BRIDGE TO SHADE: warm green and cold green mixtures with orange mixture and Acra red

1. SHADE: warm green and cold green mixtures with Acra red

SUNNY BRANCH

BRANCH IN THE SHADE

PUTTING IT ALL TOGETHER

Cool middle-ground tree (most of the yellow removed).

Cool background trees (lavenders and blues).

Distant grays.

Warm evening sunlight reflecting off the leaves (alizarin crimson).

Sunlight penetrating transparent, dry leaves (a yellow-green).

Warm shadows in sparse foliage in sunlight (a golden brown).

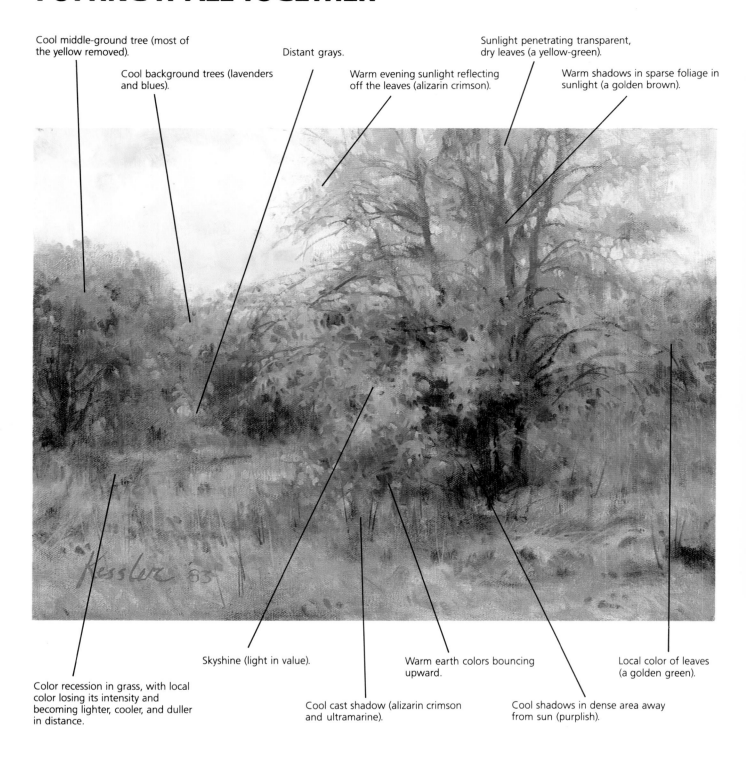

Color recession in grass, with local color losing its intensity and becoming lighter, cooler, and duller in distance.

Skyshine (light in value).

Cool cast shadow (alizarin crimson and ultramarine).

Warm earth colors bouncing upward.

Cool shadows in dense area away from sun (purplish).

Local color of leaves (a golden green).

This on-site sketch illustrates most of the points I have made about creating a sense of depth, especially in regard to color recession. Just remember: paint the darks progressively lighter and cooler and the near-whites slightly darker and cooler— removing the yellow element as things recede. Also, don't forget to mute the brilliance of the colors.

FADING INTO FALL
*1983, 12" × 16" (30 × 41 cm),
collection of H. Fowler*

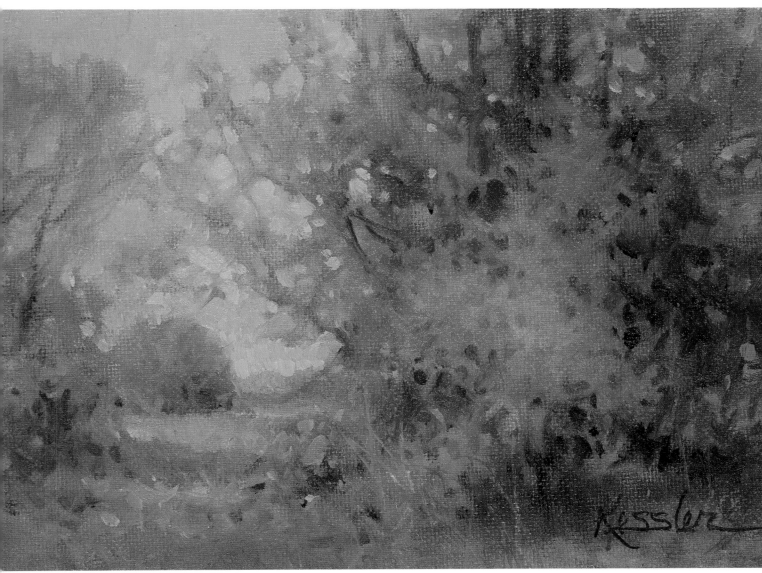

AUTUMN TREES *1986, 5" × 7" (13 × 18 cm)*

Up to this point, I have dealt with green trees. Now look at how I have used the removing-the-yellow principle to create depth within a red tree. In the oak on the right, the bright yellow-orange leaf formation advances, pushing toward the viewer, when cooler orange-reds are placed around it. Continuing through the color spectrum, the backside of this tree on the shaded side (extreme right) is suggested with a muted, cold purplish red, while the backside on the sunny side is indicated with a warmer, neutral red.

Compare the colors and values of this tree's backside to its nearside. Then try painting a similar scene on your own. Push and pull with color temperatures, creating overlapping leaf formations that convey an illusion of depth within the tree itself. Be sure to suggest a few limbs running through the backside.

Finally, compare the foreground tree in my painting with the red tree in the distance (left of center). The yellow-oranges have changed to cooler, muted reds; the values have also been adjusted.

HANDLING GRASS AND ROADS

The basic rules of color recession outlined for trees can easily be applied to other subjects. Start with the local color. For the grass in this illustration, I began with a combination of warm and cold greens. I then modified this, putting the yellowest color in the foreground and gradually removing the yellow element, cooling and neutralizing the local color as I worked into the distance. I used the same technique on the road, beginning with yellow ochre as the local color. Since the road is so much lighter than the grass, I worked with tints of the modifying colors—diluting my tube colors with white. (I prefer titanium-zinc ever-white as its pearlish luster is not as transparent as zinc white or as opaque as titanium.)

By the way, although the emphasis here is on color recession, don't forget to modify the values and details as things recede into the distance.

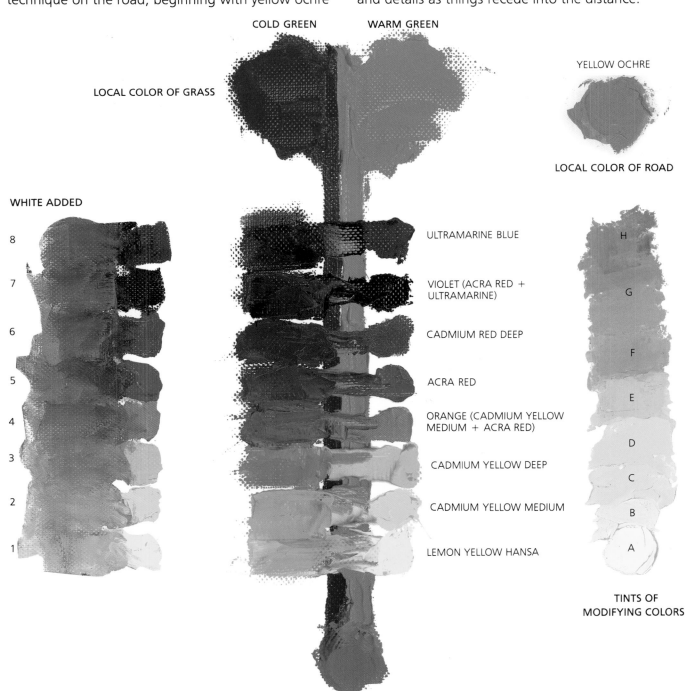

COLD GREEN

WARM GREEN

YELLOW OCHRE

LOCAL COLOR OF GRASS

LOCAL COLOR OF ROAD

WHITE ADDED

8

7

6

5

4

3

2

1

ULTRAMARINE BLUE

VIOLET (ACRA RED + ULTRAMARINE)

CADMIUM RED DEEP

ACRA RED

ORANGE (CADMIUM YELLOW MEDIUM + ACRA RED)

CADMIUM YELLOW DEEP

CADMIUM YELLOW MEDIUM

LEMON YELLOW HANSA

H

G

F

E

D

C

B

A

TINTS OF MODIFYING COLORS

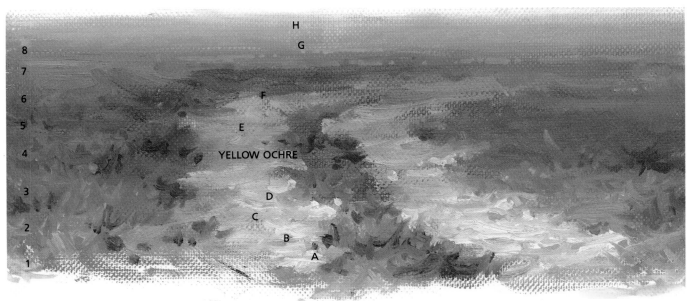

H

G

8

7

6 F

5 E

4 YELLOW OCHRE

3 D

2 C

1 B

A

HANDLING CLOUDS AND SKY

Since clouds are made up of moisture particles reflecting the lighting conditions of the moment, simply use the colors of the light as a starting point when painting clouds on a sunny day. The illustration here provides a guideline. As you can see, the sunny highlights in the cloud closest to the viewer are nearest the color of the sun—lemon yellow hansa (A) in this illustration. As the clouds recede into the distance, you should make the lemon yellow regress to cadmium yellows, oranges, and then reds (B–E). In like manner, modify the dark

form shadows in the clouds, receding from warm to cool grays, with less red and more blue. When you finally arrive at the horizon, combine a muted red (F) with a modified ultramarine blue (the zenith of the sky) to create a pinkish gray, suggesting dust, sand, and pollution.

Since clouds are rounded forms, the lightest lights are *not* at the edges, touching the blue sky—unless backlighting penetrates the form. As on any sphere, use skyshine on the top, reflected earthtones underneath, and bouncing lights along the sides to

TINTS TO MODIFY BLUES OF SKY

SUNNY AREAS OF CLOUDS

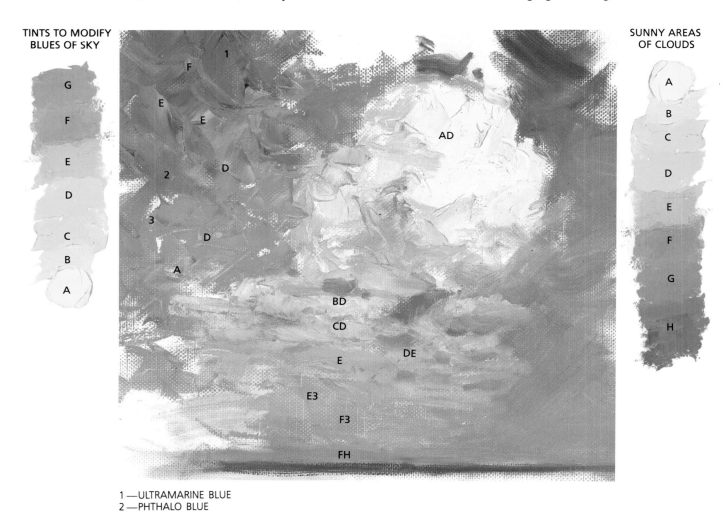

1—ULTRAMARINE BLUE
2—PHTHALO BLUE
3—COLD GREEN

A—LEMON YELLOW HANSA
B—CADMIUM YELLOW MEDIUM
C—CADMIUM YELLOW DEEP
D—ORANGE
E—ACRA RED
F—CADMIUM RED DEEP
G—VIOLET
H—ULTRAMARINE BLUE

indicate the mass and the form (see Chapter 10).

Now, let's look at the sky. Since ultramarine blue has some red in it, it is somewhat cooler than phthalo blue, which has some yellow sunshine in it. Therefore, if I am painting a skyscape that includes some of the sky's zenith, I use ultramarine blue near the top of my canvas, changing to phthalo blue as I work my way down. As I approach the horizon, I add a little lemon yellow sunlight to the phthalo blue, creating a transparent cold green. (Remember to indicate some pollution just above the horizon.)

Keep in mind that rays of warm sunlight reflect off the earth, cooling as they bounce upward. In the blue of the sky, use the yellow-orange-red modifiers,

working from cool to warm (G—A) as you move from outer space to the horizon. Specifically, in this illustration I have modified the local sky colors (ultramarine, phthalo blue, and cold green), working from the top downward, with grayed red (F), red (E), orange (D), and finally yellow (A). Don't overmix your colors, by the way; broken colors are more fascinating.

Be careful not to make the blue sky too dark or the clouds too light. Chalky white clouds need more pigment. Compare the values of the clouds and the sky; then compare these values with the general value of the landscape, relating all three values accurately—sky, clouds, landscape.

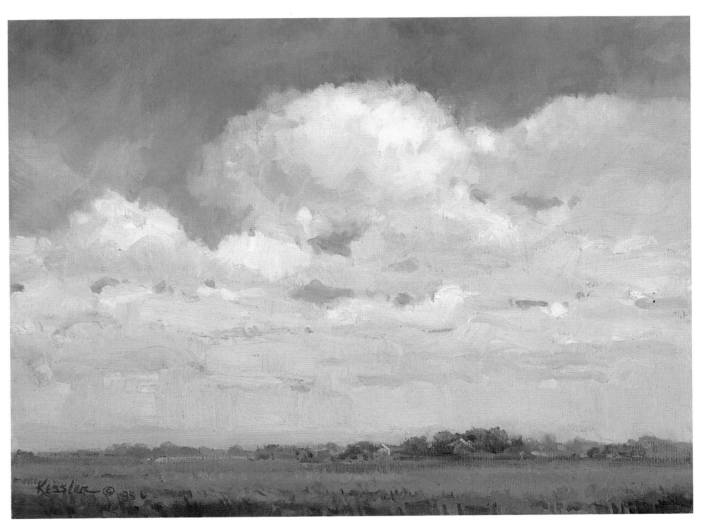

Now that you know how to use color recession, disregard color for a moment and observe the values in the clouds themselves in this finished painting (see also Home for Lunch, on page 108). Notice that the light areas of the clouds progressively grow slightly darker, as well as duller and cooler, as they recede into the distance. This phenomenon is due to the numerous veils of atmosphere blocking your view of the distant horizon.

Conversely, dark form shadows in the clouds appear lighter and cooler as they approach the horizon. In other words, lower the intensity of the value contrast as the clouds vanish into the distance. Then define a few outer edges and refine some contours to create furrows and ridges within the clouds themselves. Keep in mind that explicit details like ragged edges project forward, while smooth or lost edges recede.

BILLOWING CLOUDS
1985, 12" × 16" (30 × 41 cm)

DETAILS

Although details are discussed more thoroughly later, in Chapter 14, they are an important consideration in establishing depth in a painting. Sharp-focus details advance, appearing close to the viewer, while soft or lost edges tend to recede. In general, then, you should depict less precise information as you move inch by inch up the canvas and "back" in space. Remember: clearly defined areas inappropriately placed in the distance will pop forward, confusing the viewer.

STEMS AND PIECES *1986, 24" × 36" (61 × 91 cm)*

Notice how the stalks, leaves, and ears of corn in the foreground catch your eye; then, as you move into the distance, these individual shapes begin to mass together and highlights and dark accents disappear. Also compare the bushes on the right with distant bushes. By the way, I frequently omit distractingly descriptive passages along the very bottom of the canvas.

Notice how the intricate details in the foreground and simple shapes in the distance help to establish the sense of depth here. In the foreground, sharp value and color changes force edges into focus. In the distance, however, edges are softened or lost as value and color contrasts are lessened. Ruts, stones, and cast shadows on the road quickly lose definition. Similarly, tree trunks, pine-needle clumps, and ''sky holes'' in the trees are subdued or eliminated.

PINEWOODS *1986, 24" × 36" (61 × 91 cm)*

SELF-CRITIQUE

Does your painting contain an illusion of depth, leading the eye into the distance? Check your painting for six techniques:

1. Division of planes. *Is there a clear indication of foreground, middle ground, and background?*

2. Overlapping objects. *Have you layered objects as they go back in space, keeping the lowest object nearest to the viewer?*

3. Linear perspective. *Did you progressively reduce shapes, including cast shadows, contour shapes, and even brushmarks?*

4. Value recession. *Have you neutralized value contrasts—progressively lightening darks and darkening near-whites as they recede?*

5. Color recession. *Did you modify the local color—progressively muting its brilliance and cooling it by removing the yellow?*

6. Details. *Do explicit details advance, while smooth edges recede?*

Double-check dark openings in buildings, all dark shadows, and light and dark accents. Do any advance beyond their position in space? Also check the light areas. Did you avoid chalky white colors? Overall, have you modified local colors appropriately? Remember: warms push forward; cools pull back. Also, color brilliance and value contrast lessen with distance—inch by inch on your canvas, front to back and sometimes side to side.

9
OVERALL TONALITY AND ATMOSPHERE

Is the value range consistent with the mood?

As a landscape artist, you are essentially painting a lighting effect, which is incidentally a barn. Light is often the main subject of your painting. Capturing what light and atmosphere do to a scene will communicate a mood, thus expressing a unique emotional experience—your primary goal. Early morning light, twilight, rain, and snow all create illusions of timelessness; the objects in the scene complement (or distract from) this mood.

Controlling your values and color temperatures (which I will cover thoroughly in Chapter 13) is a good starting point for capturing the quality of the day—the atmospheric conditions, intensity of the sunlight, heat and humidity, or lack of it. Specifically, sensitive control of values can enrich the mood of a scene and make it "talk."

Identify the pitch of the day—high noon or moonlight. Observe how the light unifies the values and determines the overall tonality of the scene.

Communicate this observation by intentionally manipulating your value range.

The idea here is to convey light and atmosphere by "keying" your values to fit the mood of the day. Take a bright, happy spring scene with a lacy tree. This subject is well suited for the lighter range of the value scale—a high-key painting. Gloomy rainy days or scary night scenes are obvious examples of low-key subjects. The middle key is the most frequently used range, as it adapts well to the average daylight scene. The danger is that, unless it is handled with sophisticated sensitivity, a middle-key picture can be rather ordinary. In contrast, a predominantly high- or low-key painting is generally dramatic in nature—atmospheric, romantic, mysterious. Yet if the overall tonality of a painting is too light or too dark, the message will be lost. Values are a tool of expression and must be taken seriously.

HIGH KEY

This brilliantly lit scene inspired a high-key painting. I chose predominantly light values, with enough dark accents to prevent a faded appearance, and combined them with a delicate, warm color theme to create a harmonious unit. This picture's overall tonality, conveyed through value and color control, does not reproduce nature, but interprets it—as if you were looking at the world through colored glass.

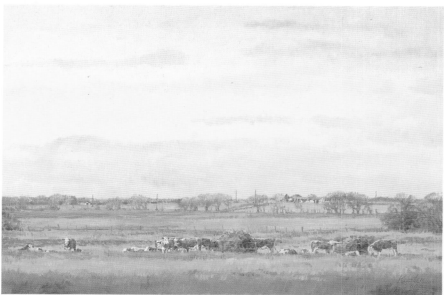

NATURE'S INDIAN BLANKET *1984, 20″ × 30″ (51 × 76 cm)*

LOW KEY

The mood of this scene called for a more subdued lighting effect, so I again kept contrasts to a minimum as I subtly focused on the movement of light across the scene. Painting on location, I limited the value and color range, using neutralized earth colors in fairly dark values.

The similarity of shapes, fairly uniform brushwork, and gently curving path of vision continue this theme. All the elements of the design, even the shape and size of the canvas, are working together to keep the interpretation humble.

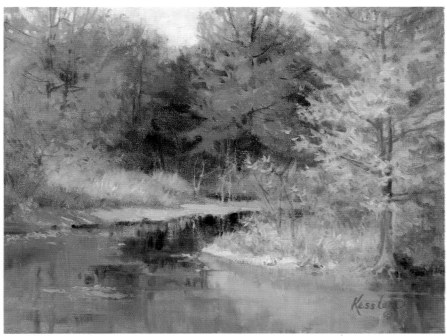

OCTOBER SERMON *1982, 12″ × 16″ (30 × 41 cm)*

MIDDLE KEY

A middle-key painting can take advantage of the full value scale—from nearly black to nearly white—creating a carnival of exciting contrasts. Here I continued this playful theme by using a wide range of bright colors. Notice how I've bleached out the colors and values in the sunny areas and intensified the shadows to indicate a strong light source and clean air. By moving toward the complementary color in transparent shadows, I made the sunlight seem to vibrate—the yellow-green highlights in the pine tree, for example, are complemented with blue and purple accents in the shadows. Be careful, however: always be aware of the sun's location, as it will determine the intensity of the light and the direction of the shadows. Also remember to make your scene predominantly sunny or predominantly shaded—no half and half.

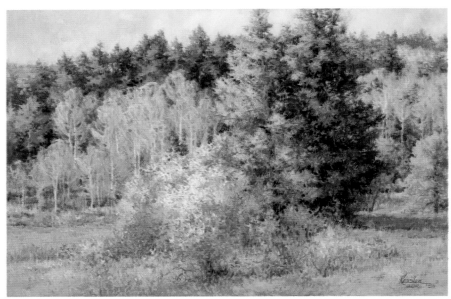

TWIN PINES *1985, 24″ × 36″ (61 × 91 cm)*

WORKING WITH COLOR TEMPERATURE

Emphasizing color temperature, as well as varying the value range, can open a whole new world of picture-making for you. Instead of simply painting a white house white, you will paint the light striking the house. Just as no object has a fixed value, nothing has a fixed color. Rather, the color of an object is modified by the way light strikes it at a particular moment. The possible color and value combinations are endless.

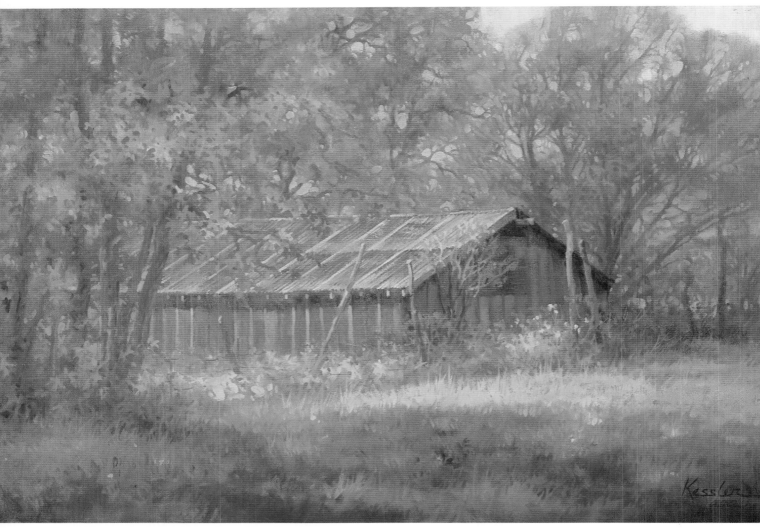

OCTOBER SUNSHINE *1984, 20" × 30" (51 × 76 cm)*

Lighting and atmospheric conditions can make or break the artistic worth of a scene. In October Sunshine I used color temperature (hot autumn colors) in conjunction with a limited value range to convey a hazy, hot, dry day. Had I passed this way on a cold, damp winter day, the same scene would have been handled in an entirely different manner.

By the way, don't make cast shadows dark and murky unless it is a moonlit night. Especially in the sunbelt, shadows are filled with reflected lights and can be more richly colored than the sunlit areas themselves. Study colors in the shadows by looking at the paintings of the Impressionists.

STEP 1

STEP 2

STEP 3

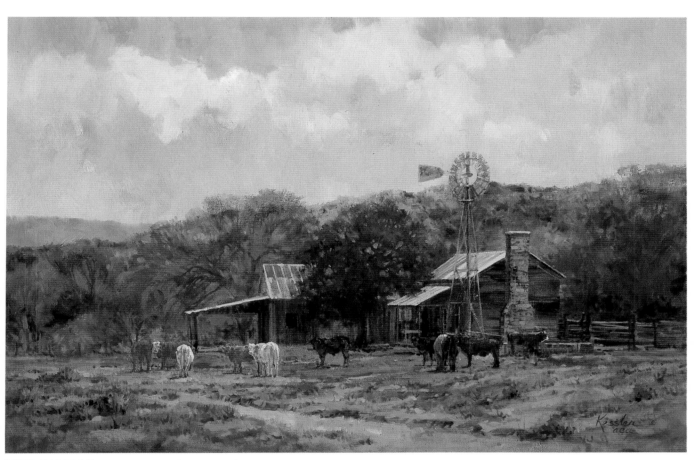

MIDDAY BREAK *1984, 20″ × 30″ (51 × 76 cm)*

A predominantly dark mood is expressed in this painting through the use of low-key values and cool, subtle colors. The emotional heaviness of this isolated, abandoned setting is lightened by spots of sunlight breaking through the clouds and spotlighting the small herd. Because of its scarcity, the light becomes important and charges the scene with dramatic intensity. The spring showers that made the scene wet and colorful carry the promise of lush, green pastures.

When you compare the painting to my original photograph you'll notice that I made certain changes to bring out the mood I wanted. Most obviously, I removed the road and added the distant hill on the left to quiet the diagonal movement. I also omitted some cows, a utility pole, and the foreground trees for the sake of simplicity. Finally, I changed the clear blue sky. Remember: the actual scene is only the starting point for your picture.

DEPICTING SNOW

Never paint snow pure white—it reflects the color of the sun or the dome of the sky as well as such objects as trees and buildings in the scene. Usually the middle or overall value of the snow is lighter than the sky, as it reflects the bright sun itself. An exception, however, occurs at sunset and at sunrise, when you look directly into the light.

In early morning and late afternoon on a sunny day, contrasting elements in a snow scene can be exciting. Consider a typical snowbank. The upright snow-covered planes catch the sunlight, reflecting its warm color and thus creating your lightest lights. Shadows, cast on the snow by trees and buildings, reflect the cool zenith of the sky and are dark in value. The flat planes in the sunlight reflect the sky (cool) and the sun (warm), so they are a neutral color in a middle value. Any shadows not exposed to the zenith of the sky are quite warm, as they

I want to stress the important role values play in picture-making. Color and texture cannot paint a picture without the support of value contrasts. You must learn to see the value of a color without being distracted by the color itself. (More on that later.)

This snow scene, Seventy-fifth Winter, has a strong and clearly visible value plan. In my first sketch the scene is simplified into about three values. This abstact design is the foundation on which I built my painting. Without this strong value foundation, the picture would have fallen apart into a mass of confusing colors and value spots.

Now look at my second, more complex sketch, in which I began to refine these values and clarify the center of interest in the highlit area. I then transferred this sketch to my canvas in the form of a value wash. Freed of the double task of handling both value and color, I used this wash as a guide while I slowly developed the painting, translating values into harmonious colors with complementary textures and details. This approach gave me the time to tend to important technical considerations involving drawing, perspective, and value relationships. That's the advantage of a clear value plan; it lets you solve problems before you are into heavy paint and rainbow colors—at which point it may be too late. Discipline yourself to make preliminary value studies in your sketchbook and then on your canvas. As a result, you'll be more satisfied with your finished picture—because, if the sketch works, the painting will too.

reflect bouncing light from nearby. This simplified understanding of the anatomy of a snowbank will help you think through a more complex scene.

Toning your canvas with a warm earth color, such as yellow ochre, and allowing it to show through occasionally, just as the earth peeks through the snow in nature, contribute to the illusion of reality. Try using luxuriously thick paint in the sunlight to add luminosity. Remember that light on the snow moves through the color spectrum: from the yellowish hues of morning to the golden orange of midday, to the pink of afternoon and the lavender of evening. Gray-day snow scenes are cool, atmospheric, and moody.

A final consideration—is the snow fresh, or days old? Straight lines and hard edges make fresh, new snow look cold. To make the whites look clean and brilliant, add a spot of red (for example, a red bird) to the scene. Old snow, as seen in my painting *Seventy-fifth Winter*, softens, conforming to the terrain. It is darker than new snow, as it is porous and dirty and therefore does not reflect the light as well. Patches of melting snow can create exciting designs.

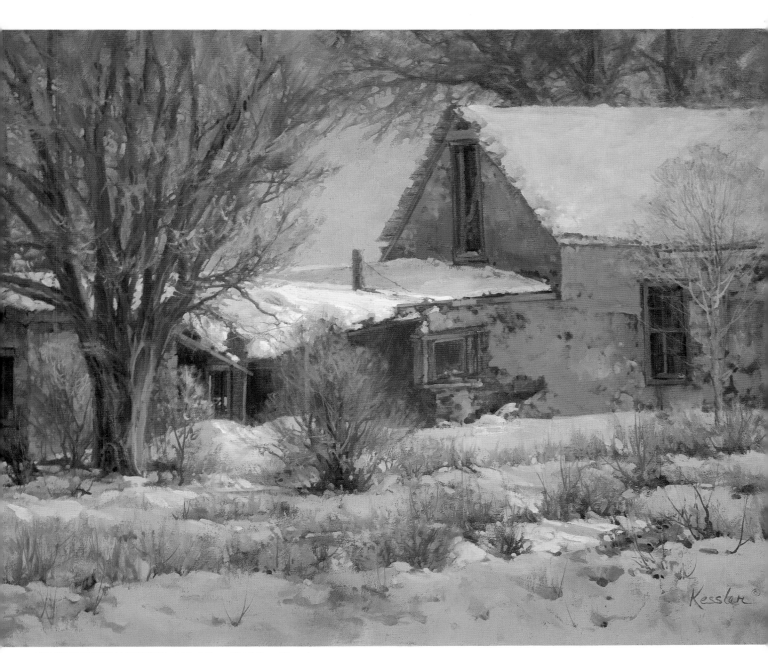

SEVENTY-FIFTH WINTER *1986, 22" × 28" (56 × 71 cm)*

PORTRAYING FOGGY, GRAY DAYS

As you can see in my painting, the silvery veils of fog rob objects of color and value. The moisture-laden atmosphere seems to flatten masses and contours and to soften and unify the overall tonality of the scene itself, imparting a dreamy, elegantly simplified strength. The mist disperses the light so that it plays on objects from all directions. This broken light destroys shadows and draws values close together, making light and dark tones only slightly lighter or darker than the neighboring tones. Working within this close value range, rather than the exaggerated range of sunshine and shadows, requires sensitive observation and dedication to perfection.

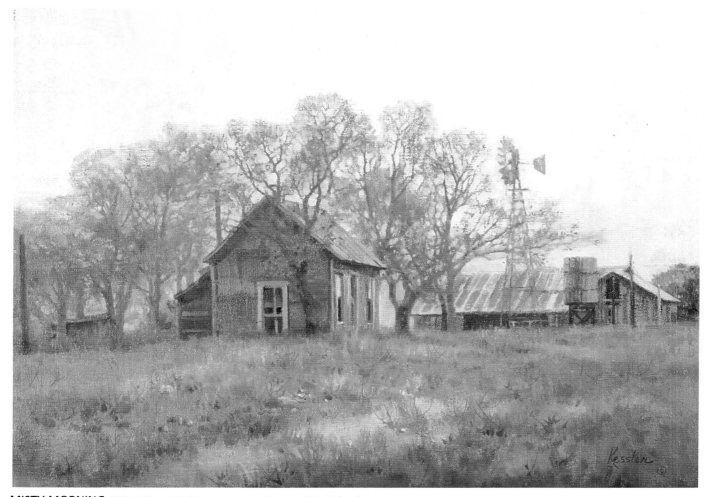

MISTY MORNING *1984, 18" × 24" (46 × 61 cm), collection of G. Richardson*

Because of the diffused light in Misty Morning, *I kept the sky light in value (lighter than a clear blue sky) and did not overmix the colors. In this way I suggest broken light (fog) with "broken" colors. Remember: on gray days, colors are rather cool, containing less of the yellow or yellow-orange element. Restrain yourself; don't add last-minute jewels—spots of warm, intense color.*

CONVEYING NIGHT

A night scene can focus on the light, the contrast of light and dark, or on darkness itself. The first two situations generally involve artificial lighting or bright moonlight. (If you must paint sunsets, tastefully understate the magical qualities.) A predominantly dark scene, as shown here, depends on an overall value and color tone to convey a mood and arouse an emotional response.

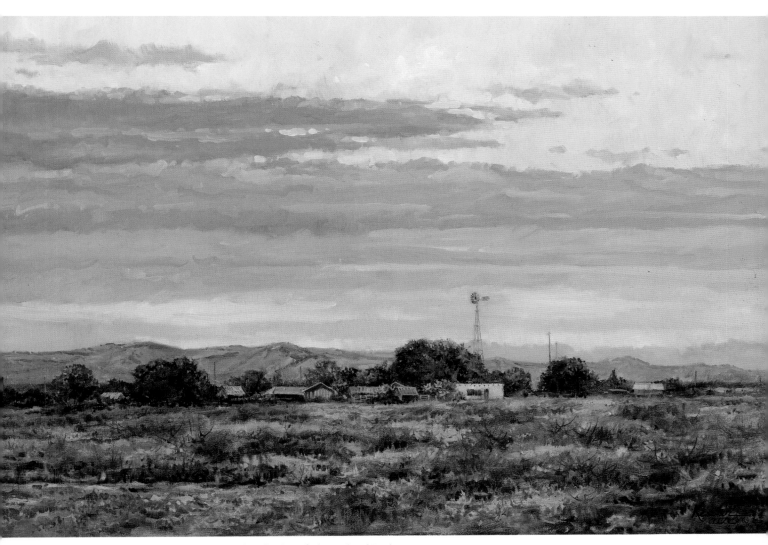

AFTER DUSK *1985, 24" × 36" (61 × 91 cm), collection of City National Bank*

Darkness can be portrayed as threatening and scary or invitingly restful. All the elements in After Dusk communicate a peaceful mood. The values and colors do not jump about, creating dramatic patterns, but rather subtly unify the theme through the overall tonality. Notice that, as darkness approaches, yellows, oranges, and some reds virtually disappear as ochre, terra cotta, mauve, burgundy, green, turquoise, purple, lavender, blue, and gray colors come to life. Since declining light neutralizes colors and values, I did not use any small spots of intense colors or light or dark accents—this would have destroyed the effect I wanted.

WORKING WITH BACKLIGHTING

A beautifully eerie sensation can be created by backlighting—if you don't paste a black silhouette over a bright, colorful backdrop. Capture a penetrating, late-afternoon light by creating strong color and value contrasts while maintaining a generally low-key picture. Without overdoing it, try using thick paint and vivid colors with their complements—yellow and purple, for example—to create a splash of excitement. As you squint, looking into the evening's damp haze, downplay the detail work. A broken arrangement of lights and darks will convey a feeling of sparkling sunlight. Remember: shadows spread out as they come toward you.

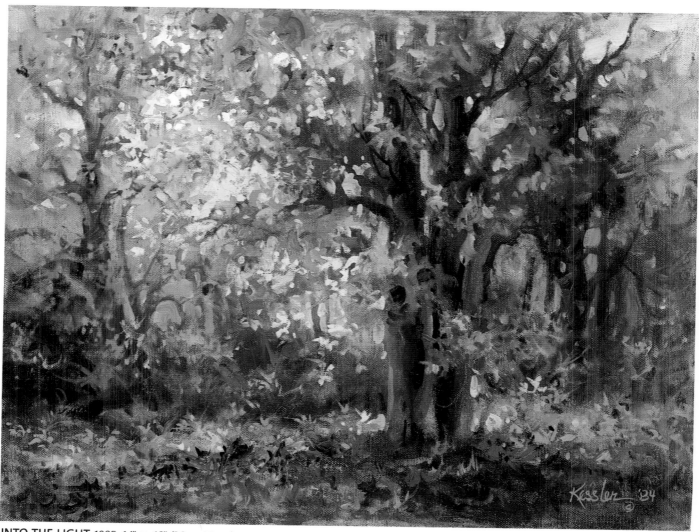

INTO THE LIGHT *1985, 14" × 18" (36 × 46 cm)*

Even though this is a quick, on-location sketch, you can sense the mood, atmospheric conditions, time of day, and effect of light on the scene.

CREATING NARRATIVE ART

Painting atmospheric conditions is not your only option. For a change of pace, consider combining skillful, sensitive landscape painting with telling a story. Look at my painting *The Garden Patch*, which exemplifies what I call "narrative art."

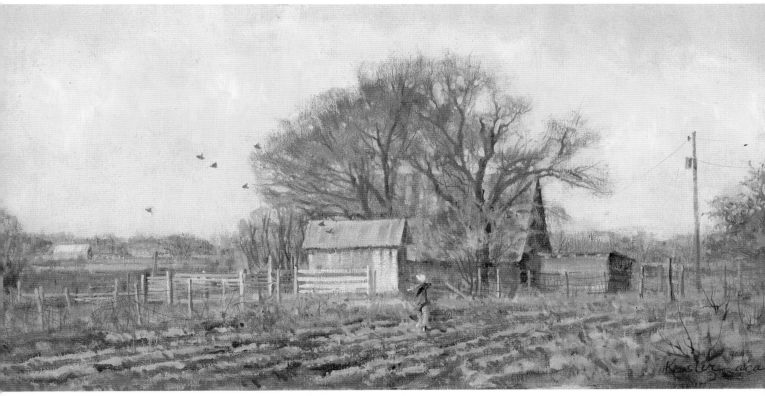

THE GARDEN PATCH *1983, 15" × 30" (38 × 76 cm), collection of C. Hancock*

This delicate, warm spring day is portrayed with cheerful colors, light values, and loose, playful brushwork in the sky. The overall high-key values and the warm colors continue this theme. The story provides additional entertainment: the onion sets have been planted, and the lettuce is up. The scarecrow is doing his job, protecting fragile new life as it tries to survive in a tough world.

SELF-CRITIQUE

Is the overall tone of your painting consistent with the mood you want? Can you detect the time of day and the season? Did you control the range of values—painting in a high, low, or middle key—to convey the atmospheric conditions of the day? Is your picture predominantly light or dark, not half and half?

Did you also modify the local colors, painting the effects of light on the scene? Or did you just inventory a group of objects?

Are you in a rut? Paint fog, darkness, rain, snow, sidelighting and backlighting, dim light and strong light.

Regarding snow scenes, is the sky darker than the snow? Did you make the snow too white, forgetting reflected colors? For night scenes, fog, and rain, did you remove the yellow element and neutralize the colors?

10
VALUE RELATIONSHIPS

Is the overall relationship of one value to another correct?

Many decisions made during the painting process are a matter of personal taste: deciding what you think looks good and what might look better. But value relationships are either right or wrong. Ignorance shows! You cannot get away with faking it.

Learning to see values by comparing them to each other is the key to painting them correctly. Painting is basically just that: seeing relationships.

Creating distinct planes of light in your composition simplifies the comparison of values. View your painting as a whole. There should be simple masses of different values. Separate the scene into no more than four value planes: (1) the void of the sky, (2) horizontal planes, such as the ground, (3) slanting planes, such as mountains, and (4) vertical planes, such as buildings and trees. Each plane, as it presents itself to the light source (the sun), should be a different value because it receives a different amount of light. Look for the middle value (disregarding the highlights and the dark accents) in each of the basic value planes; then use these guidelines to check your work:

- Is the sky lighter than the foreground?
- Is the foreground lighter than the slanting planes (hills)?

- Are these slanting planes lighter than the upright planes (walls, trees)?

These guidelines are not hard-and-fast rules. They apply to a basic landscape on an ordinary sunny day and should be modified for unusual circumstances such as cloud shadows on the ground, some manmade objects (a white house, for example), snow reflecting the sunlight, or an unusually dark or light local color (a fruit tree in bloom, for instance). Despite the exceptions, the basic principle here provides a good check on the value relationships in your painting.

The next time you paint outdoors, don't just look at the objects: a barn, a road, and trees. Instead of mentally naming the objects, try viewing the scene in three or four value planes. *Look* at the overall scene. How much darker is the foreground than the sky? How much darker still are the trees? Capture these contrasting values and the rest will be easy.

Just remember: everything is relative. One plane is relatively lighter or darker in value than another. Compare them. Keep it simple—two or three basic value areas plus the sky. Once these bold value masses are established correctly, it is much easier to develop the shapes and forms within them. Color, texture, and detail begin to paint themselves.

THREE VALUE PLANES

A simple landscape, like the one shown here, might be reduced to three basic value planes: (1) the lightest contains the source of light (the sky); (2) the middle tone is made up of flat surfaces (the ground); and (3) the darkest consists of upright planes (the trees).

ODE TO AUTUMN *1985, 12" × 24" (30 × 61 cm)*

Although this painting has a cloudy sky, even on a clear day with a blue sky, the value of the sky—the source of light—is lighter than the foreground. Now turn the page and compare the value scheme in this painting to Home for Lunch.

1 (sky)

3 (trees)

2 (ground)

FOUR VALUE PLANES

Four value planes make a painting more complex. Again, remember the basic guidelines: (1) the source of light (the sky) is lightest; (2) flat surfaces (the foreground) are medium light; (3) slanted planes (hills) are medium dark; and (4) upright planes (buildings and other objects) are dark. Note that trees should be considered upright planes, as they grow in an upright posture, but that their spherical foliage may move them toward the category of slanted planes.

Once the value planes are correctly related and depth is established through value recession, you can begin to play with the essential elements within these value masses. Be careful that highlights and dark accents on trees and other objects do not destroy the object's place in space (foreground, middle ground, background) by being too light or dark in value. Also, don't let the darkest dark accents in the foreground become too dark (black). Total absence of light in nature is highly unlikely. Think "light and less light" rather than "light and dark."

The average, or middle, value of the object usually conveys some indication of its weight. The average value of a floating cloud is high key (light). A mammoth mountain is generally dark, unless it is covered with snow. The weight of the large, dark tree on the right in my painting *Home for Lunch* is counterbalanced by the small tree in the distance on the left and by the chickens in the left middle ground (which, as living, breathing creatures, command the viewer's attention).

A black-and-white photo of this painting would show a simple, high-key sky complementing the complex subject matter. Movement in the sky is created through the use of warm and cool colors rather than strong value contrasts, thereby maintaining the basic four value planes.

As already mentioned, be sure to modify the basic guidelines for establishing value planes whenever the circumstances dictate it. The painting here provides an example. Although roofs are sloping planes, in order to convey the glare of sunlight on the metal roofs in this scene, I kept them light in value. Notice the glare on the truck's windshield too. The local color of the sunlit tree behind the truck is very light. It is early spring and the tree is just beginning to leaf out, so I made it lighter than the normally dark base-value for upright planes (trees). The large tree on the right is actually an evergreen. Falling into the norm, it is portrayed as a dark upright plane.

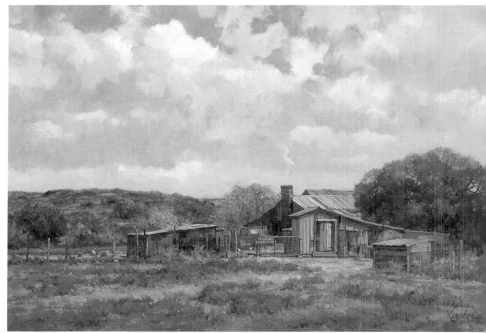

HOME FOR LUNCH *1984, 24" × 36" (61 × 91 cm)*

MAKING A VALUE PLAN

Plan the basic planes of light by making a preliminary value study in your sketchbook. Keep the value study simple; make small sketches like the one shown here, using a 4B pencil. Working out the composition, movement, and the correct value relationships in this way not only familiarizes you with your subject, but it later frees you to be expressive with the paint itself, allowing your personal technique to come through. In the long run, making a value sketch saves time, as it cuts out much of the trial-and-error work from the painting process.

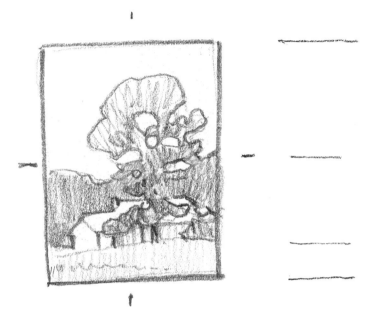

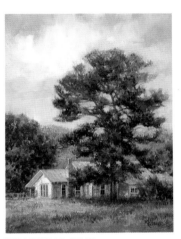

In this sketch for my painting Towering Pine, *the horizontal lines to the right indicate the division of the canvas into three unequal value bands—small, medium, and large.*

TOWERING PINE
(see also page 33)

BREAKING THE RULES

Value relationships should be checked during the painting process. This value block-in is the groundwork for a painting of a snow scene. The values in this underpainting were established with a turpentine wash. The white areas are raw white canvas—not paint. Before going beyond this point, compare the basic value planes to each other to see if they are correct.

This scene—a snow scene—does not fit the norm I've been describing. Special care must be given to correctly relating the value planes. Since the sun is shining on the snow, the snow's reflective quality makes it lighter than the sky. Although the house is an upright plane, it is a higher-than-normal value because of its light local color (white).

Don't get discouraged. Seeing values and putting them down on your canvas can be learned. It is not an innate gift.

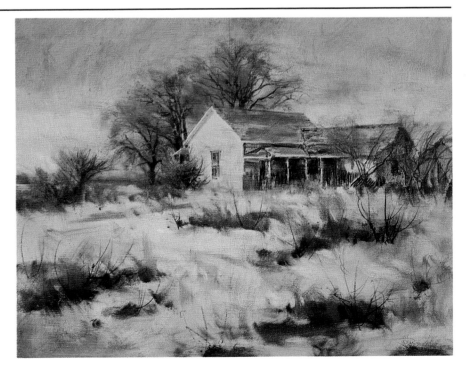

UNDERPAINTING

LOOKING FOR GEOMETRIC FORMS

When you do develop the forms (buildings, individual trees, and the like) within the three or four value planes, "paint the head first, not the eyelash." In other words, go for the big idea—simplify the essential objects in the scene into geometric forms and paint those shapes. When something seems complicated, think "form" and then paint it with the correct values so that it resembles a sphere, cube, pyramid, or cylinder.

Just about everything, manmade or natural, can be broken down into geometric forms. Even clouds have volume, form, and weight. A mountain range is a group of pyramids. A bush can be seen as a sphere. Tree foliage is usually a group of spheres placed in perspective. A tree trunk is essentially a cylinder, while a steeple is basically a cone.

Draw the structural form first—a cube for a building, for example—before you add details like windows and doors. When you draw the form, pretend that you are carving it out of a block of clay with a knife rather than placing it on a flat surface with a pencil. If you think "sphere" rather than "round," or "cube" rather than "square," you will be better able to capture the feeling of mass. Use light and shade to create the sense of volume. Color and detail come later.

"Form over subject" is the rule of thumb. Identify the geometric structure of an object and fit the subject onto that form—the windmill onto the pyramid, for example—just as you would fit a dress onto a mannequin.

Use this illustration to review some of the points made in earlier chapters. Notice for example, that the sense of depth is created in part by overlapping objects. The lowest objects on the canvas are closest to the viewer. Remember: try not to show objects half in the sunlight and half in the shadow; here only one-fifth of the round bush is in the shade and about two-thirds of the fence is turned away from the light. Keep windows and doors in their proper place. If you make them too dark, they may appear to advance in front of the building itself.

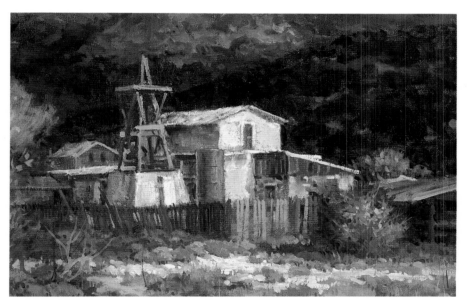

DETAIL

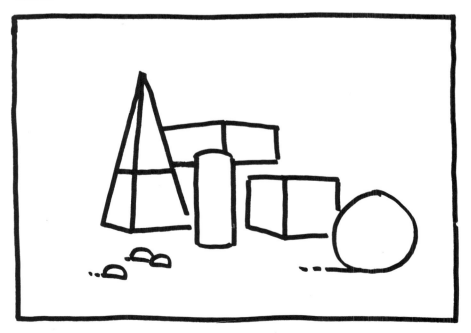

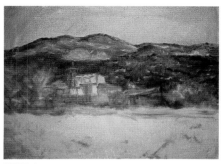

STEP 1

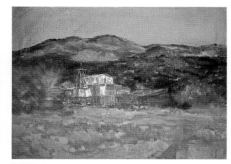

STEP 2

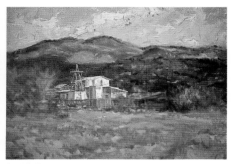

STEP 3

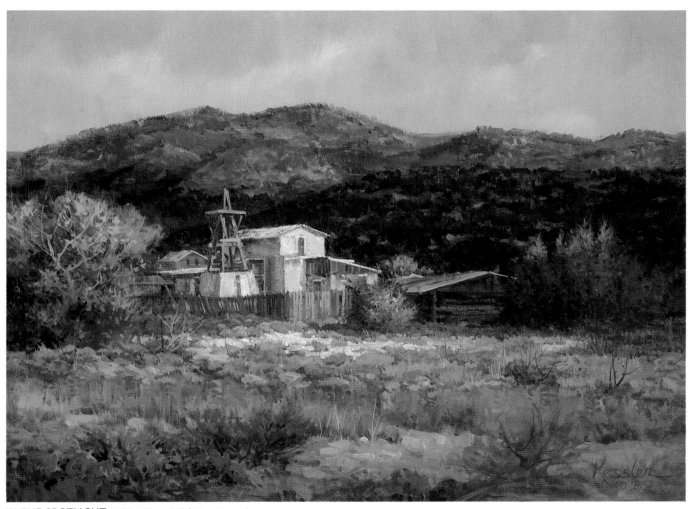

IN THE SPOTLIGHT *1985, 18" × 24" (46 × 61 cm)*

Don't be afraid to exaggerate or limit the value range in your painting to dramatize a scene. This painting has a wide value range (nearly white to nearly black). Whether you use an extremely wide value range like this or a very narrow one, you must correctly relate the values of the basic value planes (upright, horizontal) to the values on the individual forms (highlights, form shadows). One other point: the sunny side of a white building is usually lighter in value than the sky, but the side away from the light is generally darker than the sky.

DESCRIBING FORM

How do you set about describing form? The way to convey the mass of the geometric form is to relate values. Skillfully modeling the essential nature of an object, such as a cubelike rock, through steps of light and dark values creates a sense of reality of the mass. Light and shade indicate form; color, texture, and detail cinch it.

Usually it helps to think of form and color as two separate elements. Neutral gray and brown tones construct the form; colors entertain. The old masters often modeled the form in neutral hues and then added transparent glazes of colors such as alizarin crimson or ultramarine blue. You might experiment with this yourself.

SPHERES

Bushes and tree foliage are spheres. Light gives definition to these spherical forms. There are highlights and shadows on the form, as well as cast shadows on the ground. By relating one shadow value to another, you can correctly model the form. Then, using the modeled form as a guide, just add color and detail to create realistic-looking foliage.

Incidentally, all things being equal, a shadow cast from a tree is not as dark and well defined as a shadow cast from a bush, which is closer to the ground. Also, be careful with the highlights; landscape students frequently make highlights too light and too brilliant in color.

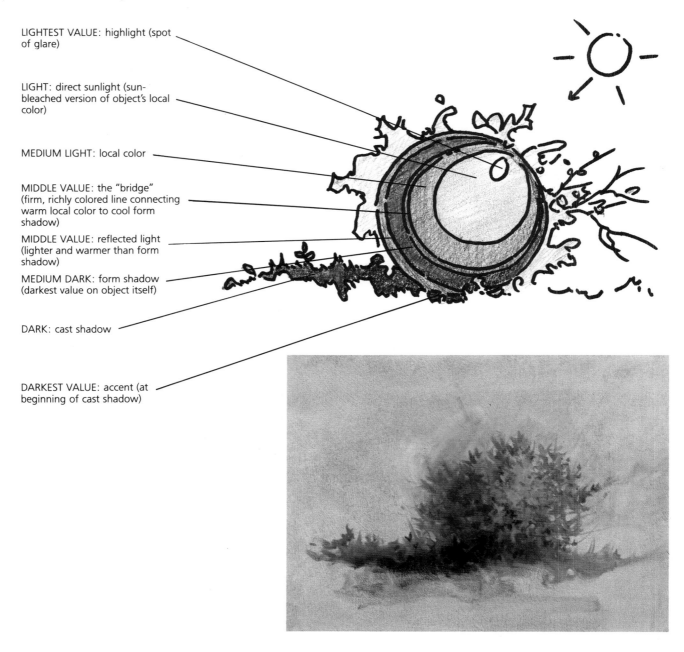

LIGHTEST VALUE: highlight (spot of glare)

LIGHT: direct sunlight (sun-bleached version of object's local color)

MEDIUM LIGHT: local color

MIDDLE VALUE: the "bridge" (firm, richly colored line connecting warm local color to cool form shadow)

MIDDLE VALUE: reflected light (lighter and warmer than form shadow)

MEDIUM DARK: form shadow (darkest value on object itself)

DARK: cast shadow

DARKEST VALUE: accent (at beginning of cast shadow)

CUBE

To give you an idea of the values on a cube, I've chosen to illustrate a white house on white sand on a clear, sunny day. Keep in mind that the local color of an object will influence the value and the color temperature. Atmospheric conditions and reflective properties of surfaces must be taken into consideration too. Remember: don't use photographs to judge value relationships. Analyze the subtle relationships on location and paint or sketch what you see.

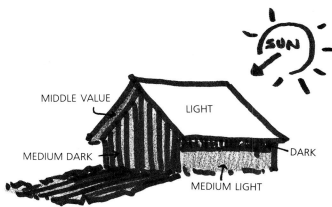

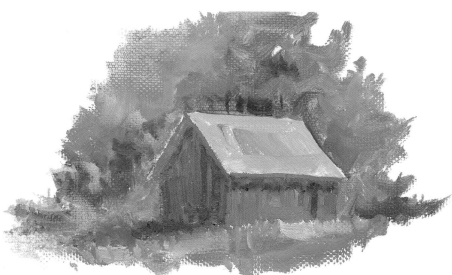

Pay particular attention to the cast shadow in this oil sketch. A shadow cast on the ground stabilizes the height of the object above it and adds a restful horizontal line to your composition. Within this cast shadow, the darkest value is at the sharp-edged beginning point. As the shadow fans out from the point where the object touches the ground, it grows lighter and cooler, and the edges become softer.

Remember: a cast shadow indicates the location and the intensity of the sun—important elements in your painting. Unless you want to indicate harsh lighting conditions, keep the shadow edges soft. Cast shadows also define the contour and texture of the surface upon which they fall. Keep shadows transparent and colorful—a dark doesn't have to be dull.

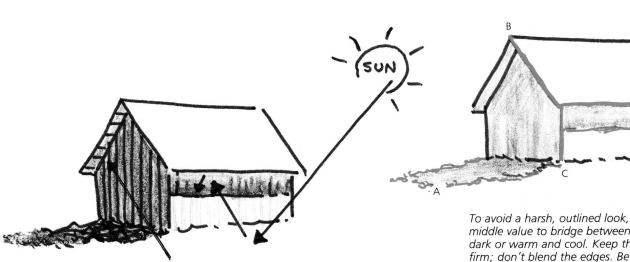

A cast shadow on the sunny side of a building is lighter and warmer near the roof than at the lower edge of the shadow, because the warm sunlight on the earth bounces up onto the roof overhang and then reflects down into the cast shadow. (Visualize a bouncing rubber ball, picking up and spreading color.) Naturally the roof overhang itself is

similarly affected by reflecting colors—light and warm.

Don't forget to bounce colors from nearby objects into both cast and form shadows, reflecting the colors your composition needs. And keep in mind that, because of reflected light from the cold blue sky, a cast shadow is cooler than the upright plane casting it.

To avoid a harsh, outlined look, use a middle value to bridge between light and dark or warm and cool. Keep this line firm; don't blend the edges. Be subtle; it should be nearly invisible.

For cast shadows, subtly place this narrow line of intense color along the outer edge of the shadow (A). On a building, place this halftone line along the edges of the roof wherever the sunny roof touches the cool shadows on the building (B). Another bridge is located at the corner where the building turns away from the light source (C).

CYLINDERS

Tree trunks, limbs, branches, and twigs are cylinders—not flat lines. Convey the roundness of these cylindrical forms just as you convey the roundness of a bush—with value changes on the form itself. Cast shadows properly drawn on the limbs and trunk will also help define the cylindrical shape.

As tree branches stretch upward, they seem to flex their muscles at the joints, causing a swelling of the joint. If space is available, branches twist and turn, reaching toward the sunlight as they taper to a tiny tip. Closely placed trees, on the other hand, grow tall and slender as they compete for the light.

Whatever you do, don't defy the law of gravity and create a branch that is held up by a tiny twig. Keep in mind that as a dark branch tapers to a twig, it grows lighter in value—"the wider the line, the darker the value." Also, a lacy tree is lighter in value than a fully formed tree as more light penetrates it.

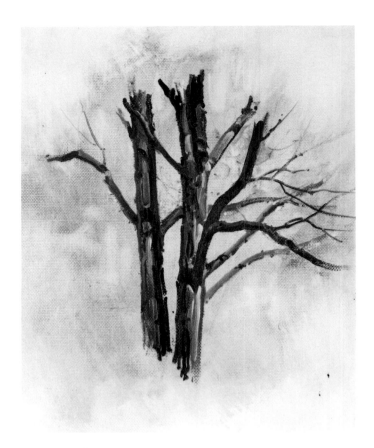

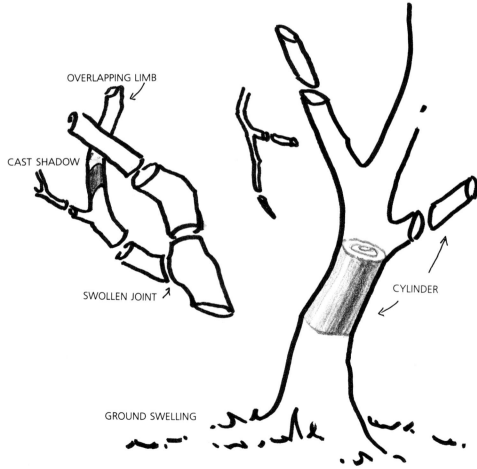

OVERLAPPING LIMB

CAST SHADOW

SWOLLEN JOINT

CYLINDER

GROUND SWELLING

CONES

Just as dark tree limbs grow lighter as they diminish in size, so it is with anything that tapers—steeples, windmill towers, lighthouses, mountains. Conversely, objects that are light in value gradually become darker as they taper. Of course you must also establish a cone's roundness with values.

A NOTE ON VALUE RELATIONSHIPS

In representational art, perspective, color, and the overall value range (high-key or low-key) can be distorted to create a dramatic or a romantic mood, but all values must be related to each other correctly. While taking value recession (depth) into consideration, you must also relate the values of upright, horizontal, and slanting planes. Then, too, you must indicate correctly the values on individual forms. You can, for example, paint an elongated tree in many shades of purple and make it believable. You cannot, however, tamper with the relationship of the lights and darks to each other, or that purple tree will lose its sense of volume and become a decorative, flat design on a two-dimensional surface.

The best way to check your skill at handling values is to make black-and-white photographs of your paintings. You can try photocopying a color photograph; but when the value range of your painting is extremely tight, even the best copy machine may not provide a helpful black-and-white reproduction. Also, you can view your work through a transparent red plastic filter. You can find these filters among school supplies as they are used for notebook dividers.

11
UNDERLYING ABSTRACT PATTERN

Is the basic light-dark design an interesting abstract pattern?

Good representational art has a strong underlying abstract pattern of light and dark. This two-dimensional design forms the foundation that holds the objects in your picture together. Eliminating color and even the identity of the objects themselves, organize a decorative arrangement of the essential shapes before you begin to paint. The success of your finished painting lies in how well you compose these simplified masses. Beautiful colors and elaborate details will not compensate for a poor design, so be sure to take time at the start and plan ahead.

What constitutes a good abstract design? A sense of order—the feeling of a unit with variety, rhythm, and balance. To create this sense of order, simplify and link the dark (or light) shapes together into an aesthetically pleasing arrangement. Be sure to emphasize one or the other overall—either the darks or the lights—as objects of equal interest create tension and confusion. To further unify the design, avoid isolated spots, which compete for attention and clutter the design, causing it to look disjointed and chaotic.

Take care not to repeat shapes over and over monotonously. Once again, practice repetition with variety, playing big against small, angular against organic, and active against stationary. In conjunction with skillful placement, this is the key to an arresting design. Employ unequal spacing, but rhythmically relate the various shapes to each other. with an eye to both the positive shapes (the objects themselves) and the negative shapes (the spaces between and around the objects). Where the design leaves the canvas is important too. Vary the location and the strength of attachment at the edges.

As you develop rhythmic patterns, distribute the weight of the shapes to maintain a comfortable sense of balance. Be forewarned: perfect balance is formal and boring. Look to nature itself for ideas. Steer clear of perfect circles, squares, or triangles. Large, bold shapes seem to work better than busy, little shapes.

The goal in all this is to develop the basic shapes into a complex, sophisticated composition that is a treat for the eyes. You don't want a shallow statement—one quick look and you've seen it all. As you create a variety of shapes within the simple abstract pattern, use your plan as the starting point, not the endpoint. Don't be too obvious or mechanically perfect.

CREATING A SENSE OF ORDER

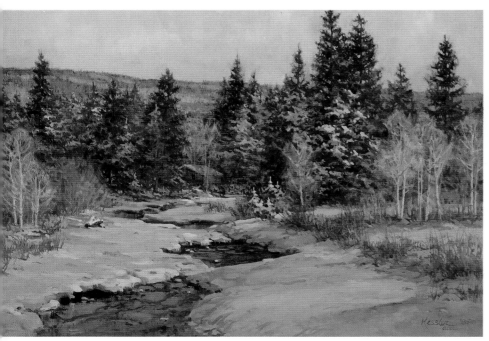

CABIN CREEK *1985, 24" × 36" (61 × 91 cm)*

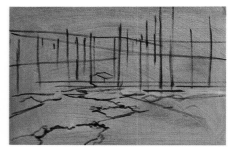

To set the mood, I toned the canvas with a golden brown, made of Acra red, cadmium yellow medium, and a speck of phthalo blue. I placed the horizon line first, then linked the foreground water to the background mountains and located the center of interest—the cabin. Next I created the vertical movement of the pine trees, rhythmically varying the spaces between the lines, as well as the portion of the tree that is visible before it is lost into another bank of trees.

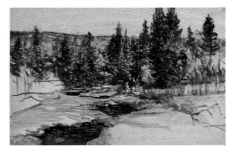

Here, avoiding details, I developed the bold value pattern, duplicating the one I had worked out on a smaller scale in my sketchbook. I linked the darks (mixtures of ultramarine, Acra red, cadmium yellow medium, plus yellow ochre for variety) with a soft cheesecloth rag.

At this point I stopped and critiqued my picture. I noticed that at the top edge the two big pine trees regrettably exited with equal strength—identical twins rather than brother and sister. I also discovered that the closest section of flowing water narrowed as it reached the bottom edge. By opening the width of this shape, I enhanced the sense of depth and invited the viewer into the painting more readily.

The underlying structure of Cabin Creek conveys a sense of order. The darks are linked together in an interesting, balanced abstract pattern. The eye is entertained with a variety of rhythmically placed shapes. Like the dark water patterns, the pine trees, aspen, and bushes come in all shapes and sizes. The cabin on the creek—the only sign of mankind—adds to the presentation.

A major contributor to the feeling of unity in this scene is the overall tonality. Daylight is nearly gone and, with it, the yellow element of the color spectrum. The red hues in the spots that still catch the sunlight (the pines left of center) and the purples and blues in the shadows indicate a setting sun. The green local color of the pine trees is lost, giving way to the shadows of the night. The overall low-key value range maintains the theme of approaching darkness.

In a snow scene, the sky is generally darker than the snow because of its reflective qualities; in this particular snow scene, however, I made the snow darker than the sky. The sun was so close to the horizon that, while it was leaving the valley floor, it was still throwing a lot of light into the sky.

It was extremely tempting to add some dramatic highlights as a finishing touch, but, rather than adding interest, they would have created confusion about the time of day. So I quickly signed my name and cleaned my brushes.

MAKING A DESIGN WORK

Fusing the cone-shaped pine trees in Cabin Creek *together into one simple, but attractive, shape begins to create the abstract design. Similarly, linking together the three areas of open water and attaching this shape to the larger one add variety to the design and unite the otherwise isolated objects. Flattening and reducing the size of the water shapes as they recede suggest depth. Balance and stability are conveyed by firmly attaching the design to the canvas edges. Although the natural objects—the trees and water—are abstract and unrecognizable, they are artistic and decorative and provide a sound foundation for the painting.*

Five cones of varying size, shape, and height, joined together and attached to the canvas edges, would create a stronger design.

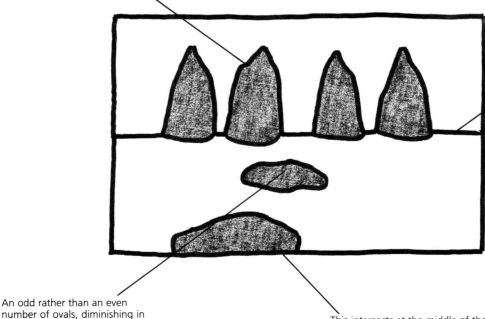

It is boring when the horizon line divides the canvas into equal parts.

An odd rather than an even number of ovals, diminishing in size, would be more exciting and suggest greater depth.

This intersects at the middle of the bottom edge, dividing the canvas in half.

If you take the abstract design for Cabin Creek and think of it in terms of a spider's web, it looks something like this. It is possible to suggest a feeling of security by attaching the web to just three sides, but in this painting I anchored it firmly to all four sides of the canvas. I used different degrees of strength to support the weight of the web and dramatize the pull of the composition. I also attached it at different intervals to create more interest through variety. Notice that the hub of the web, which indicates the location of the cabin, is placed off-center.

A neat and tidy spider built this last web. It is barely attached to the supports and only at even intervals. The hub is dead-center. It certainly would make a boring painting.

THINGS TO CONSIDER

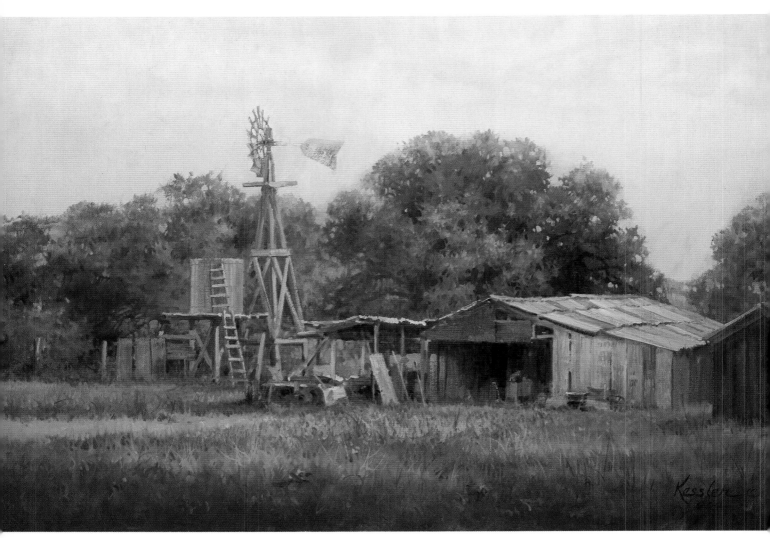

RURAL GRANDEUR *1984, 20″ × 30″ (51 × 76 cm)*

Variety adds spice to life. This typical barnyard scene provides all the ingredients you could possibly want to concoct a feast for the eyes. The water tank, windmill, shed, and other small objects relate to and yet differ from the barn itself. The flowing forms of organic growth—the trees—then accentuate the cylinder, cube, and pyramid forms seen in the manmade structures. Notice, by the way, how I've distorted these structures just enough to add character. Tension between the cool, neutral grays and greens and the dash of bright red adds flavor to the scene.

The abstract pattern can be a play of light against dark or dark against light. Observe how the darks in Rural Grandeur form interesting value patterns. The lights are also linked together and weave their way through the design, without leaving any isolated spots. The light windmill, a vertical shape, breaks through the dark, horizontal band of trees to create the focal point.

In Rural Grandeur *notice the wide variety of interlocking pieces created by the basic value masses. Each is unique in size and shape. Interlocking interesting shapes in a jigsaw-puzzle fashion helps unify your composition. Study some of your recent paintings to see if they have irregular, interlocking value masses.*

BALANCE

An important aspect of design is balance. The placement of objects—as indicated in the illustrations here—is an obvious element to consider, but it is not the only one. Any element that is different from the rest of the painting carries weight; for instance, a spot of texture on an otherwise smooth surface. Also, warm colors and intense colors carry more weight than their counterparts; so you can change the distribution of weight, and therefore the balance, by changing the color—warming or cooling, brightening or dulling it.

Variety within a group of objects influences balance, too. A zebra leading a herd of antelope pulls the eye to one side. Sometimes you can correct a balance problem by deleting an object—eliminate the zebra.

Placing the objects of interest too close to one side of the canvas creates an unstable atmosphere. The sense of order is gone—and so is your audience. If you want to have your principal objects this far to one side, they must be counterbalanced by a smaller object on the opposite side.

This house is centered on the canvas and flanked by twin trees, competing for attention. The horizon line divides the picture in half, making everything equal. The distant hill crosses the picture at the same level as the top edge of the roof, and it monotonously repeats the straight-line movement of the background trees and the road. This perfectly balanced composition is static and dull.

The objects in this illustration relate to each other in an informal, but harmonious, manner. The road, leisurely moving back to the slightly off-center house, divides the yard into two interesting shapes. The two trees flanking the house are portrayed in different sizes and shapes. Notice how the hills help to stabilize the position of the house by adding weight on the left. The suggestion of the distant hill, with the contrasting large and small shapes, dramatizes the sense of depth in the picture. Overall, the diversity adds up to a unified whole while bringing vitality to the scene.

CHECKING THE DESIGN

After you have transferred your value study to the canvas from your sketchbook, stop and check it thoroughly for artistic appeal. Hold the unfinished painting up to a large, well-lit mirror and look at the reversed image. As I've illustrated here with *Cabin Creek*, you will see your abstract design from a fresh, new vantage point. It is then easy to spot any problems—or you may locate "happy accidents" that you want to preserve.

Also check to be sure that you have maintained the value scheme you want. By standing back some distance from the mirror, and thereby reducing the size of the image, you can clearly see if you have blocked in the correct values.

There are many other ways to check your painting. Remember: you can simplify your picture by viewing it through a red filter, or you can squint, reducing the number of values you see. Peripheral vision is effective, too. Also view your canvas from thirty or forty feet away. If the light-dark design still reads and is attractive, you have a winner. Don't forget to look at it upside down and sideways—straight on *and* in a mirror. You can even stand beside the painting and view it from an angle.

Locating the center of the canvas will help clarify organizational problems. Also try looking at your picture under a variety of lighting conditions. Study it under natural daylight—both full light (stand with your back to the north wind) and dim light (near dusk). Compare this to bright and dim incandescent lighting, as well as fluorescent lighting. The difference is shocking! A rheostat on your incandescent light is handy.

How you choose to study your value block-in is not important, but do stop and study it. Look for linked or interlocking value masses that form an interesting abstract design—a unit organized with rhythm, variety, and balance.

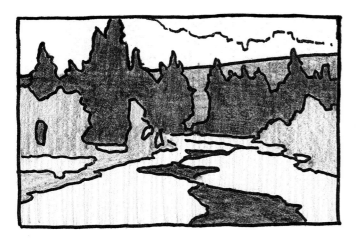

NEGATIVE SHAPES

Are the negative shapes in the painting varied?

I cannot talk about abstract design without devoting some time to negative spaces and shapes. As I mentioned in the last chapter, the positive shape is the shape of the dominant object itself— for example, a dead tree. The negatives are the spaces between and around the object. For the dead tree, this would include the holes between the limbs where the sky peeks through ("sky holes") and also the spaces between the tree and the four edges of the canvas. The shapes of these negative spaces must be varied and interesting, so it is important to watch what you are *not* painting.

If you are not in the habit of "thinking negative," develop this skill by doing contour drawings using only negative shapes. Starting with the major interior shape and building around it, draw each negative space as a complete shape, sometimes using the edge of the picture to complete the shape. You will see the object itself magically appear.

Take a different approach. Draw the negative spaces rather than the object itself.

If the negative space of the sky is an interesting abstract shape, chances are your subject is equally interesting. Visually remove and examine this shape, checking for artistic appeal. Indirectly this exercise reveals pictorial balance.

Note, by the way, that in the illustration here the two negative shapes around the window are varied in size and shape—large versus small, angular versus oval.

We've already looked at this illustration in terms of its boringly perfect balance. Now focus on the sky area. If the negative shape of the sky is boring, your subject probably lacks emotional excitement too.

Interior negative shapes, such as sky holes in trees and dark recesses in foliage, although small in size, are not unimportant. They allow air into the form, bringing it to life. Without air holes, the mass will appear solid and impenetrable. As they say when that happens, "You might as well paint a dead bird at the base of your bush, as that's what you'll have if one tries to fly through."

NEGATIVE SHAPES:
Sky holes Spaces around foliage

POSITIVE SPACES:

Foliage

Path

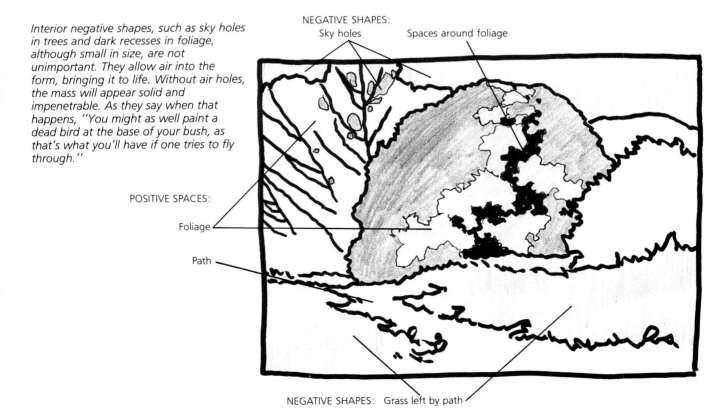

NEGATIVE SHAPES: Grass left by path

RELATIONSHIPS AND PATTERNS

Rhythmic patterns in negative spacing convey harmony and cohesion in a picture. Once again, "Repetition with Variety" is the name of the tune.

In this illustration, observe the negative shapes left by the trees and fence posts. Visually remove these shapes. Then, based on their size, transform these pauses into musical notes—whole notes, half-notes, quarter-notes. When developing rhythm, make it flow without striking a discordant note.

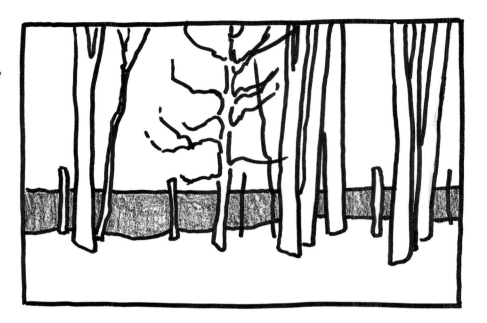

NEGATIVE SPACES
(shapes left by tree trunks and posts)

"REPETITION WITH VARIETY"

126

Avoid dull spacing and a soldiers-on-parade regularity. Vary the spacing between objects. And don't forget to consider the spacing between the objects and the edge of the canvas.

Equally spaced trees.

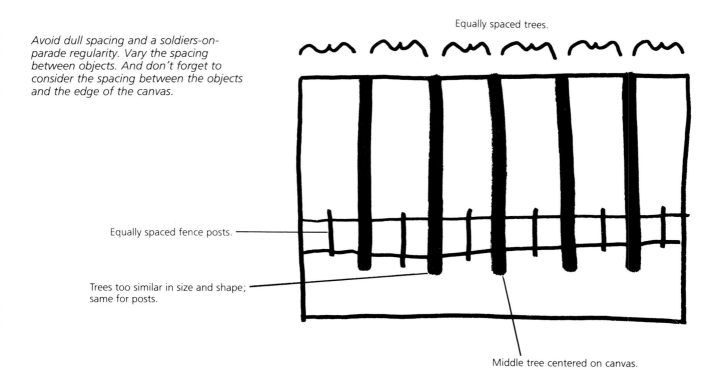

Equally spaced fence posts. ——

Trees too similar in size and shape; same for posts.

Middle tree centered on canvas.

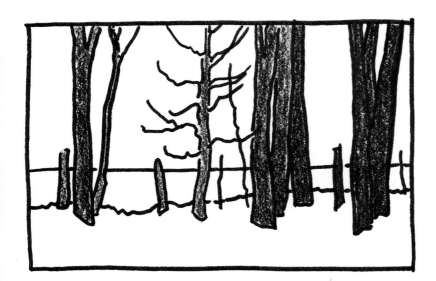

When working with negative spacing, you cannot completely ignore the positive shapes. That is, since both positive and negative shapes are interdependent, how the objects themselves relate to each other is important too. One way to add character to your painting is to think of the objects as characters—as illustrated here.

FATHER AND DAUGHTER

A YOUNG MAN

FOUR GENERATIONS

FATHER, MOTHER, AND AUNT TILLIE

PAINTING SKY HOLES

Learn how to paint sky holes by doing quick, on-location sketches like *The Pecan Tree*. Bare or dead trees, with their skeletal forms, are ideal for study. You will soon be able to identify different kinds of trees by their silhouettes. This skill will expand your ability to entertain with variety.

To depict a dormant tree, you may be tempted to paint the sky, let it dry, and then paint the tree on top. The results, however, are generally disappointing, as the tree appears to be detached from its surroundings. There seems to be no illusion of atmosphere.

To knit your tree into the atmosphere, try this technique. First, block in the masses of limbs and twigs with thin paint on a textured surface. Lift off selected areas, indirectly suggesting where you are going to place primary tree trunks and major limbs. Then paint sky holes back into these masses, as I did in this study. When you do this with a rhythmic sense of design, your skeletal trees will have character. As you paint the sky holes and concentrate on negative spaces, keep in mind that indirectly you are defining tree limbs. Be sure to taper the limbs as they branch out, and take care not to break them into two pieces with the sky holes.

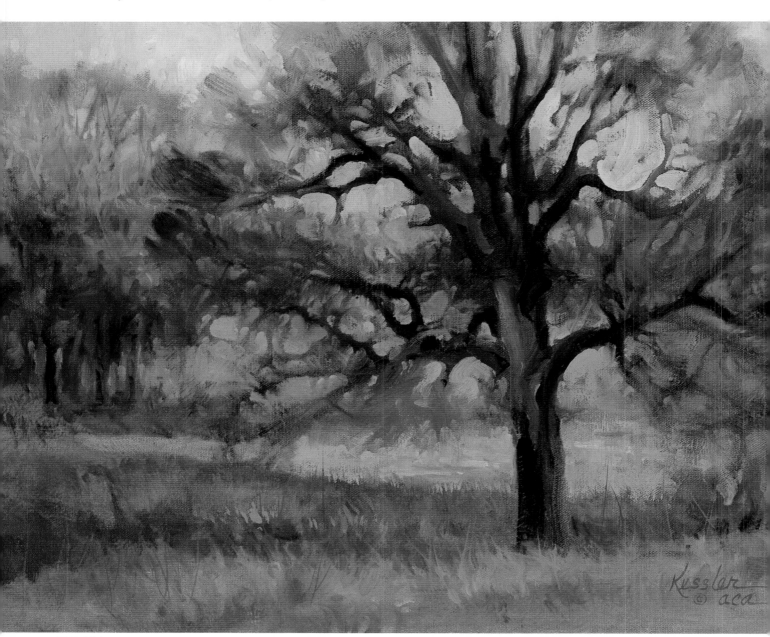

THE PECAN TREE *1984, 14" × 18" (36 × 46 cm), collection of J. Young*

After establishing the value block-in, I placed the major sky holes, using thick paint and a large filbert bristle brush. (The rounded edges on filbert brushes adapt naturally to sky holes.) When placing these large negative spaces, I find it helps to think in terms of three or five. I then develop the detail of tangled limbs and twigs by working from the largest negative spaces to the smallest ones, reducing the size of my brush as I work.

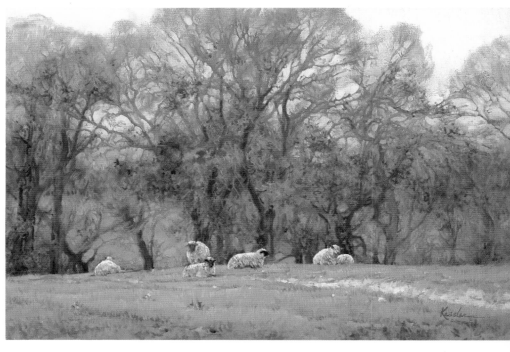

GREEN PASTURES
1984, 18" × 27" (46 × 69 cm),
collection of K. Simmons

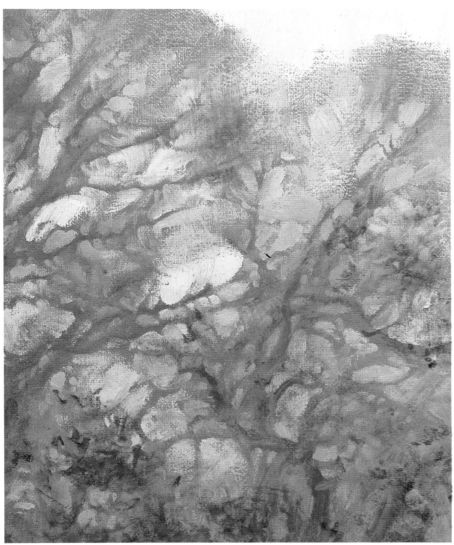

Because of atmosphere and tree density, sky holes generally become slightly darker, duller, and cooler than the sky itself. The smaller the hole, the more apparent this is. If they are too light, bright, or warm, they tend to leap out at the viewer—a common error. Avoid flat silhouetting by indicating similarly darker, cooler, recessing shapes in the tree form—ones that do not go through to the sky. Don't forget to suggest the skeletal form of the tree in some of these openings. Again, don't misalign limbs.

Keep the negative spaces interesting by varying their size and shape. Clearly define the edges of some of the shapes and lose some edges by dragging thick paint over the thin underpainting. By using a feather touch—pressing the brush lightly against the surface and then quickly pulling away—you can take advantage of the texture on the canvas. Paint back and forth—sky holes, limbs, sky holes, twigs—knitting sky and tree together. Notice that sky holes in the dense area of the tree are reduced to mere dots. Be patient. Don't develop details too soon. And remember—think negative.

DOS AND DON'TS

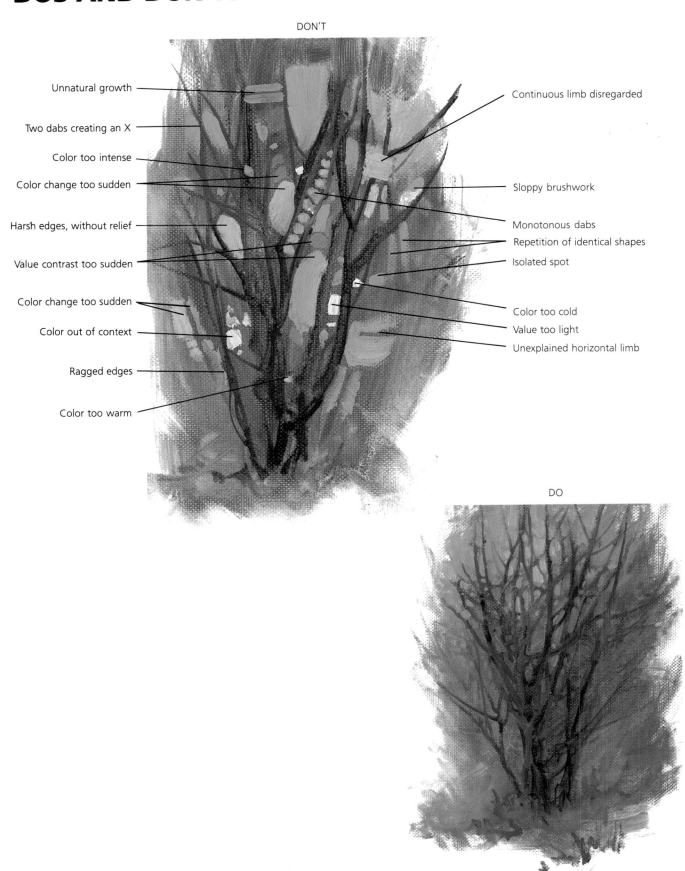

DON'T

Unnatural growth

Two dabs creating an X

Color too intense

Color change too sudden

Harsh edges, without relief

Value contrast too sudden

Color change too sudden

Color out of context

Ragged edges

Color too warm

Continuous limb disregarded

Sloppy brushwork

Monotonous dabs

Repetition of identical shapes

Isolated spot

Color too cold

Value too light

Unexplained horizontal limb

DO

OTHER APPLICATIONS

The principle of painting negative spaces should be applied to other areas besides trees. Try using it when you are working on foregrounds. Paint weeds with "grass holes" and grass with "dirt holes." Another tip: on partly sunny days design with sky-blue holes between cloud formations, creating a floating sensation through the size and shape of the sky holes themselves. (Elongated shapes, for example, would convey windy conditions.) Try to link or interlock these negative shapes, avoiding isolated spots as much as you can.

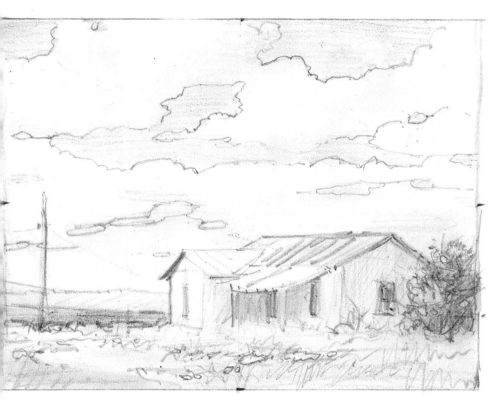

In this rough sketch it's the shape of the sky between the clouds that defines the cloud forms.

SELF-CRITIQUE

Is the sky an interesting abstract shape? Also check the shapes left by dissecting rivers, roads, and footpaths. Are the spaces between objects rhythmically varied? What about the spaces between objects and the edge of the canvas?

Did you pay careful attention to sky holes in trees and recesses in the foliage? Do some of your sky holes pop forward because they are too light, bright, or warm? Did you design grass patterns, picket fences, and cloud formations by thinking negative? Check the shapes around windows and other openings. Are all your negative spaces varied in size and shape? Color and value? Lost and found edges?

13
COLOR HARMONY

Is your painting predominantly warm or cool?

Now that we've examined the many diverse aspects of composition, let's turn our attention to color. Are you aware that, when you enter an art gallery displaying similarly sized canvases, color is typically the factor that first draws your attention to a specific painting? Only after absorbing the emotional impact of the color do you view other elements—design, subject matter, linear movement, focal point, brushwork.

The problem is we have preconceived ideas about color. We think the sky is blue, clouds are white, grass is green, and mountains are purple. When a task is too complex for us, we tend to paint it according to our preconceived ideas—only to discover that our painting looks starkly primitive and lacks unity, atmosphere, and emotion. There is no magic because the picture lacks a feeling of light, illuminating, reflecting, and bouncing colors around within the scene and creating color harmony.

You must forget these preconceived concepts and learn to observe subtle color relationships. Train your eye. Instead of seeing "things" like green bushes, analyze relationships—the green vine is orange-green when compared to the blue-green shrub and the yellow-green bush. Or compare color temperatures—the vine is warmer than the shrub and cooler than the bush. Then, keeping in mind the discussion of overall tonality in Chapter 9, unify your color scheme by modifying these local colors with the color of the light. Remember: local colors are influenced by the color of the primary light source (time of day and weather conditions), the environment (air pollution), and reflected lights (from nearby surfaces and the sky itself).

The key to establishing color harmony lies in maintaining a predominantly warm or predominantly cool picture. Once again: no half and half; using two color schemes in one picture produces total chaos.

I've already mentioned one technique you can use to maintain temperature dominance: toning your canvas with one overall color and allowing it to show through your finished painting. Almost any set of colors can be pulled together in this way. Another technique is to use a "base" color. Let this color—a warm or cold dark such as brown or purple—come into play from the very beginning stages, when you draw the scene on the canvas. Then allow traces of this color to appear here and there throughout your finished picture, thus harmoniously uniting the color scheme. Repeating traces of the sky color through your painting helps, too.

These techniques can, of course, be combined. You can also establish a dominant color temperature by deliberately exaggerating one color—preferably the color of the light—to create a "golden" picture or a "blue" picture.

THE LANGUAGE OF COLOR

Colors talk. To me, green speaks of fertility; white is cold and harsh; purple is royal; pink is delicate. Yellow symbolizes caution. I think of some colors as smelling good—pink, lilac, violet, and cool greens, for example. Some—yellow-green, yellow-orange-red, and caramel—seem to taste good, while others—gray and black—taste bad. Colors evoke emotions; they can calm or energize the soul. Blue and blue-gray, for example, are cool and restful. Red and red-orange, on the other hand, are loud, hot, violent.

Colors can be used to our benefit. Hospitals use blue-green, the complement of blood-red, in surgery, as it is easier on the doctor's eyes than cold, harsh white. Alexander Calder appropriately chose childlike, primary colors (red, yellow, and blue) for his playful mobiles.

Most artists prefer warm colors, as they are strong and dramatic. There is a caution, however: although bright colors grab your attention and stimulate you, they become tiresome in the long run. People generally prefer to live with quiet, muted colors.

To convey unity, colors must harmonize with the mood of the scene. In this painting, springtime, redbuds, and cedar trees suggest colors that smell good—pink and lilac. Be careful, however: don't be nauseatingly sweet, like cheap perfume. It is the color in this painting, along with the playful brushwork, that expresses the feeling; minute details are not necessary.

ON VIEW THIS MONTH *1985, 12" × 16" (30 × 41 cm)*

To convey a restful mood, I avoided intense colors and used a horizontal canvas. The quiet, understated colors also add a touch of class to the scene. The warmth of the golden sunlight, the natural greens, and the fresh water suggest fertility. Notice how the cool tones of the sky are reflected into the stream and onto the trees, uniting the subjects in this predominantly warm picture.

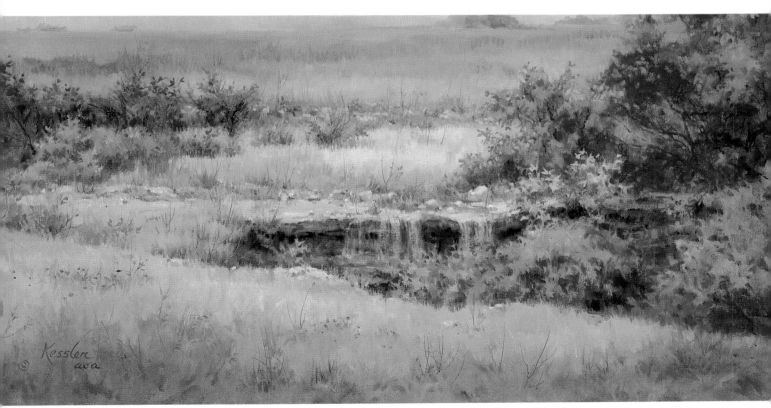

PRAIRIE CREEK *1982, 15" × 30" (38 × 76 cm), collection of A. Steede*

SOME TRADITIONAL COLOR SCHEMES

The first step is to choose the overall color temperature—predominantly warm or cool. After you have selected a subject, visualize it in warm tones and then in cool tones. Since there are no right or wrong color schemes, trust your instincts. Make a decision based on the colors you see and the lighting effects of the moment.

Within the framework of your chosen temperature theme, explore one of the many conventional color schemes that have been passed on from generation to generation. Try a limited palette or use related colors, working with analogous, complementary, or triad color combinations, to name a few. Don't randomly choose colors when you're in the heat of battle.

To develop the color harmony in your painting, use thick paint and large brushes, blocking in large masses of color. Rhythmically orchestrate masses; don't dab spots. Adjust the masses as you work until you have an orderly arrangement of attractive colors. Using your underpainting as a value guide, concentrate on color temperature and intensity. Place your most intense colors at the center of interest. Balance your colors; even a predominantly warm painting needs a few cool accents, just as bright colors need a few neutrals for contrast. Avoid details until you have a compatible variety of colors on your canvas.

LIMITED PALETTE

Restricting yourself to a limited number of colors simplifies the painting process. Color is downplayed, while design, subject matter, and execution are emphasized to communicate the mood of the scene. If you choose to use two tube colors, select one warm and one cool, so you can push and pull with color temperature to establish depth. For a three-color painting, select some form of red, yellow, and blue. Alley Cat was painted with Acra red, cadmium yellow medium, and ultramarine blue, as well as yellow ochre. To establish the effect of the light and thereby unify the colors in the painting, I toned the canvas with yellow ochre and let this color show through the finished work. I chose a dark, cool theme to emphasize the spot of warm light enjoyed by the cat—the center of interest.

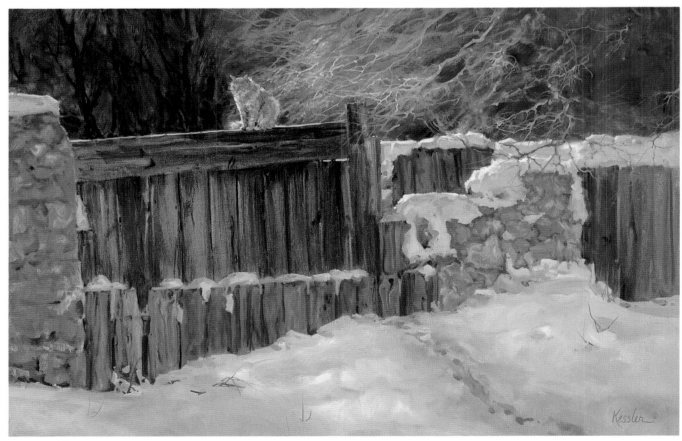

ALLEY CAT *1986, 24" × 36" (61 × 91 cm), collection of J. Webb*

ANALOGOUS COLORS

Conveying an emotion while working within the context of a dominant color temperature is relatively easy when you use analogous colors (next to each other on the color wheel). With Desert Canyon, for example, I chose a purple theme and then subtly stretched this color in both directions, toward red-purple and blue-purple. The golden green accents complement the warm purples, adding vitality to the scene.

Overall, the magical quality of the evening light is captured through a warm undertone (yellow ochre, cooled with cadmium red deep), a purple base color, low-key values, closely related (analogous) colors, and muted tones. I deliberately avoided any spots of bright, intense color, which would have jumped out of context. Notice, too, how peacefulness is conveyed through the horizontal canvas, nonconfronting focal point, and leisurely linear movement.

DESERT CANYON 1985, 18" × 36" (46 × 91 cm), collection of City National Bank

COMPLEMENTARY COLORS

In this painting I used complementary colors—red and green—to create visual excitement through contrast. When using complements like this, it is especially important to create a dominant warm or cool color theme.

Keep in mind that large masses of complementary colors, as seen here, are visually assertive; whereas small dots of complementary colors will mix together when viewed from a distance (see the work of Georges Seurat and other Pointillists). If you make these small dots the same value and distribute them equally, they will neutralize each other—appearing gray or brown.

Also take into consideration that a color is influenced by the colors around it and appears different when placed in a different setting. A spot of dull red, for example, appears warmer and brighter when surrounded by green than when placed beside a close relative such as purple. A cool gray looks blue when placed in an orange setting. Work with this principle to control your colors.

You can use the complement to reduce the brilliance of any color. But rather than mix pure red with true green to neutralize it, try using a neighboring color such as orange-red, thereby keeping the new color exciting, not static and dull.

In The Little Red Shed, I did not paint a red building and green trees with blue sky and water—preconceived ideas. Instead, I painted the effect of the hot, late-afternoon sun on the scene, warming the greens with reds and thus relating them to the red shed. I also bounced some greens onto the red shed, especially on

THE LITTLE RED SHED 1983, 18" × 24" (46 × 61 cm), collection of Texas Green Inc.

the shaded side, and then reflected these colors into the water. By repeatedly bouncing the complementary colors through the painting and adjusting the local colors, I related the objects to their surroundings and unified the overall color scheme.

TRIAD COMBINATIONS

Increase the range of your color presentation by working with triad colors—three points, regularly spaced around the color wheel. Within a triad color scheme, you can handle the full rainbow of colors and still create a sense of order in your picture—just maintain that predominantly warm (or cool) theme. Remember: warm or cool, blue, gray, green, or gold, the sky is very important in establishing color harmony in your picture; so reflect its color repeatedly throughout your painting.

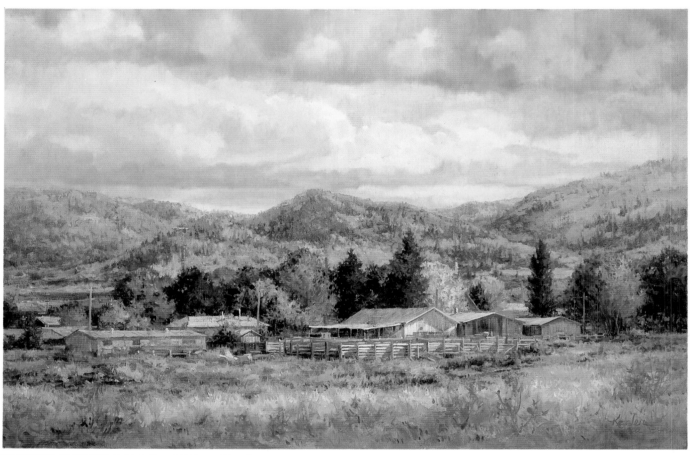

FOOTHILL CLUSTER *1984, 24" × 36" (61 × 91 cm)*

A triad combination of orange, green, and violet is ready-made for landscapes—especially an autumn scene like Foothill Cluster. There are many other triad color schemes. Study a color wheel and experiment with all the combinations. See which ones will adapt readily to your chosen mood. Also explore subtle triad combinations, as I did in Misty Morning (page 102), using cadmium red medium, lemon yellow hansa, and phthalo blue.

Painting a small preliminary sketch like this gives you the opportunity to develop a workable color scheme without investing a great deal of time. Here the sketch also helped me solve the dilemma of what to emphasize—village, mountains, or sky. Depicting all three clearly would overwhelm the viewer.

FOOTHILL CLUSTER—A SKETCH *1984, 5" × 7" (13 × 18 cm)*

A NOTE ON MIXING PAINT

I mix all my colors from the primaries (plus white) to keep them rich and vibrant. My palette includes a warm and cool of each primary: lemon yellow and cadmium yellow medium and deep, cadmium red deep and Acra red, phthalo blue and ultramarine blue. I must admit, though: I'm not a purist, as I do use yellow ochre from the tube. I am careful, however, to modify it with other colors and tints, as it is easy to overuse this color—especially in landscape painting.

When mixing colors on your palette, keep them pure by using a knife rather than a brush. To mix two colors, start with the lighter color and gradually add the other one to it. Specifically, don't cut off a chunk of phthalo blue and add white to dilute it. Instead, begin with white (or another light color) and add the dark phthalo blue. Don't be afraid of colors with strong tinting qualities such as phthalo blue. Just add them to the lighter color a "fly speck" at a time.

White is cold, and when you mix it with a color like red, you are inadvertently lowering that color's intensity; that is, the red becomes a rather dull, chalky pink. If you want to reenergize your new color, restore warmth to it—add a tiny touch of yellow to that pink puddle of paint.

To avoid heavy, muddy colors, don't combine more than three colors, excluding white. Combining muted earthtones quickly results in a nondescript color. I prefer to use brilliant colors and modify them as I did with the warm and cold green in Chapter 8. Whatever colors you combine, don't overmix—on the palette or on the canvas. A thoroughly mixed color is dull and pasty; keep it alive, flickering with hints of broken color.

When you add a new color to your picture, be sure it is repeated in at least two other spots. As you apply colors to the canvas, start with the warm color masses and work gradually toward the cools. Before returning to the warms to modify or refine them, clean your brush. Prematurely dragging cold colors back into the warms will rob you of the chance to create color vibration later. Similarly, start with the brights and gradually mute them.

If you are not happy with a color area, don't scrape if off and start over unless the color is too cold or the pigment is too thick to handle. Instead, modify it, making it warmer or cooler, brighter or duller. (Be sure, however, the value of your color duplicates the value established in your underpainting.) These adjustments will keep your painting alive and energetic.

A final tip: when it comes to palettes, do not use a white surface. You cannot judge values and color temperatures accurately in such a harsh environment. Try using a warm neutral (gray or brown) in a middle value, as this more closely resembles your finished painting than does white.

SELF-CRITIQUE

Is your painting unified by a dominant color temperature—warm or cool? Be sure your colors are in harmony with the mood—warm brights to stimulate, muted cools to calm. Did you use color symbols to your advantage? Instead of relying on preconceived color ideas about blue skies and white clouds, did you carefully observe and analyze the color relationships?

What kind of color scheme did you use —a limited palette, analogous colors, complements, or triad combinations? Are your colors arranged with a sense of order,
balancing temperature and intensity as well as value? Check for colors that jump out of context because they are one of a kind—too warm or cool, too bright or dull, too light or dark. Did you pull the colors together with an undertone, a base color, reflected sky colors, or a one-color theme?

Does any one color dominate the painting to the point of monotony? Are your colors fresh and vibrant, or overmixed and muddy? When you made a color lighter by diluting it with white, did you reenergize its intensity by adding a touch of warmth?

14
BRUSHWORK AND DETAILS

Is your brushwork expressive?
Have you used detail appropriately?

Robert Henri once wrote, "Your style is the way you talk in paint." That being the case, there are as many styles as there are individuals. Edward Hopper is known for his flat, bold shapes; Vincent Van Gogh, for his expressive brushwork conveying his inner response to life; and Grandma Moses, for her primitively magnified details, which complement her childhood memories. Jacob van Ruisdael, George Caleb Bingham, and Albert Bierstadt amaze us with incredibly detailed paintings.

Just as, with time and experience, you have developed a highly individualistic handwriting style, so too your own painting style will evolve. The subject matter you select, the way you compose it, and the colors you emphasize all express your own unique personality. Another important element of style is your brushwork.

Regrettably, quality of paint application is an element of art that is often overlooked. The craft of applying paint can be learned. Expressing joy, energy, and rhythmic movement with paint while keeping the results fresh and direct is the challenge. Hesitant, indecisive brushwork and overworked passages betray agonized struggles. Before you touch brush to canvas, visualize how your mark will look. Then execute it quickly and boldly.

Your brushstrokes are an integral part of your emotional theme, so don't mindlessly slap paint on the canvas. Use dashing diagonal strokes to convey windswept clouds, rugged textures for rustic subjects, luxuriously thick paint for spots of shimmering sunlight. Try sharp, aggressive marks to emphasize excitement; then balance them with subtle, reserved strokes—relating the two styles together as you work.

THE ROLE OF DETAIL

After you've established the values and the color harmony, you'll want to refine your brushwork, making certain areas more clearly defined. How much detail is too much? Where do you begin? When do you stop? To answer these questions, consider the options. Too much meticulously painted detail can be tiresome to paint and to look at. It robs the painting of an air of mystery and the viewer of a feeling of participation—filling in the missing details with the mind's eye. Equal detailing

is monotonous, as it loses the element of tension between order and disorder. Besides, the human eye cannot register everything with equal attention; you cannot, at the same moment, see your shoelace and a cat crossing the street two blocks away. Most likely, you'll decide to develop details in selected areas, simplifying other areas for contrast.

"Which areas?" you ask. There is no right or wrong answer. You must make your own decision about what is essential and what is not, what to emphasize and what to downplay. Personally I favor developing detailed information at the focal point and keeping everything else subservient. I don't, for example, want elaborate details on a barbed-wire fence in the foreground to distract from a barn down the lane if the barn is my focal point.

Another way to use details is to indicate depth, as mentioned in Chapter 8. A typical method would be to create a few details in the foreground and use less descriptive work in the distance. Or you might focus intently on a specific plane, such as the middle ground, by emphasizing details there.

Refrain from outlining, as it has an isolating effect on an object. To start, indicate forms with masses of thin paint; then, build on them with thicker paint, using directional brushwork to help model their basic geometric shapes. Don't draw every minute detail with a one-hair brush.

Be selective in your use of detail. Clearly defining one object often makes the other objects read. After blocking in the overall color harmony, create a few areas of contrast (especially along edges of carefully selected objects) to bring your picture into focus. Try to suggest, rather than inventory, such details as individual leaves or sky holes in gingerbread house trim. If you're unsure how to do this, review the section on contrast (pages 62–63).

Remember: no amount of detail will save a bad design. Be careful to maintain the value range indicated in the underpainting. While refining the details, don't wander from the original value scheme and lose your mood theme.

Stop when you have polished your painting enough to ensure comprehension of the subject. Vagueness to indicate mystery is encouraged, but vagueness to hide ignorance of shape and form must be avoided.

CEDAR RIDGE *1986, 24" × 36" (61 × 91 cm)*

In my painting Cedar Ridge, equal detailing would have been tiresome, so I focused on the center of interest—the two round yucca plants contrasting sharply against the sky. To augment this focus, I subdued the third yucca, located just off-center, but kept the clump of prickly pear cactus near the center clearly defined. Even a few needles are suggested. Compare it with similar clumps in the lower right and left corners. Because they are quite distant from the center of interest, relatively little detail is depicted on these cactus pads. Finally, notice the variations in color, value, and texture in the shrubbery along the ridge, and how the three major rock formations are simplified as they carry the eye into the distance.

In Red Rock Canyon the clearly defined details in the foreground give way to suggestive forms in the distance. Value contrasts and colors are subdued; edges are no longer emphasized. Notice the changes in the hill on the right as it recedes into the distance. I depicted one intense sky hole in the clouds to indicate another dimension of depth, to bring the painting back into focus, and to unite the otherwise quiet sky with the busy landscape.

RED ROCK CANYON *1986, 20" × 30" (51 × 76 cm)*

ON-SITE TO STUDIO

Painting on location is a quick way to develop your own personal style. Paint rapidly, recording the essence of the scene in your own "handwriting." Establish reasonable expectations: strive to build a storehouse of knowledge, reawaken your awareness of smells and sounds, discover new visual elements, and loosen up conservative studio work.

Travel light. Once on location, "get it down"; capture the personality of the subject, keeping it simple. Avoid undue concern with drawing and even composition. After you have visualized your painting, allow yourself thirty minutes to block in the important shapes and values before the light changes. (Use an inexpensive instamatic camera to "freeze" the light.) Concentrate on comparing and recording values, thus avoiding an "I-can't-do-this" mental block. Occasionally back away from your painting and look, not at the last brushstroke or two, but at the total presentation. Allow a maximum of three hours, from start to finish. Skip eloquent elaboration—that can be done later, if at all.

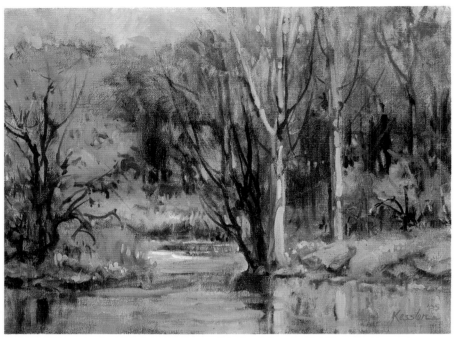

WILSON'S POND—A SKETCH *1985, 12" × 16" (30 × 41 cm), collection of J. Young*

A NOTE ON WATER REFLECTIONS

The two illustrations here demonstrate the intermediate steps in creating the reflective water in Wilson's Pond. After toning the canvas with yellow ochre and Acra red, I used a heavily loaded, large bristle brush to reflect colors vertically into the water, as shown in step 1. With a large, soft brush dipped in turpentine, I then wove the color masses together, moving the paint with horizontal brushstrokes, as shown in step 2. Be careful: don't overwork the paint. To take these steps further, add some definitive information, such as skyshine, ripples, light and dark accents, and modeling along the water's edge.

Remember: water is not necessarily blue, as it is filled with reflections of all kinds. Each situation is unique, so look closely and paint what you see. When you observe value contrasts, you will find water is generally darker than the sky. Also, actual colors are slightly cooled and muted when reflected.

There are always exceptions to any rule. Although reflections are generally darker in value than the objects being reflected, sometimes—because of the poor reflective qualities of the surface— dark objects reflect slightly lighter in value, light objects reflect slightly darker in value, and middle values reflect in middle tones. Pulling the contrasting

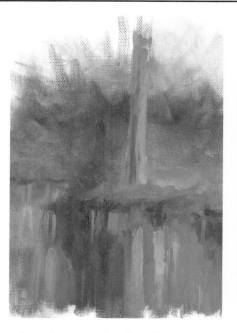

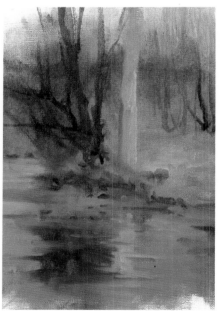

values closer together like this dramatizes a somber, emotionally moody scene. On the other hand, emphasizing value contrasts—whether of the object against the object's reflection or of highlights against dark accents within the water itself—conveys lighthearted excitement.

For still water, simplify and echo the scene—upside down, as if reflected in a mirror. Keep in mind the rules of perspective: ripples in the foreground (reflecting the sky) are bolder and farther apart than those in the distance. Perspective lines of reflected objects converge to the same vanishing point as the object itself.

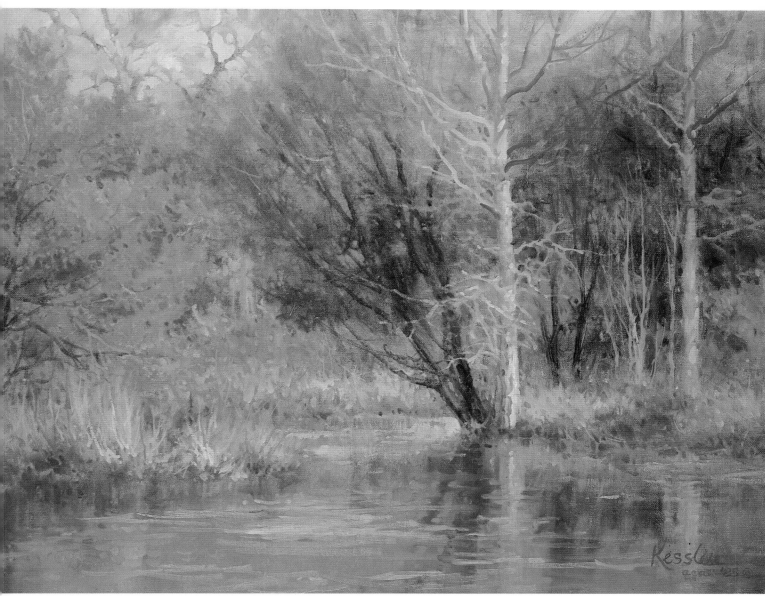

WILSON'S POND *1985, 18" × 24" (46 × 61 cm)*

I left Wilson's Pond to return to my studio—refreshed, renewed, and better for the on-location painting experience. Working from slides and my oil sketch, I spent about three days, rather than three hours, painting this studio version of the same scene.

Because of the emotional stimulation of the setting and the intense sunlight, my on-location sketch is quite rich in color, dark in value, and thus dramatically romantic in appearance. This studio painting is more refined, with clearer definition of the various forms and more emphasis at the center of interest—the base of the light tree on the right.

BRUSHWORK AND EDGES

There are an infinite number of gestural marks you can use to tell your story. Similarly, there are a number of conventional tools and techniques that you can adopt to build confidence and courage in handling the medium skillfully. Here are some specific tips.

To emphasize vibrating luminosity in the sky, apply bright tones in patches of broken color directly onto your canvas with a palette knife. (I recommend the Langnickel P3, a modified trowel, which is quite versatile and can be used for mixing on your palette as well.) The knife will help you keep the warms and cools separated until you are ready to mix them, and it will also expedite the painting process (see the steps for *In the Spotlight* on page 111). To blend the patches, use a large, flat bristle brush and work from warm to cool, but don't overmix. Then define a few edges on the clouds by painting some carefully placed, sky-blue negative shapes.

I don't recommend bright bristle brushes, as their short, stubby bristles do not spring into action—no bounce, no rhythm, no music . . . no fun. I also stay away from panel boards, which—unlike stretched canvas—reject the beat of the brush.

Another technique to try is turning a medium-size filbert bristle on its side and using it as a chisel to suggest a few outer edges where darks meet lights. In this way you can define such forms as trees and bushes. (If the brush is old and will no longer hold a sharp edge, throw it away!)

Save your small sable brushes for hard edges. If you define too many edges, smudge some with your finger or thumb—a few more readily available tools. Remember: contrasting elements create details—especially sudden changes from light to dark, warm to cool, and bright to dull. Conversely, the more limited the degree of contrast, the looser the edge.

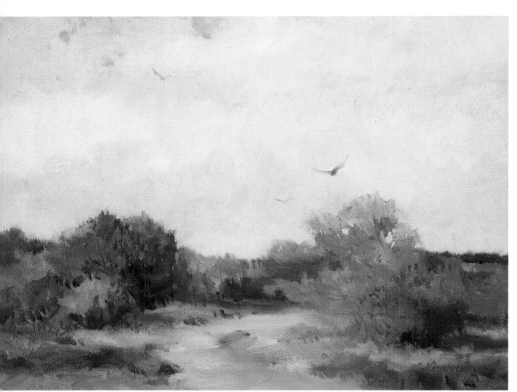

A NEW DAY *1985, 12" × 16" (30 × 41 cm)*

In this on-location sketch, the brushwork is loose and carefree; edges are predominantly soft; details are virtually nonexistent. The dreamy effect of the early morning light and the soft, spring breeze is conveyed by the power of suggestion.

Remember: toning your canvas and allowing that color to show through is a technique that emphasizes the effect of light on the scene. You can see the golden undertone here and there throughout this sketch—except in the impasto sky. This tone is especially visible on the sunny side of the big tree on the left. Note that on the road I used a scumbling technique to suggest texture as well as this golden sunlight.

DESERT BRUSH *1985, 12" × 16" (30 × 41 cm), collection of R. Gissler*

Don't develop all of your paintings to the same stage of completion. Based on your emotional theme, paint both soft-edge and sharp-focus pictures. In Desert Brush, I explicitly defined edges in the foreground and receded gradually to smooth or lost edges, entertaining with variety. The subdued sky provides a peaceful pause when compared to the busy bushes. I did not opt to amaze you with eloquent elaboration of details throughout the entire painting.

Speaking of variety, look at the brushwork here. You can see the broken-color technique in the sky, chisel marks on the mountains, soft edges in the distance, and areas of negative painting (sky holes and mountain holes in the big bush, dirt holes in the weeds). Now focus on the ball-shaped bush: note how I've allowed the tone to show through, defined selected edges where lights meet darks, and bleached out details in the lights while entertaining in the cast and form shadows. In the big bush behind, there's another technique to note: loading the lights with opaques while keeping the darks transparent. I have also used calligraphy as well as scumbling, wiping-off, and scratching-out techniques (discussed on the next page). I imagine you could even find a few fingerprints in this painting.

CALLIGRAPHY AND BROKEN COLOR

Calligraphy adds a personal touch. For variety, try adapting this watercolor technique to your work in oils. Use a rigger—a long, red sable script brush. Dilute the paint with turpentine to a watery consistency, load your brush, and gracefully scribe some details, such as twigs and a few individual blades of grass, into your painting.

Also experiment with broken color, using spots of partially mixed colors, as a way of achieving a vibratory lighting effect. You can make shadows and sunlit areas dance with excitement by letting the viewer finish mixing the colors in his or her mind's eye. As already noted, this technique adapts itself especially well to foggy or overcast skies.

After establishing the underpainting, subtly glide the tip of your rigger brush across the surface, allowing the texture to work for you as much as possible. As a way to stop thinking "limbs and twigs" and instead concentrate on design elements, experiment with turning the canvas upside down to paint the skeletal form. Pull the paint down rather than up; then return your canvas to its proper position to refine your drawing. As you drag the fluid paint away from the base, slowly lift the brush off the surface, thereby gradually tapering the line.

Start thin and build to thick paint as you define the details. To add complexity and character, smudge and restate lines. If you lose control and must begin again, scrape down the canvas with your knife and work over the stain. For variety, but without overdoing it, scratch out a few delicate lines with the wooden handle of your brush. When necessary, use a small, flat sable brush to add a few busy little marks symbolizing individual leaves. With color, indicate the full span of lighting conditions, passing from highlights through the local color to the shadows.

From the very beginning, be patient; don't develop details too soon. If you were building a house, you would not hang wallpaper before you put on the roof.

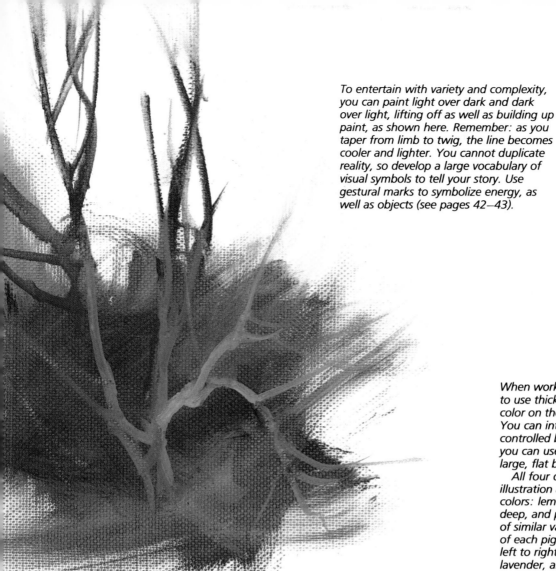

To entertain with variety and complexity, you can paint light over dark and dark over light, lifting off as well as building up paint, as shown here. Remember: as you taper from limb to twig, the line becomes cooler and lighter. You cannot duplicate reality, so develop a large vocabulary of visual symbols to tell your story. Use gestural marks to symbolize energy, as well as objects (see pages 42–43).

When working with broken color, be sure to use thick paint, mixing the patches of color on the canvas, not on the palette. You can interlock the colors using controlled brushstrokes as seen here, or you can use bold, flip-flop marks with a large, flat bristle brush.

All four demonstrations within this illustration are made up of the same three colors: lemon yellow hansa, cadmium red deep, and phthalo blue. By using colors of similar value and varying the quantity of each pigment, you can create, from left to right, a golden color, green, lavender, and gray.

TEXTURE

Texture adds another dimension to your painting, as it tantalizingly alludes to the sense of touch. It also provides another opportunity to entertain with contrast: rough versus smooth.

Texture can be created by the rough surface of the support (for instance, by coarsely applied gesso or the weave of the canvas itself), by the buildup of paint, or by a combination of the two. Although texture, like elaborate detail-work, can be used throughout your picture, applying it in selected areas is more effective. Saving the thickest paint for the final stages of the painting process, explore different uses of contrasting textures:

- Emphasize your center of interest. (Rough is more expressive than smooth texture.)
- Depict bright sunlight and highlights, pulling an area forward in perspective or emphasizing the volume of a form.
- Suggest the textural quality of an object itself—for example, rough rocks or smooth glass.
- Balance the visual weight within your painting.

(Rough is optically heavier than smooth texture.)
- Generally enrich the visual quality of the surface.

Remember: anytime you want to draw attention to a specific area, you can employ contrast by placing a few touches of thick paint on a predominantly smooth surface.

You can, of course, depict texture without creating a surface that is rough to the touch. Visual textures can be used to represent actual surfaces like bricks, short grass, or gravel. When interspersed with quiet pauses, a lively textural feeling can also be created by such brushwork techniques as splatters, swirls, dots and dashes, stringing paint, ragged edges, crosshatching, and stippling.

Whatever combination of techniques you use, be sure that they are compatible—that there is one dominant characteristic relating the textural qualities to each other and to your other painting techniques: Remember: "different" commands attention. Avoid random, isolated textural techniques and gimmicky devices.

Scumbling—dragging light, opaque, thick paint over dark, transparent, thin paint—creates a rich surface quality that sparkles with light. This adaptation of the thick-over-thin technique offers another way to depict textured surfaces as diverse as wood, dirt, porous rocks, or roof shingles.

Scumbling is effective when you are working with windows and doors too. A thickly painted, light door-frame projects forward, just as thin, darker transparents in the opening itself recede, allowing the eye to enter the depth of the building. Keep in mind that, when your finished painting is hung, the display lights will reflect off any ridges and lumps of paint, creating bright highlights. If you load the opening with dark, thick paint, the lighting will reflect off this surface, pulling the opening forward—thus confusing the viewer. For these reasons, I generally use thin, semitransparent washes in the shadows and impasto opaques in the lights.

These four illustrations show you how to build a form, step by step, with the thick-over-thin technique. First, capture the form—in this case a sphere—by blocking in the proper values, using thin, transparent paint. With a piece of cheesecloth, wipe paint onto the canvas; then simply wipe it off to lighten selected areas. (Notice that the cast shadow is already slightly darker than the form shadow.) This technique differs from the popular mode of line drawing to place objects: rather than filling in an outline, you think ''form'' from the start.

Now begin to block in the color harmony, with thicker paint, starting with the local color, using large brushes and loose brushwork. Then indicate form shadows and cast shadows in color. Finish with highlights and dark accents, building as much texture as you wish and defining a few crisp edges with a small, flat sable brush. Don't forget reflected lights, skyshine, and sky holes. Remember: you are refining and adjusting your original composition—always designing, even as you apply the finishing details.

SELF-CRITIQUE

Did you clearly define a few details in selected areas or monotonously develop everything? Where did you emphasize details—the focal point? Where lights meet darks (edges)? In the sunlight or shadows? Foreground or middle ground?

Rather than laboriously paint every detail (one leaf at a time), did you suggest form and then refine it? Did you model with brushwork, avoiding outlines? Did you emphasize the elements of contrast to create details and subdue these same elements to lose edges? Have you used vagueness as an excuse to hide ignorance of shape and form?

Is your brushwork fresh and direct, graceful and energetic? Or is it cautious, indecisive, overworked? Did you adopt a number of painting techniques to create variety? Which of these techniques did you use: broken color, show-through tone, lost and found edges, scumbling, chisel marks, wiping off, scratching out, finger smudging, calligraphy, dark over light, or light over dark?

Did you entertain with texture, too? Was the surface of your canvas textured? Did you build texture with the paint itself (thick over thin)? Did you indicate textural qualities with visual marks, such as swirls, ragged edges, crosshatching, splattering, and stringing paint? Where did you emphasize textural qualities? Are your painting techniques and textural qualities compatible with your emotional theme?

15
GALLERY READINESS
Is the total presentation attractive?

Whether you display your painting for pleasure, for sale, or for entry into a competition, it is important to consider the overall presentation. This includes your signature, the surface gloss, framing, and even the title.

Look at the signature on your painting. Does it call too much or too little attention to itself? When viewed in relation to the overall picture, is it too light or too dark, too warm or too cold, too bright or too dull, too large or too small? As with every brushmark on your canvas, it must be compatible with its environment. I use a no. 2 round sable to sign my name. Remember: your signature is not the featured attraction.

Your completed painting should be varnished before it is displayed (see page 21 for specifics). Not only will the surface of your picture be protected from dust, smoke, and other impurities, but the glossy finish will reveal the true colors, restoring life and vitality to your painting. Take care, however, not to create a surface that is so glossy that it is distracting.

When it comes to framing, make sure you enhance the work, creating a unified package. Avoid "loud" frames—elaborate wood carving, gold glitter, and other forms of razzle-dazzle. Don't overframe, engulfing an 11 × 14-inch (28 × 36 cm) canvas in a five-inch (13 cm) molding or underframe. Consider using a rustic frame on a rustic scene and a formal frame on a formal scene. Wide matting relieves tension in a crowded, busy composition and expands the vastness of a panorama.

Without some form of contrast between the painting and the frame, your painting will dissolve into the frame and be lost. A dark frame on a predominantly dark painting is desirable, but the frame itself must offer enough contrast (light/dark) with the painting to work as a "stop," confining the eye to the painting. Off-white linen matting can provide this contrast. Similarly, a painting with a predominantly warm color theme calls for a warm frame—again with some degree of contrast.

The frame must be strong, and the strength of the picture wire and the size of the screw eyelets must correspond with the overall weight of the picture. Don't use delicate eyelets on a heavy frame. Tension clips do not hold the canvas firmly in the frame; nails pierce the fabric edges and do not allow for expansion of the stretchers. There are other options on the market that overcome these problems.

Finally, there's the title. A good painting will reveal its meaning without the aid of a title; on the other hand, a title is yet another opportunity to entertain your audience. In an effort to get better acquainted with your painting, viewers will ask, "What's the title?"—just as you would ask a potential friend, "What's your name?" Don't disappoint them with responses like "Untitled #4791" or "Barn #437."

Title ideas are all around you—phrases in songs and printed articles discussing art as well as names of streets, apartment complexes, and housing developments. Keep a written list of title ideas to use for reference when you need inspiration. Since, over a period of years, you can accidentally repeat titles, it is a good idea to assign each painting an inventory number. (These numbers, when assigned consecutively over the span of a career, are personally rewarding.)

When using 35mm slides to present your work to galleries or to juries for competition, the quality of presentation is essential. Of course, it is best to have your paintings photographed by a professional, but if that is not an option, you can take reasonably good slides yourself.

This reproduction illustrates what not to do! The most obvious error, and the easiest one to eliminate, is the distracting background. Try draping an exterior north wall or fence with a large piece of flat, black, nonshiny fabric. Hang and photograph your unframed paintings, beginning with your largest and working down through the smallest. When the finished slides are shown in a dark room, the black fabric disappears. With no background distraction, the only thing the viewer sees is your painting.

For equipment, I prefer a 35mm SLR camera, tripod, cable release, and Kodachrome 64 film. Don't forget to move in close and fill the camera lens with the painting. If you photograph your paintings on a mildly overcast day, the colors will be quite accurate.

THE WHITE HOUSE *1980, 12" × 24" (30 × 61 cm)*

SELF-CRITIQUE

Is your painting gallery-ready? Is your signature legible but discreet? Is the title interesting without being trite or cute?

If you did not use a medium (other than turpentine) during some phase of the painting process, did you spray varnish on your painting and let it dry overnight before you brushed on the final varnish? Don't forget to wait two to three months before varnishing—even if you do not build up a thick layer of paint.

Does your frame enhance your picture or detract from it? Avoid "loud" framing, overframing, and underframing. Is your frame predominantly warm or cool, light or dark, formal or informal—in harmony with the picture? Does the frame provide just enough contrast to hold the viewer's eye within, or does your painting dissolve into the frame? Is your frame, including wiring and eyelets, strong?

EPILOGUE

Critiquing and repairing your work

When your eye can stroll through your painting again and again, enjoying the journey without stumbling, you know you have completed your task successfully. You have established your emotional theme skillfully, accomplishing just what you set out to do, without many problems along the way. Or you hope your picture at least looks as if it were created without a struggle.

No artist, of course, does everything perfectly every time. Fortunately, oil paints are very forgiving. Even after they are dry, they can be modified, adjusted, patched, and repaired extensively until you have clarified your theme and harmoniously related all the elements. Although it is wise to preplan your paintings with value studies and thereby avoid most pitfalls, once your picture is finished, the challenge is to identify the problems and change them before the painting is sold and gone—only to reappear and haunt you later, publicly.

Now it's time to draw on everything you've learned in this book to critique one of your own paintings. Temporarily snap one of your landscapes into a frame, sit back, put your feet up, and begin by reviewing, one by one, the fifteen questions in the "self-critique summary" (on the facing page). As you look for problems, also identify and analyze successes. For an in-depth study of your painting, review the self-critique at the end of each chapter.

Understand that not every "rule" can be applied to each one of your paintings.

Also turn to the section on checking the design on page 123. Adapt those evaluation techniques to your finished painting. Remember: the most revealing test is a black-and-white photograph of your painting, as it clearly displays your value plan—or lack of it.

Don't expect to locate all problem areas in one sitting. Usually you can be more objective about your work if you set it aside, out of sight, for a couple of weeks. Paradoxically, if you put your painting in a place where you will see it casually, several times a day, problems will also gradually become obvious to you.

Once the problem areas are located, many of them can be solved by simply asking yourself, "Is it too dark or too light, too warm or too cold, too bright or too dull?" Then make the appropriate adjustments, beginning with the area that bothers you the most.

With skillful alterations, you can make a bad painting better or a good painting excellent; but you must accept that some paintings just cannot be saved. Basic compositional mistakes in the abstract design—balance problems, for example—are extremely difficult to change. Repair what you can, and learn from the rest.

SELF-CRITIQUE SUMMARY

1. Why are you painting this scene? What do you want to say?

2. Do the shape and size of your canvas help or hinder the overall theme of the painting?

3. Is the division of space decisive? Is the scene clearly a landscape, skyscape or closeup?

4. Is there an organized movement through the painting?

5. Have you grouped objects artistically?

6. Is there just one focal point? Is it well located?

7. Is the perspective correct without being mechanically boring?

8. Have you created a sense of depth?

9. Is the value range consistent with the mood?

10. Is the overall relationship of one value to another correct?

11. Is the basic light-dark design an interesting abstract pattern?

12. Are the negative shapes in the painting varied?

13. Is your painting predominantly warm or cool?

14. Is your brushwork expressive? Have you used detail appropriately?

15. Is the total presentation attractive?

A TYPICAL CRITIQUE

With a copy of the self-critique summary in hand, let's look at a painting that I did a few years ago. At the original site I was captivated by the sparkling lights and gentle breezes of the late-spring day. I chose a large, horizontal canvas to emphasize the bright sky and broken clouds. To convey a peaceful mood, I composed the scene with a gently zigzagging movement, beginning just inside the lower left edge. The utility pole on the right, the shed on the left, and then the dominant tree on the right work as "stops."

As you compare the progressive steps with the finished painting, you'll notice that I shortened the distractingly prominent utility pole just to the right of center, making it recede into the distance. Now, using twenty-twenty hindsight, I wish I had also leaned the pole on the far right *into* the painting to augment the linear movement and made it a little taller than the next pole to suggest depth and create more variety.

In terms of groupings, I composed a large mass of buildings just to the right of center and balanced it with the smaller shed on the far left. Notice that there are three rolls of hay on the right and five utility poles (uneven numbers). I also assembled three tree shapes, of various sizes and textures, around the main focal point—the sunny side of the barn. Observe the contrast here between the dark, cool trees and the light, warm side of the barn. The large sky creates a secondary point of interest. When I checked the painting during the painting process, I discovered and removed a foreground fence row on the left, which was distracting; in this way I strengthened my focal point.

While taking perspective into account, I made sure the buildings had some personality. Depth, although not emphasized, is conveyed. Notice, for example, graduated elements in the sky, as well as the distant treetops over the horizon. The wide value range—from fairly light to quite dark—and the predominantly cool temperature, with warm accents, capture the bright, carefree mood of the pleasant day.

The trees, clouds, and buildings have volume and form. The terrain is contoured. The sky is lighter than the ground, which is lighter than the upright planes. The abstract pattern is simple, but balanced. So far, so good.

When I came to consider the negative spaces, however, I found several problems. Originally, the tractor was placed between the two building groups. But when I studied the spaces between the objects along the horizon, the tractor seemed distracting. I then scraped the tractor off with my palette knife and relocated it, making it a part of the focal point. There was, however, another problem with negative shapes that I did not catch until after the painting was sold and gone—the abstract shape of the sky is boring. If I had deemphasized or even eliminated the cluster of budding trees on the left of the main barn, the composition would have been greatly improved.

When it came to color harmony, I discovered, during the painting process, that I could improve the general unity and harmony of the painting by removing the tall grass I had planned in the middle foreground and replacing it with rocks. These rocks repeat the shapes and colors of the clouds, thereby uniting the sky with the scene.

As for the brushwork, it is varied and entertaining—controlled strokes at the focal point, loose and expressive marks elsewhere.

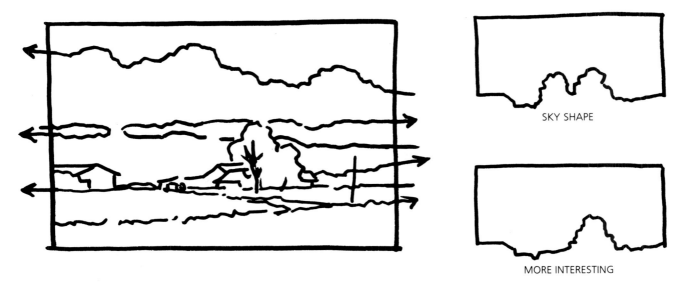

SKY SHAPE

MORE INTERESTING

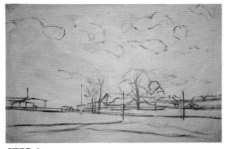
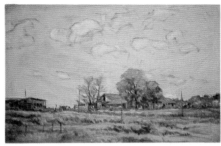
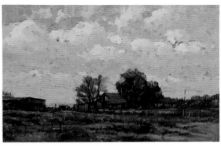

STEP 1

STEP 2

STEP 3

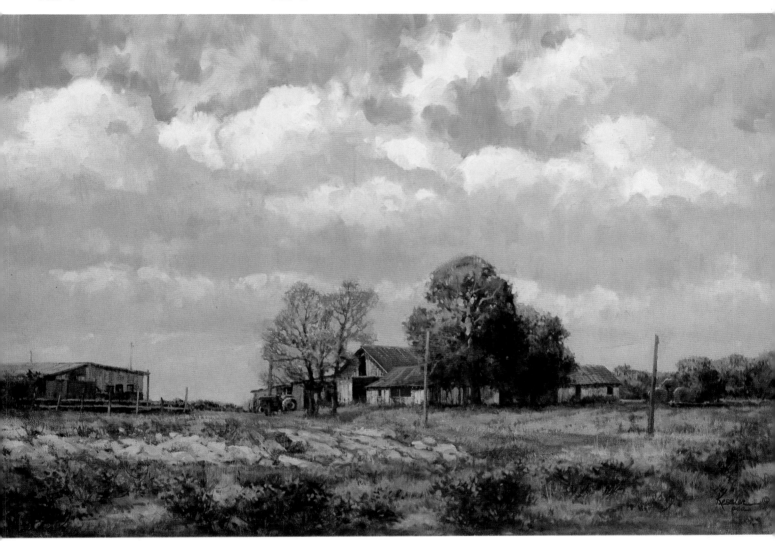

FARMBOY COUNTRY *1984, 24" × 36" (61 × 91 cm)*

ADJUSTMENTS AND CORRECTIONS

When you make adjustments on a painting, the surface must either be wet and workable or perfectly dry. Do not try to rework partially dry paint. The soft areas in the thick paint will lift off, leaving random potholes in the surface. This revolting development is nearly impossible to repair.

When adjustments are made after the paint has thoroughly dried, you must apply some form of painting medium over the dry surface so the new paint will adhere to the old. For *Aspen and Pine* (below), I sprayed the area to be reworked with damar retouch varnish and then applied the new paint as if I were working on a new canvas. (As an added benefit, retouch varnishes restore brilliance

This painting has a number of problems. Regrettably, the focal point is in the upper left corner—the dark, cold, lacy pine against the light, warm, simplified sky. In this case, the sky is solely at fault. As you can see in the corrected version, I darkened and cooled the sky area and made it more complex, changing it from "sky" to "distant trees."

In making your correction, don't look solely at the object you are painting at that moment—you must consider it in relationship to its overall environment. When, for example, I drastically reduced the degree of contrast in the upper left corner of this painting, the center of interest shifted automatically to the secondary focal point—the foreground aspen just barely to the left of center. This was not a desirable development either.

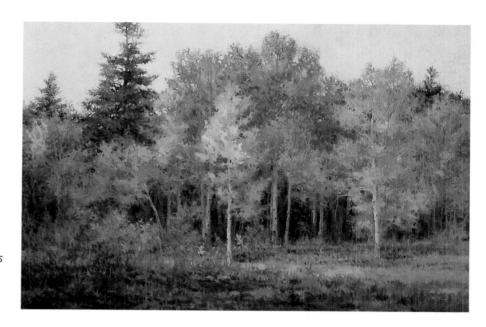

To move the center of interest to a more desirable location, I chose to leave the nearly centered tree alone and lighten, brighten, and clarify edges on the foreground aspen tree on the right. To draw additional attention to this new center of interest, I lightened and brightened the ground area leading to the tree. My goal was to make the upper left pine and the nearly centered aspen subservient to this new hero.

Sometimes you can emphasize a particular area by deemphasizing another area. In the first version of this painting, the lower left corner is quite busy with contrasting middle tones and darks. By subduing the dark values in this area, tension is relieved, so the eye is no longer distracted from the intended focal point. Conversely, you can draw the eye away from an overly dramatic focal point by intensifying the contrasting elements in another area. You may remember that I did this in Fred's Junk *(page 69).*

To "fine-tune" Aspen and Pine, *I adjusted the rhythm of the light tree trunks in the dark of the woods— emphasizing some and deemphasizing others, constantly aware of the negative spaces being created.*

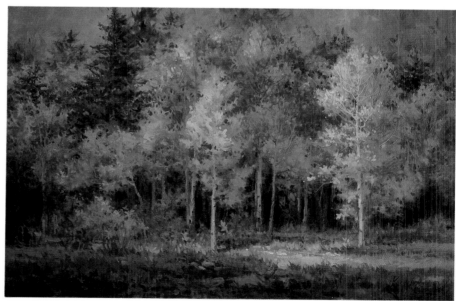

ASPEN AND PINE *1984, 20" × 30" (51 × 76 cm)*

to colors that have dried disappointingly flat.)

An alternative to a spray retouch varnish is an oily medium like the one I used for *Return of the Elements* (below). To make this varnish, use one part damar varnish, one part stand oil, and five parts gum turpentine. Mix and store this in a plastic squeeze bottle with a hinged spout. Let it stand a few minutes until it has dissolved. Then, to correct your painting, squirt this oily medium directly onto the problem area to lubricate the dry surface. As you apply the new paint into this slippery mixture, it feels as if you were working wet-into-wet, thus inviting painterly brushwork and even finger smudging. This mixture is especially well suited for situations where you need to patch an area and match colors and values perfectly. As you work out from the problem area, gradually use less and less new paint until the old and the new become one.

After critiquing this painting, I corrected two major problems. Not only does the utility pole with the crossbar, resembling a religious cross, attract too much attention, but it is too close to the corner—the upper left corner at that! Remember: corners should be subdued.

The other problem I discovered during the self-critique was an unpleasant overall tone in the warm, light colors. I had used too much cadmium red deep when I applied the preliminary tone to the canvas. Everywhere this tone showed through, the painting glowed irritatingly red, especially when it was viewed under warm incandescent lighting.

Eliminating the crossbar muted the impact of the utility pole. To correct the color situation, I glazed especially troublesome areas, like the foreground grass, with a cool color. That is, I washed a thin, transparent veil of cool colors over the offensively hot areas, modifying the color temperature.

To glaze, just squirt some painting medium onto your palette and gradually add a little pigment until you have the desired color and value. Then, using a fairly large, soft brush, wash this transparent glaze over the troublesome areas. Although you can buy ready-made painting mediums such as Winsor & Newton's Liquin for glazing, I prefer the oily varnish formula given above. Whatever your medium, dilute it with turpentine if it is too thick.

Some tube colors, such as alizarin crimson, ultramarine blue, and phthalo blue, are obviously more transparent than others. All colors, however, become relatively transparent when mixed with the quantity of medium it takes to prepare a glaze.

You may be surprised to discover that when you use glazing to solve a color problem you may actually enhance the

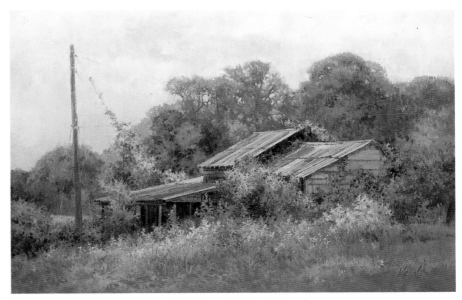

RETURN OF THE ELEMENTS *1984, 20″ × 30″ (51 × 76 cm)*

lighting effect in your painting. Glazing is another technique that oil painters use to create luminosity. If you take a thickly applied, light color such as yellow, which is dry to the touch, and glaze it with a transparent veil of a darker color such as blue, the new color (green) has a reflective quality that seems to radiate energy—more than if the two colors had been mixed on the palette.

MORE REPAIR TECHNIQUES

When desperate, crop. But remember, once cropped, always cropped; there is no turning back. Although cropping a painting is rather drastic, in the end it is not how you got there, but whether you won or lost, that matters.

Rural American is an example of one of those hard-to-correct problems. The bottom fourth of the painting is boring. It does not contribute anything to the design or the mood of the painting; if anything, it distracts. To salvage the painting, I had either to strengthen the design of that section and incorporate it into the overall composition or eliminate it all together.

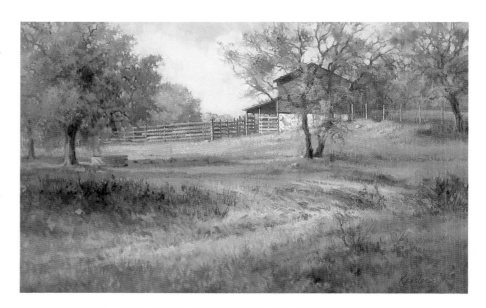

I decided that the original choice of format, both size and shape, was not the best of decisions. By cropping the bottom edge and restretching the canvas, I made the scene more restful and intimate in nature. The gentle zigzagging movement now leads to a center of interest without a visual uphill struggle. Notice that I also removed the water tank, thus eliminating another distraction.

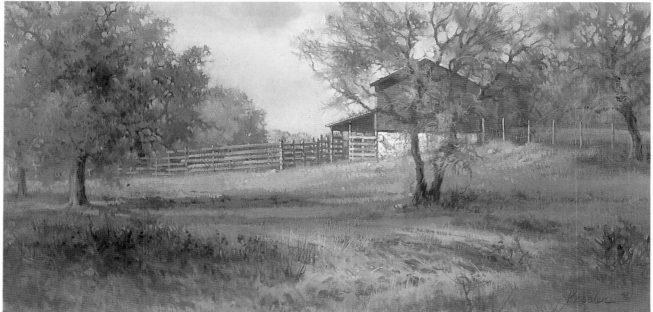

RURAL AMERICAN *1984, 15" × 30" (38 × 76 cm)*

A CAUTIONARY NOTE

Because canvases are expensive, you may be tempted to paint a new painting over an old, failed painting. Don't do it. Just as sure as not, your new painting will be a masterpiece—except for an area or two of distracting texture created by the old painting underneath.

Another caution: do not turn a used canvas over and paint on the back side. With changes in the weather, canvases shrink and stretch. A canvas cannot "breathe" if there is paint on both sides.

If you know before the surface has dried that you want to destroy a painting,

take it out to the wood pile and scrub it down with turpentine. The stain left on the canvas makes a nice tone for a new painting. Do not apply gesso (a water-based substance) over this oily surface, as in time it will peel off, taking your new painting with it.

SOME FINAL COMMENTS

Most patch-and-repair work can be avoided by planning ahead. Remember to develop your idea with a value study before you begin to paint. Check and double-check the sketch for design problems.

Know and practice the rules, but don't let them inhibit you. Use them as tools to expand your ability to communicate. If you understand why the rules work, you will retain the information longer; but eventually you must put them out of your mind and let your subconscious work for you.

It is important to paint regularly; don't wait for the mood to strike. Set time aside for yourself. Also set goals, such as doing one painting a week.

After you have finished, critiqued, and altered your painting to the best of your ability, invite comments from fellow artists and friends. Get over being emotionally sensitive to their remarks. Brainstorm with them, learning to verbalize the strong and the weak points in your work. In the end, be selective of the advice you are given.

Overall, have fun painting, be open to new ideas, and have the courage to challenge yourself and the discipline to "hang in there" when the going gets tough. Risk failure, as fear of failure will cripple you. Think quality; strive for perfection. Above all, keep those brushes wet.

BROOKSONG *1986, 24" × 36" (61 × 91 cm)*

BIBLIOGRAPHY

You will seldom see me without an art book under my arm. I read while I wait—at the dentist's office, the car repair center, and the beauty shop. Over a period of years, through the following books and others, I have been able to study with accomplished artists from far and near.

Ballinger, Harry R., *Painting Landscapes*. New York: Watson-Guptill Publications, 1965.

Battershill, Norman, *Painting and Drawing Skies*. New York: Watson-Guptill Publications, 1981.

Biggs, Bud, and Marshall, Lois, *Watercolor Workbook*. Westport, Conn.: North Light Publishers, 1978.

Birren, Faber, *Principles of Color*. New York: Van Nostrand Reinhold Co., 1969.

Blake, Vernon, *The Way to Sketch, with Special Reference to Water-colour*. New York: Dover Publications, 1981.

Caddell, Foster, *Keys to Successful Color*. New York: Watson-Guptill Publications, 1979.

————, *Keys to Successful Landscape Painting*. New York: Watson-Guptill Publications, 1976.

Carlson, John F., *Landscape Painting*. New York: Sterling Publications, 1953.

Clifton, Jack, *The Eye of the Artist*. Westport, Conn.: North Light Publishers, 1981.

Cole, Rex Vicat, *Perspective for Artists*. New York: Dover Publications, 1976.

Edwards, Betty, *Drawing on the Right Side of the Brain*. Los Angeles, Cal.: J.P. Tarcher, 1979.

Gruppé, Emile A., *Brushwork*. New York: Watson-Guptill Publications, 1977.

————, *Gruppé on Color*. New York: Watson-Guptill Publications, 1979.

————, *Gruppé on Painting*. New York: Watson-Guptill Publications, 1979.

Hawthorne, Charles W., *Hawthorne on Painting*. New York: Dover Publications, 1965.

Janson, H.W., *History of Art*. New York: Harry N. Abrams, 1979.

Kautzky, Ted, *Ways with Watercolor*. New York: Van Nostrand Reinhold Co., 1963.

Montague, John, *Basic Perspective Drawing*. New York: Van Nostrand Reinhold Co., 1985.

Richmond, Leonard, *From the Sketch to the Finished Picture: Oil Painting*. New York: Pitman Publishing Corp., 1959.

Schmid, Richard, *Richard Schmid Paints Landscapes*. New York: Watson-Guptill Publications, 1975.

Sloan, John, *Gist of Art*. New York: Dover Publications, 1977.

Sovek, Charles, *Catching Light in Your Paintings*. Cincinnati, Ohio: North Light Publishers, 1984.

Strisik, Paul, *The Art of Landscape Painting*. New York: Watson-Guptill Publications, 1980.

Taubes, Frederic, *The Art and Technique of Landscape Painting*. New York: Watson-Guptill Publications, 1960.

INDEX